P9-AOU-546

741.092 Lin

Lines of vision.

The Lorette Wilmot Library
Nazareth College of Rochester

Lines of Vision

Drawings by
Contemporary Women

Lines of Vision

Drawings by Contemporary Women

Judy K. Collischan Van Wagner

Foreword by Thomas W. Leavitt
Introduction by Judith Wilson

Hudson Hills Press · New York

DISCARDED
LORETTE WILMOT LIBRARY
NAZARETH COLLEGE

For Brien Grey Collischan Van Wagner,
who I hope will grow up to be a humanist.

First Edition

© 1989 by Judy K. Collischan Van Wagner
Introduction © 1989 by Judith Wilson

All rights reserved under International and
Pan-American Copyright Conventions.

Published in the United States by Hudson Hills
Press, Inc., Suite 1308, 230 Fifth Avenue, New York,
NY 10001-7704.

Distributed in the United States, its territories and
possessions, Canada, Mexico, and Central and South
America by Rizzoli International Publications, Inc.
Distributed in the United Kingdom, Eire, Europe,
Israel, and the Middle East by Phaidon Press Limited.
Distributed in Japan by Yohan (Western Publications
Distribution Agency).

Editor and Publisher: Paul Anbinder
Copy Editors: Barbara Einzig and Karen Siatris
Designer: John Morning
Composition: U.S. Lithograph, typographers
Manufactured in Japan by Toppan Printing Company

Library of Congress Cataloguing-in-Publication Data

Lines of vision : drawings by contemporary women /
 [assembled and introduced by] Judy K. Collischan
 Van Wagner ; foreword by Thomas W. Leavitt ;
 introduction by Judith Wilson.
 p. cm.
 Bibliography: p.
 ISBN 1-55595-027-2 (alk. paper)
 1. Drawing, American. 2. Drawing—20th
 century—United States. 3. Women artists—
 United States—Biography. I. Van Wagner, Judy
 K. Collischan.
 NC108.L54 1989
 741′.092′273—dc20
 [B] LC 89-33217
 CIP

Contents

741.092
Uin

6

Foreword

"omen's drawings are recognizable because of their lighter, more delicate touch." "Women select subject matter that is organic and relational rather than structural and isolated." "You can tell women's art by its feminine focus." It is really quite fascinating that all of these conventional statements, and many other generalizations frequently asserted to distinguish female artists from male artists, are patently false. Certainly, being a woman is very different from being a man, both biologically and sociologically. Differences in physical dimensions, bodily functions, and reproductive roles are basic but probably less important than early training and expectations in determining the orientation of men and women in society. Beginning with the selection of our crib toys and first clothes, we are constantly inculcated with possessions and behavior patterns "appropriate" to our sex.

In the face of biology and the ubiquitous social conditioning we all encounter, it is remarkable that the differences in drawings and paintings by female and male artists are so difficult to discern. The richness and diversity of the drawings in this collection belie the notion that any specific criteria can reliably indicate the gender of the artist. Perhaps this means that the experience of being human creates a stronger bond among us than does the fact of being a woman or a man. And it may also affirm that individual differences of temperament and creative power are more significant than gender in the creative process.

In these days of postmodernist self- and social consciousness, however, the situation is not quite so clear. Many women artists today are consciously creating work that affirms their womanhood. Both in theme and in style they demonstrate the subtle power of female energy in a male-dominated society. Art has become a political and social battleground for them, as they sound the cry for recognition and acceptance of feminist ideals. Art has always been a vehicle for the expression of social, political, and religious convictions, and the issues of today are certainly as important and as valid as those of previous times.

ll of us should, therefore, welcome the challenges and the insights of feminist art, recognizing that it may not be possible at present to assess its artistic quality because it and we are so enmeshed in the struggles of our time. We can also enjoy the works in this volume, which defy classification and celebrate the individuality of contemporary artists. For now, it is sufficient to appreciate and try to comprehend the works of art before us, savoring both the affirmations of womanhood and the tremendous range of human sensitivity that these drawings bring to us.

Thomas W. Leavitt
Director, Herbert F. Johnson Museum of Art
Cornell University, Ithaca, New York

Acknowledgments

First and foremost, I want to express my thanks to the participating artists for their enthusiasm and interest, for expressing their thoughts on drawing, and, most of all, for lending their work (except where otherwise noted, all works have been lent by the artists). I am also grateful to the many dealers who facilitated these loans and to private collectors who agreed to share works from their collections.

For their assistance with the preparation of this book and the accompanying exhibition, I am particularly thankful to a few individuals. To Margaret Kerswill, I am indebted for many dedicated hours spent contacting artists and verifying information in the arduous interest of accuracy. Others helpful in assembling and checking data and proofs were Virginia Clow, Jill Bowman, Peter Klann, and Karen Siatris. For their assistance with the organization of two exhibitions (domestic and international versions) and this volume, the author is most appreciative of the work of Mary Ann Wadden, Judith Lintz, and Carol Becker Davis.

With a few exceptions, all artists are represented in both versions of this exhibition; the author of this volume served as curator for both shows. In the United States, the exhibition travels under the auspices of Long Island University to the following venues: Blum Helman Gallery, New York (July 3–August 17, 1989); Murray State University, Kentucky (November–December 1989); Grand Rapids Art Museum, Michigan (January 12–February 25, 1990); University Art Gallery, University of North Texas, Denton (September–October 1990); Richard F. Brush Gallery, St. Lawrence University, Canton, New York (November–December 1990); and the University of Oklahoma

Museum of Art, Norman (January 18–March 3, 1991).

An exacting and thorough editing of the book was undertaken in a helpful and conscientious manner by Barbara Einzig. I would also like to acknowledge Paul Anbinder, Publisher, Hudson Hills Press, and Anne Sue Hirshorn, Program Officer, Arts America, United States Information Agency, for their suggestions and interest. Ms. Hirshorn must also be credited for her efforts directed toward the Latin American tour. Moreover, I would like to express my gratitude for the aid provided by the USIA, by Abraham Krasnoff, President, the Pall Corporation, and by Long Island University, and in particular I wish to thank the University's President, Dr. David Steinberg, for his support of this project.

Several of the artists' statements included in this volume were originally published elsewhere. The author and publisher wish to express their gratitude to the publishers for materials herein reprinted, the sources of which are listed in the Sources section at the end of the book.

We also wish to thank the following galleries by whose kind permission illustration of the specified artist's work is reproduced (except where otherwise noted, galleries are in New York): Bourgeois, Fish, Hesse, Krasner, Mitchell, and Neel: Robert Miller Gallery; Brandt: Trabia-MacAfee Gallery; Joan Brown: Allan Frumkin Gallery; Buchanan, Ringgold, Schapiro, Smith: Bernice Steinbaum Gallery; Cheng: Lang & O'Hara Gallery; Connell and Teague-Cooper: Siegeltuch Gallery; Coyne: Jack Shainman Gallery; Dickson: Brooke Alexander

9

Gallery; Ewing: Diane Brown Gallery; Fasnacht and Laufer: Germans Van Eck Gallery; Ferrara: Michael Klein Gallery; Frank: Zabriskie Gallery; Graupe-Pillard and Pinto: Hal Bromm Gallery; Hall: Zeus-Trabia Gallery; Anne Griffin Johnson: Lynn McAllister Gallery, Seattle; Keeley: Tomoko Liguori Gallery; Lane: Barbara Mathes Gallery; Li-Lan: O. K. Harris Gallery; Lutz: Marilyn Pearl Gallery; Marisol: Sidney Janis Gallery; Pfaff: Holly Solomon Gallery; Phelan: Barbara Toll Gallery; Renouf: Blum Helman Gallery; Scotti: Michael Walls Gallery; Sheehan: Bruno Facchetti Gallery; Sigler: Dart Gallery, Chicago; Joan Snyder: Hirschl and Adler Gallery; Stuart: Fawbush Gallery; Theobald: Cirrus Gallery, Los Angeles; Walking-Stick: M-13 Gallery; Way: Brody's Gallery, Washington, D.C.

Introduction

Some Thoughts on Drawing and Women

Judith Wilson

The traditional notion of drawing as the cornerstone of artistic achievement is a tradition mainly of the West. In the calligraphically based pictorial (as opposed to three-dimensional) arts of China and Japan, for example, a brush-wielding linear discipline and painterly tonal effects are fused to such an extent that "drawing" and "painting" become inseparable. Africa, in precontact times or today in enclaves indifferent to imported aesthetic preferences, offers few instances of drawing as an independent pursuit. There are various rupestral "graphics"—prehistoric or precontact engravings in rock. There are the magnificent bark-cloth designs made by Mbute pygmy women in Zaire. But there is nothing like the European sketch, study, or architectural plan.

African carvers pride themselves on an ability to work from a purely mental image—a feat that involves visualizing their final product from the moment they choose a piece of wood and continuing to firmly grasp that vision throughout the successive phases of a mask's realization. A similar absence of preparatory drawing typifies the sometimes quite elaborate designs with which African women traditionally paint or incise the walls of earthen domiciles throughout the continent's grassy regions. Such decorative muralists may scratch a few lines in the dirt to guide themselves. But they seldom leave more permanent records of their preliminary acts of imagination, analysis, adjustment.

Contemporary American artists can tap any or all of the preceding cultural attitudes—as well as ones not mentioned, such as those of America's indigenous populations—toward freehand, two-dimensional image making. If they choose to emulate non-Western approaches, however, they seldom do so in complete innocence of the Renaissance view of drawing as "the foundation and theory" of painting and sculpture described by Lorenzo Ghiberti in his mid-fifteenth-century *Commentarii*. Instead, when academically trained artists of our time reject conventional modes of drawing, they tend to stand the Renaissance tradition on its head and produce works that echo or rival less elemental modes of expression.

By incorporating mass-produced household objects like the beer coasters on which she "draws" in watercolor and crayon, Candida Alvarez thwarts expectations of absolute flatness and visual economy. With its lush painterliness, Cynthia Carlson's *Belly Roll* is reminiscent of her thickly painted, decoratively patterned installations. Meanwhile, Maren Hassinger, in her arrangements of preserved rose leaves on paper, quietly collapses boundaries between romantic and reductive tendencies in recent art. The poise with which these artists pull off such feats recalls the serene virtuosity of Mary Cassatt, whose astonishing color print of a woman bathing forced Edgar Degas to exclaim, "I will not admit that a woman can draw that well!"

Although the prejudice so ironically confessed by Degas has probably been widespread, it seems odd that more gatherings like the present one have not been made. Women, after all, *have* played a historic role in the development of American drawing. In colonial times, Henrietta Johnston, the plucky wife of an Anglican missionary, was the pioneer of work in pastels. Despite Indian wars, malaria epidemics, and her spouse's tendency to get lost at sea, Johnston steadily turned out competent, if somewhat formulaic, portraits of many of South Carolina's earliest white settlers.

We know the paintings of such nineteenth-century artists as Sarah Miriam Peale or Cecilia Beaux. But what about their drawings? Beaux, a member of the Academy of Arts and Letters as well as the National Academy of Design, was an instructor of drawing and painting at the Pennsylvania Academy of the Fine Arts from 1895 to 1915. Surely an artist with those credentials would be included regularly in surveys of American drawing if she were a "he"!

Then there are the sculptors who settled in Rome in the 1860s—Harriet Hosmer, Edmonia Lewis, Anne Whitney. Where are their drawings? Some of the most striking work in this volume comes from artists better known for three-dimensional creations—Beverly Buchanan, Heide Fasnacht, Yong Soon Min. One can't help wondering what's obscured, what links we've lost by our neglect of their forerunners in this century and the last.

So we have a beginning here: an exhibition that stirs curiosity, invites questions, whets our appetites for more of the intimate history of artists' activity that only drawing, with its wondrous immediacy, can provide.

Drawing New Definitions

Judy K. Collischan Van Wagner

Within the context of contemporary art, especially that of the past two decades, drawing has undergone expansion in definition, format, and media. Its independence and amplification have increased steadily in correspondence with greater recognition of a widening variety of drawing modes and of the primacy of drawing to the human imagination. In comparison with its historical position since the Renaissance as a preliminary preceding the main discourse of painting, sculpture, or architecture, drawing has gained acceptance within the nineteenth and twentieth centuries as a viable vehicle for individual expression. Whereas it was once considered only as a preparatory stage, currently drawing may be considered an end in itself. Although it possesses a long and illustrious tradition, drawing has received comparatively little attention and has been relegated to a level of lesser importance. This form of art has persisted through the course of time, but in a capacity limited by conventional conceptions and market interests. Nevertheless, more artists today are devoting their energies solely or partially to drawing as they realize its intrinsic significance as independent object as well as ancillary aid. Now there are reputable collections devoted to drawing, as collectors and curators have come to recognize drawing as an art form intimate with the act of creating. Drawing's status among other arts has risen with acknowledgment of its independence, multiformity, immediacy, and unique potential to convey thought and feeling.

New interest in drawing is dependent in part upon its proximity to the human urge to give form to experience. The action of drawing may be broadly defined as both force and attraction. It involves application that can be assertive and alluring. The contiguity and directness of drawing as an active verb connects an artist's hands and mind. Linkage of subconscious with conscious motivation is inherent in this interactive process. To the artist, drawing is often a stimulant that can exist in its own right or in relationship with some other objective. For viewers, drawing is revelatory of the artist's awareness and insight.

In this volume of women's drawings and statements, emphasis on drawing linked to inspiration and the subliminal is particularly evident. As artist Nancy Brett observes, "Drawing is a main line to the unconscious," and her sentiment is echoed by several others, including Sandy Gellis, who writes, "My drawings are exploratory and express 'mind-states.'" For Jill Baroff, "Drawing facilitates a moving beyond what I currently know," and Maura Sheehan states cryptically, "Drawing is tracking a twister by radar." To many artists, drawing constitutes a visualization of thought processes. As Nancy Grossman puts it, "The act of drawing exists somewhere between reflection and action," and Jody Pinto contributes, "Drawing is a physical way of thinking." The intimacy of drawing and its identity with the artist's inner self is conveyed by Chris Griffin: "I have always felt that drawing sets up an authentic dialogue with the artist herself—there is no place to hide."

Beyond the artist's conceptual or perceptual intent, it is gesture, surface texture, and timbre that qualify a drawing. To draw is to engage a causative force. Like the verb in language, it affirms and expresses an act, occurrence, or mode of being. The word "draw" as an active verb connotes potency. Like a force field, drawing represents manifestations of inherent power. The imagery or signs may be strokes, marks, and structures indicative of personal predilections. A peculiar and distinctive resonance informs the act, distinguishing an individual artist's inclinations and intentions. In recent years, a mark or line has in itself been considered a carrier of meaning. Correspondingly, drawing is understood to be possessive of a generative mien, identifiable with a particular artist's personality and approach. In the words of Kay WalkingStick, "Drawing has the look of the hand; you can feel the energy of the artist in the marks themselves."

For some, drawing is an occasion for play, a relaxed but alert meandering that may result in discovery. For the artist interested in informal exploration, there is a reflexive tone and unstudied manner. This tendency does not exclude seriousness, nor does it exempt the resultant work from being considered a major and important piece. It does suggest a time framework that is usually short in duration, a pause that allows a free flow of ideas, feelings, and imagery. In order to capture the moment, working processes are comparatively truncated, so as to retain a sense of initial inspiration. In her work, Ursula von Rydingsvärd asserts the ephemeral as a positive presence: "I can deal with a moment in the present and take a more tentative stand."

In other instances, drawing is slower, extended, more considered. It may serve to work out an already found form. Thus, abbreviated notations are made concrete through diagrams, plans, or blueprints for a painting, sculpture, or structure. This more systematic strategy is represented by the work of Alice Adams, Elizabeth Egbert, and Nancy Holt. Drawing may also occur in the period between one completed work and another. For example, Lauren Ewing's obsessively detailed fantasy drawing presents possibilities for large-scale sculpture. Likewise, several artists, including Joan Semmel, Joan Snyder, and Susan Laufer, draw to further their thinking about painting. Such drawing functions as a transition, a means of guidance toward new work. Or the artist may be so satisfied with a given work that a drawing of it provides additional gratification. Such an extended mode is employed by Mia Westerlund-Roosen and Chris Griffin, who draw completed pieces as a means of further study or reflection.

The time at which a drawing occurs—whether it be initially, in due course, or after another art form—has some impact upon its look. The visual result may veer toward rapidly executed touches or, at the other extreme, to ruled lines. Drawing can be loose, spontaneous, producing direct, straightforward conveyance of passion, anguish, or pleasure, or it can entail deliberately controlled outlines, suggesting a more studied state of mind. Whether the drawing is rendered in a careful or casual manner, it makes visible inventions of the mind, be they emotional or intellectual.

Within the realm of contemporary art, technique in drawing has been redefined beyond the traditional execution of points and lines with charcoal, chalk, pen, or pencil. It now includes scratching, cutting, punching, folding, perforating, incising, or imprinting a surface, using tools such as scissors, knives, sandpaper, and other abrasives or cutters. Carole Seborovski, Howardena Pindell, and Margery Edwards are among those artists who have experimented with new means. A drawing may be erased, smudged, or smeared in process and as an important constituent of the resultant object. The classical, academic manner of drawing involving single, unadulterated lines has been amplified to include a romantic profusion of options. Errors, chance effects, redrawing, and pentimenti may be incorporated, betraying the drawing's evolvement and history. Resultant tactile attractions range from smooth, serene surfaces to rough, scumbled, and worked effects. Precision and surety of hand share equal distinction with a more labored handling, reflec-

tive of doubt, hesitation, and reconsideration.

Moreover, in our era the range of materials available to drawing has undergone liberation. In addition to paper, artists such as Winifred Lutz, Ana Mendieta, and Merrill Wagner have chosen tree bark, leaves, rocks, or other natural substances for use as a ground. Prepared goods such as wallpaper, cardboard, screen, or even beer coasters (Candida Alvarez) may also be utilized as a backdrop. Pigment, once considered the exclusive domain of painting, can be employed in drawing. A few artists, for example Lois Lane, Marina Gutierrez, Grace Knowlton, and Terry Niedzialek, have incorporated photographs or other found and manufactured objects in works that could be termed collage as well. Drawings may be stitched with thread or woven like a mat. They may be embedded with dirt (Michelle Stuart), folded, torn, or otherwise charged by unusual means. Generally, today there are no restrictions placed upon drawing's means or ends. They can be "mixed" in media, unlimited in numbers or combinations of constituent materials, and volumetric in scale. Ultimately, the artist's medium and technique depend upon and frequently contribute to an original and abiding intent, and a final judgment regarding category of work rests with the artist's objective.

Another factor differentiating present from past drawing is scale. Earlier drawings were small in size, due in part to their limited components and purposes. This conception lingers, contributing to a notion of drawing as unpretentious in dimension and character. It is true that some drawings continue to be diminutive. Their humble proportions are part of their appeal; some artists fancy drawing specifically for its portability and handling ease. Individuals preserving this tradition are Dotty Attie, Louise Bourgeois, Claire Lieberman, Judith Murray, and Ellen Phelan. Nonetheless, in our day greater emphasis is placed on drawings monumental in dimension. Although there is historical precedent in cartoons executed for frescoes and mural paintings, large-scale drawings are today frequently intended as separate en-

tities. This volume, although not always directly indicating it, does include some artists who regularly or occasionally work with an enlarged format: Nancy Graves, Mary Miss, Rona Pondick, Maria Scotti, and Mia Westerlund-Roosen. Certain artists, for instance Judith Bernstein and Shelagh Keeley, are interested in drawing *in situ* or directly on a surface, usually a wall. In this case they adjust work to what may be an architectural setting, much in the manner of the current site-specific sculptural installations. Certainly, artists have drawn on walls before in preparation for large paintings, but recently the large, situational drawing is declared an end in itself.

Whether a drawing is great or modest in magnitude, it possesses a poetic nuance. Like poetry, the drawing format frequently partakes of a private or confidential air that coincides with the concoction of putting the mind's fancies and fabrications into tangible structures. As does poetry, drawing may share an intimate relationship with individual artists and their interior predilections. Even the drawing of great magnitude may possess a subtlety of tone, a lyricism, a rhythmic and arousing beauty.

The contemporaneous drawers represented herein exhibit a wide range of approaches and results running the gamut in terms of current possibilities. As a book devoted to women's drawings, this volume attempts to reveal and delineate various manifestations realized by white women and those of color. Rather than imposing guidelines or strictures other than size limitations necessitated by attendant exhibition requirements, there has been a conscious effort to make the selection as various as possible. The underlying aim is not to separate women's art from that of men. This grouping has been necessitated instead by the continuing exclusion of artists on gender or racial basis, and by the fact that writing devoted to "women's art," Afro-American art, Hispanic, and Asian-American art rarely includes drawing as a discipline. Through concentration upon drawings by women, one also realizes an opportunity to present the diversity, difference, and deviation extant within drawing today.

The purpose is one of celebration in honor of the dissensions among us and our multifarious creative urges. In this regard, only a few of the artists presented in these pages have devoted their efforts entirely to drawing. They are drawers in the most focused sense of the word. The others are primarily painters or sculptors who for one reason or another draw as part of their creative endeavors. Certain of these artists realize drawings in an informal manner as they search for and discover new imagery, techniques, and materials; the balance use drawings to work up solutions to problems, to design structures, to map out possibilities and strategies. Drawing may be used by them to complete a particular concept already realized in another medium or to formulate a transition from one idea to the next. All manner of technical procedures and media are set forth, and specific works have three- in addition to two-dimensional bodies. Mary Frank undoubtedly conveys the feelings of other artists in her statement: "Drawing is so many different things. It can change from day to day, depending not only on the subject but on the material I use, the mood I'm in, and the weather—all those things." Specific drawings have been deliberately selected to confirm variation within drawing considered as a whole and to promote dissimilarity as a positive feature.

Despite such diversity, the term *drawers* is meaningful in signifying a particular activator of creative effort. There is a need for a specific word to identify one who draws. The art of drawing demands designation of professional expertise as much as does painting or any other art form. The term "draftsman" not only involves a masculine usage but also suggests a narrow concentration upon skill rather than inspiration. "Drawer," like "painter" and "sculptor," would distinguish a particular individual primarily engaged in a special form of art. Without such particular identification, the endeavor loses comparative stature. "Drawer" not only offers personal identification but also extends critical vocabulary, allowing due and proper consideration to be given to this body of work. Dignity is conferred through proper title.

Drawing as defined in this document is a matter not only of technique or materials but of individual sensitivity and consciousness. The aim is to make available the wealth of visual material created by women and to emphasize the degree to which drawing can be an effective vehicle for a wide range of purposes and meanings. No matter what its modus operandi, each drawing is uniquely and intimately identifiable with its creator. Aptly expressed by Ellen Lanyon, drawing is "a vehicle of invention for diverse sensibilities." Drawing derives from dream. It gives concrete shape to impulse and desire. Drawing objectifies the contemporary artist's quixotic imagination, improvisations, ideals. Today's drawing transcends tradition to conjure the multiplicity of human creativity.

Drawings and Statements

Alice Adams

Drawing has always been my way of analyzing my thoughts about a sculpture when the idea first crosses my mind—and again when I am in the process of planning for materials and dimensions. The scale of my first site sculpture, *Adams's House*, built at the Nassau County Museum of Fine Art in 1977, led me to draw as an architect does, in plan and elevation. Just as this way of drawing became useful in working out dimensions, it also allowed me to get to know my way around a certain space. Later, after completing another piece, I found that a photograph was inadequate to show a landscape sculpture, so I decided to draw it in perspective, choosing a view from above the work. It was exciting to draw as though I were thirty feet above a place on earth that I had created myself.

The drawing represented here is one of many that came out of three years of work on a large public-art endeavor, the Downtown Seattle Transit Project. As one of five design-team artists, I developed a number of ideas through sketches, diagrams, study drawings, and, after one was chosen, technical construction drawings for this series of large gates on the Seattle bus station platform.

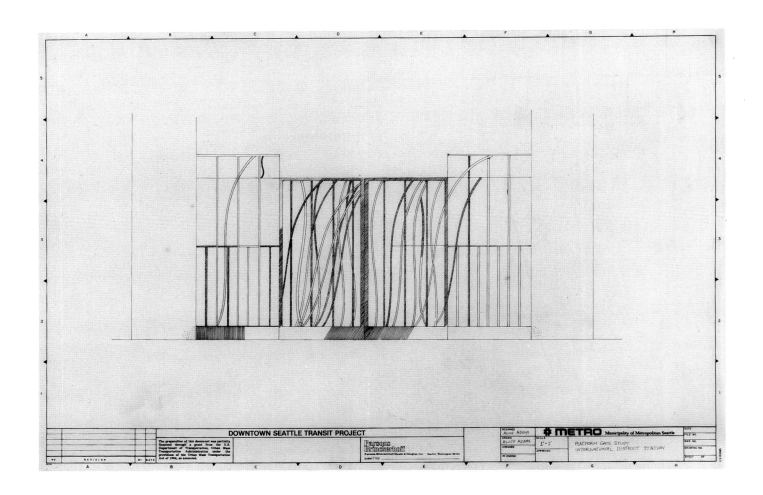

Platform Gate Study, 1986, ink on vellum, 22 x 33 in.

Candida Alvarez

I draw to clear my mind, to empty myself of all external and internal debris. I strive to build a fluid bridge between the hand and mind so that they can become one voice that speaks to the moment.

As a reservoir for ideas, drawings are indispensable. They help to uncover the essential in art, and aid in the formalization of a visual vocabulary. Although my drawings are distinct from my paintings, I find the two media to be essential to each other. They forge a delicate balance between the conscious and the unconscious mind.

Drawing has no boundaries. I like the challenge of transforming real-life objects and artifacts into the raw material for making art. While in Cologne, West Germany, I created a series of drawings on beer coasters. They explore the format of the diptych, which I have used as a formal device for the past several years. These drawings also continue my concern with humanizing abstraction by articulating, in visual terms, memories and personal iconography.

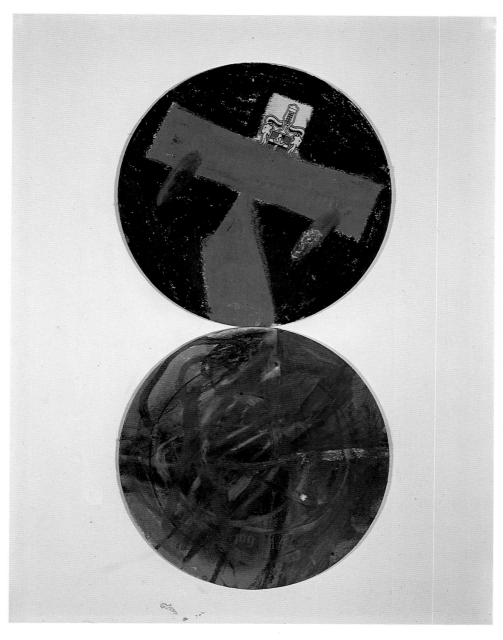

The Prost! Series No. 2 (diptych), 1987, crayon and watercolor on beer coasters mounted on board, 14 x 11 in.

Emma Amos

As a painter, printmaker, and teacher, I consider drawing to be the thinking that connects head to hand and idea to canvas. Drawing can be about design, exploration, making things work, recording the model, real life caught in the sketchbook, scaling images up or down, copying, inventing, a cartoon for another work, or a finished work of art. To me, it is all these things.

My concerns usually center around the figure in air, water, or a situation that forces me to invent surroundings. Drawing has become a game for me to expand my drawing skills by using perspective, foreshortening, and the movements of people, animals, and things in the process of making a new space form on paper or canvas.

Drawing to me is never mindless. I don't doodle. Drawing is like good sex; you have to work at it, but it's worth it.

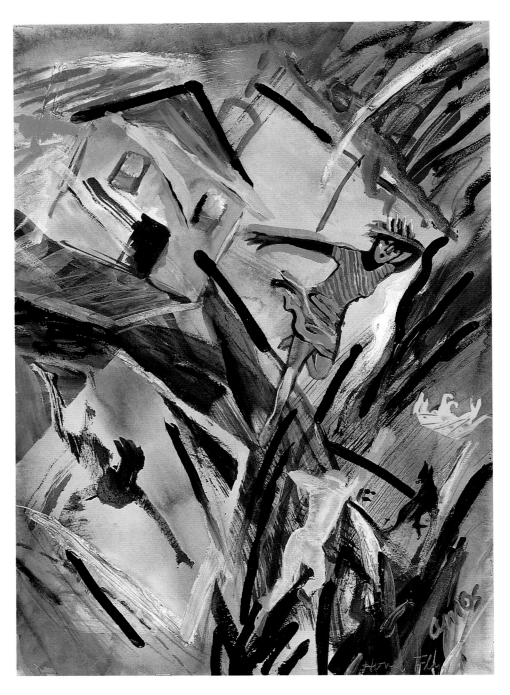

Starchart with the Twins, 1987, acrylic, 32 x 23½ in.

Dotty Attie

In my work text and image follow each other in an orderly fashion on a gallery wall, a bit like a book with its pages spread out—and, like a book, there's a story, there are characters, places, and plots.

The narratives are about the forbidden, the shameful, and even the hateful. Lust and violence are a constant undercurrent and implied are their most horrifying forms: murder, incest, child abuse, dismemberment. Nothing, however, is explicitly stated. By focusing and counterpointing details and text, gaps are left, and the viewer's mind must follow a trail of his or her own associations and accept complicity in the outcome.

The story, however, is just one part of what my work is about. Technical facility, arrangement on the wall, the choice of images to be reproduced as fragments from old-master paintings, size, and even the ultimate place of display are all as important to the meaning as the story.

To stand in a gallery or museum, traditionally strongholds of the highest human aspirations, to look at beautifully crafted copies of our most revered old masters, laid out with neatness and care, to read a text written in detached, reserved, and politely old-fashioned English . . . and yet to find oneself becoming involved in a narrative that might not be out of place on Times Square—this is exactly the disturbing experience I'm after.

His Smile (triptych), 1985, pencil, 5¼ x 5¼ in. each

Jill Baroff

Drawing encompasses a large range of my work—usually in relationship to painting, sometimes not. When I draw it is the activity of drawing that engages me, not the desire to have a finished work. I rarely start to draw with a fixed notion of what it is I want to end up with. It is an open-ended activity.

What I appreciate most about the process of drawing is its potential for spontaneity. Whether I am working with graphite, pen and ink, or oil, I look to the automatic gesture as an opening of sorts—an opportunity to move between what I know and what is unknown to me. A generous mark can often be the trigger for a series of associations and movements.

Sometimes I think my most important work is done in drawing because of its directness. Because less thought is needed to keep materials in check and under control, drawing allows me the freedom to leap between conscious and unconscious, to enter ambiguous regions and capture fleeting imagery. These images are often the first glimpse of central developments in later work. Drawing facilitates a moving beyond what I currently know.

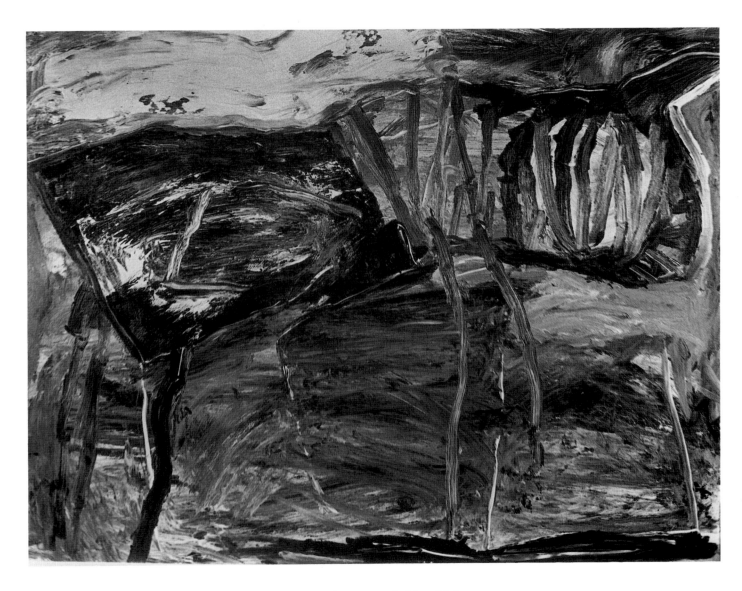

Field #7, 1987, oil, 23 x 29 in.

Judith Bernstein

The work is a continuum of sexually explicit imagery, starting in 1966 with scatological graffiti drawings and paintings. The images were very graphic, like *Supercock*—a superman with a cock twice the size of himself flying through the air. Another painting called *The Fun-Gun* involved an anatomical drawing of a phallus with a trigger drawn in and forty-five bullets collaged on. From these works evolved huge drawings of screws. I have been working on expressionistic charcoal drawings on an architectural scale since 1969. My major images have included *Horizontal*, a hybrid power-icon based on the mechanical object of the screw; *Anthurium*, a heart-shaped tropical flower with a projecting stamen; and *Venus*, a personalized prehistoric figure. All three entail visual and sexual allusions to the world of nature and technology. Another major image took the form of a site-specific, 14-by-45-foot enlargement of my signature done in 1986 as a parody of art-world stardom and stardom in general.

For me, art is phantasmagoria, coming from the artist's innermost secrets and creating a body of work that is an architectural environment of the mind. Started in 1985, Untitled Series I is a series, is a series, is a series that deals with anxiety, just for starters.

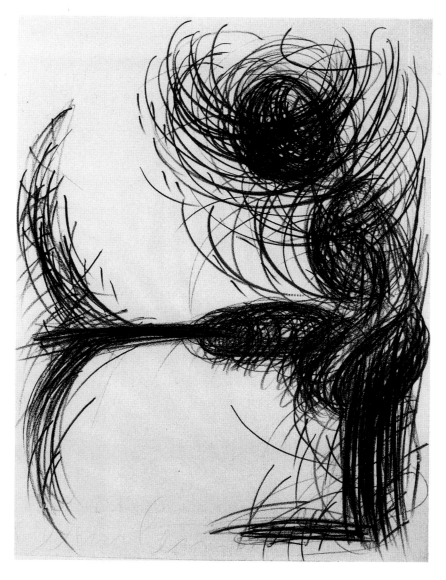

Untitled Series I—#1, 1985, pencil, 30 x 22 in.

Camille Billops

From the Story of Mom (a series of four drawings) is about the life of my godmother, Camille McClanahan. Even though I was only thirteen years old when she died, I was very impressed and awed by this woman and her lifestyle, which was filled with luxuries not usually associated with domestic workers. She worked as a maid in the houses of rich white people, as did my mother and many other black people during the 1940s. But her home, reflecting another concept of class, was rich in satins, silver, china, and style. She slept on silk sheets on a round bed set on a round, rose-colored rug. In the corner of this sun-filled room there was a French writing desk and a chaise lounge with small satin pillows, where she would take naps on her days off. Near the wall stood a large glass-topped dresser smothered in perfume bottles of every fashionable name: Joy, Chanel, Crêpe de Chine, Arpege, and Givenchy. In her bathroom, towels matched the soap. In her living room there was a fuchsia-and-blue satin sofa and chairs. It was a wonderful room, but not quite for lounging, and she was always on the watch with a little monogrammed towel to place between our oily hair and her couch. We loved her just the same, and I loved her for the adventure of her life. Perhaps in the drawing seen here she is on her way back to that lovely apartment now occupying some inner landscape.

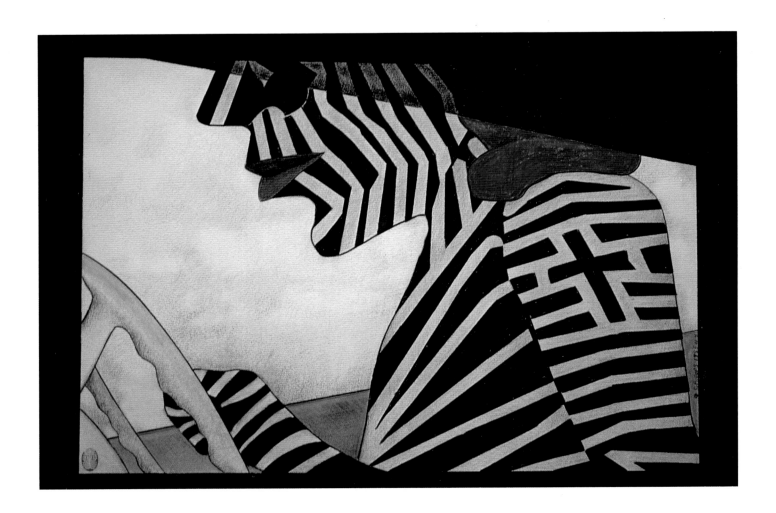

From the Story of Mom, #4, 1986, colored pencil, 15 x 22 in.

Judy Blum

1) true 2) false 3) incongruous 4) log 5) life 6) color 7) lens 8) fiction 9) irrational 10) barometer 11) magic 12) familiar 13) foreign 14) mask 15) imaginary 16) prehistory 17) geometry 18) history 19) picture 20) force 21) culture 22) weird 23) chronicle 24) map 25) science 26) topological 27) black 28) juxtaposition 29) bite 30) province 31) debris 32) information 33) white 34) eraser 35) visual 36) problem 37) format 38) paper 39) ink 40) territory 41) geography 42) red 43) anxiety 44) thermometer 45) pencil 46) charcoal 47) describe 48) lead 49) graph 50) chalk 51) grid 52) point 53) pastel 54) line 55) shadow 56) tension 57) diagram 58) compare 59) pull 60) elicit 61) remove 62) poetry 63) evolution 64) irony 65) rectangle 66) square 67) perspicacious 68) lucid 69) situation 70) excerpt 71) detail 72) image 73) eye 74) absurd 75) transform 76) seismographic 77) series 78) background 79) change 80) dimension 81) register 82) sight 83) idea 84) fragility 85) routine 86) conjure 87) tight 88) thin 89) soft 90) loose 91) hard 92) thick 93) scale 94) location 95) vignette 96) modern 97) scene 98) punctuate 99) illusion 100) failure 101) expand 102) confine 103) edge 104) character 105) resolution 106) style 107) past 108) escape 109) parody 110) witness 111) language 112) structure 113) art 114) cry 115) instruct 116) destruct 117) obstruct 118) substruct 119) doom 120) time 121) concrete 122) gloom 123) cosmic 124) harmony 125) draw

Heart Map, 1988, colored pencil, 30 x 22 in.

Louise Bourgeois

My work is not primitive. It is not agnostic. My husband said fifteen years ago that primitive art is no longer being made. The primitive condition has vanished. These are recent works. Look at it this way—a totem pole is just a decorated tree. My work is a confessional.

My work is often about murder. Primitive art does not usually deal with that, nor does it with the woman.

I really want to worry people, to bother people. They say they are bothered by the double genitalia in my new work. Well, I have been bothered by it my whole life. I once said to my children, "It's only physiological, you know, the sex drive." That was a lie. It is much more than that.

They may say my work looks primitive, but it is far from it.

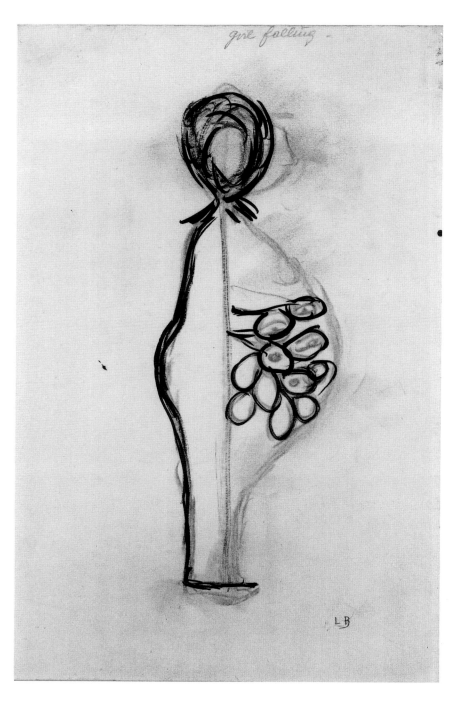

Girl Falling, *1947, charcoal and ink, 11¼ x 7⅛ in.*

Dove Bradshaw

Drawing is elemental and functions as an end in itself. In my work, layers of found imagery are rendered in line or mass. Although chance plays a large part in the initial placement and structure, the finished piece involves some decision. Accepting that taste is habit, I strive to resist its seductions wherever possible. This seems the central battle right now—fleeing intentions and opening up the work. I try to position myself so that I'm able to respond to propitious accident, always prepared to change direction. I have learned to pay attention to by-products. Their relaxed demeanor can often be put to use in the piece that produced them. I want to use every-thing—to develop an atmosphere in which art can exist as naturally as breathing.

By concentrating on concrete aspects, the unconscious is free to enter unawares. Whatever threatens to narrow the work is put aside so that the widest variety of possibilities can play. With each work new modes of operating are learned. Finding means that can be discarded or even forgetting a particular manner of working when it interferes with the next step requires focus. When successful, I'm brought back to a position of inexperience. The process makes for a way of life, a way of making sense and nonsense out of what happens.

Untitled, 1984, encaustic crayon collage on wood, 14⅝ x 11 in.

Phyllis Bramson

Making a work of art is to touch base with the core and innermost part of me. This is the time when my self and the world meet in a very intimate and passionate way. By presenting my version of the spiritual and psychological tensions of the eighties, I know that the viewers' reactions may have more to do with the fact that I have affected their "pressure points" as well.

I look at the artist as the seducer—and the seduction will only be successful if the viewer has understood what has been made of the "painted moment." Using the figure as a vehicle for conveying desire, she/he is often standing on the sidelines, watching, longing, judging.

The feeling of longing is at its very peak and presents a state of erotic apprehension (and self-exposure). One might say that the images deal with a "private" language involved in a "public" performance. In such pantomimes of desire, the masks have slipped and the spectacle of the individual is staged in all its shimmering, simmering intensity, in anticipation of the night.

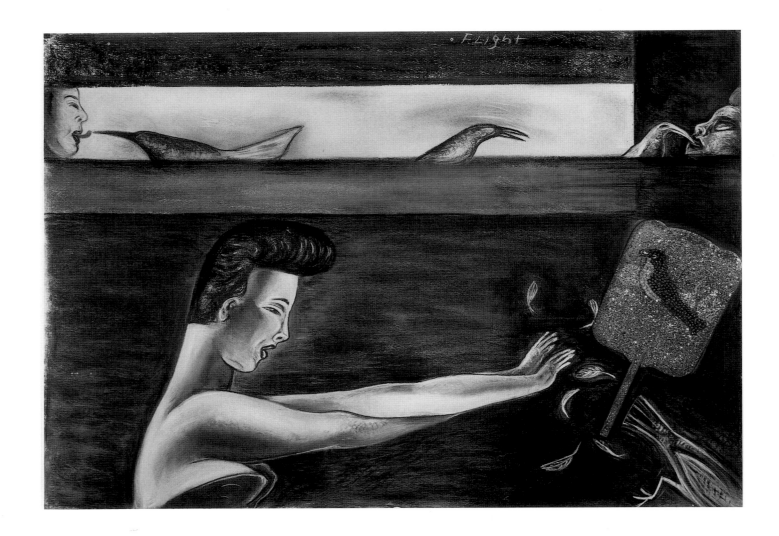

Flight, 1988, pastel, 25 x 35 in.

Helene Brandt

I am primarily a sculptor. Using steel tubing as a way of drawing in space, I make structures that relate to or contain the human body. Some are made directly around my own body. My drawings on paper don't look like my sculptures, although they may look like the figures that could be inhabiting them.

I first drew mainly in pen and ink. I needed the security of the unambiguous, unchangeable ink line. Slowly, I developed the courage to choose other media. My first big step from pen and ink was to pencil, then to charcoal, and now pastel.

The main reason I draw is to find out what I am feeling and thinking. There is a certain part of me that I have no access to except through drawing. I start by tacking a blank piece of paper to the wall. Then I turn out the lights and, with great concentration, I begin making some marks. I turn on the lights and sit in front of the drawing until I begin seeing things on the paper. Then I slowly, often painstakingly, develop these images. What emerges tells me with disturbing clarity what my unconscious concerns are at the moment. The completed drawing also renders these concerns less unsettling because it gives them order.

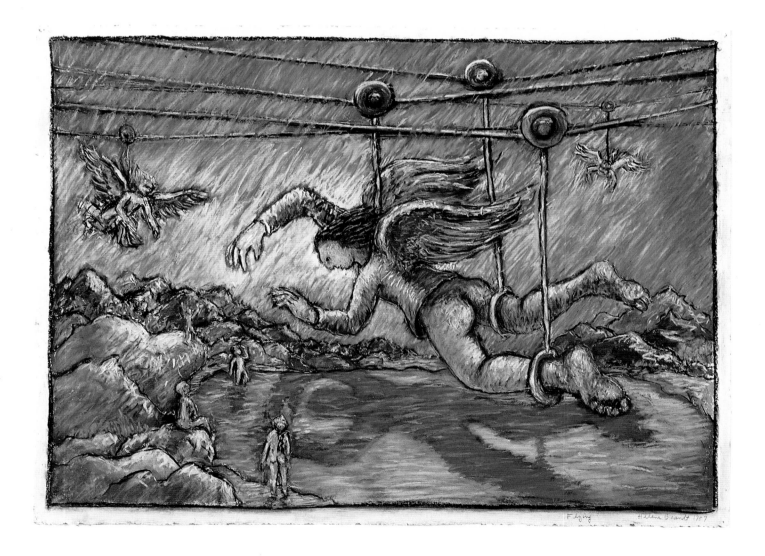

Flying, 1987, pastel, 22 x 30 in.

Nancy Brett

Drawing is the start of every painting and the means by which I think visually. For me, drawing is the most natural way to develop an image and to explore the options. Over the years I've developed different ways of drawing to serve different needs.

The first is a method of note-taking. I fill sketchbooks with fragments of things I see and think about. These images serve to evoke rather than describe. They are like parts of a puzzle that I assemble while painting. This is a process of discovering and locating.

Another way I draw is directly into the wet paint while the painting is in progress. Sometimes in the course of a painting it becomes necessary to make dramatic changes. Drawing is a reductive technique here, pushing pigment aside rather than piling it on with a brush. It's an emotionally charged search for form.

I also make drawings as finished works. As my imagery has changed through the years, it has been steadily advanced through drawing. Because it feels simple and unpretentious and because it's an immediate and direct expression of thought, drawing is a main line to the unconscious. For this reason, drawings seem to "predict" paintings.

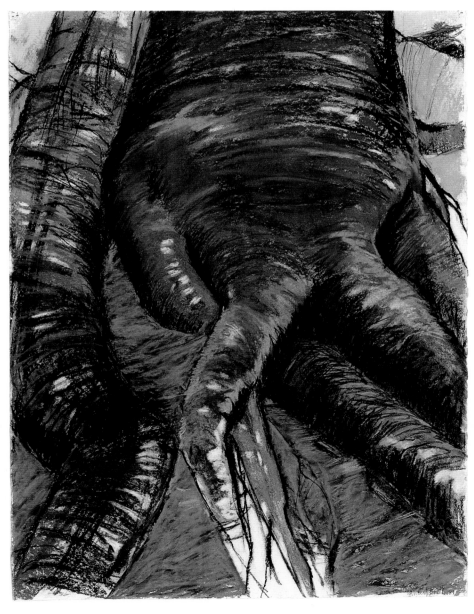

Study for "Roots," 1984, pastel, 30 x 22½ in.

Joanne Brockley

The precious with the unsightly
The nook of seductiveness
The dressing up of the functional
The fragments of construction and destruction
The redefining of objects
The common turning to the unique
Fragments of urban life
Regeneration and transformation
The living in the man-made
An object adopting a personality
The layers of history in the remains

For my drawings the above ideas are takeoff points. Free from the limitations of gravity and hardware, I can play with manipulation. The sculptural form I want to make is in a flexible stage in my mind; the drawings help this to become concrete. Importantly, there is a point where the drawing takes over; any idea of sculpture is put away. The result is more than a blueprint for an object and is often altogether different from the future sculpture. The drawing becomes the real, as opposed to a vehicle for the imagination.

Study for Sculpture on Site ("Scorpion Dweller," Long Island University),
1988, gouache and photographs, 19 x 24 in.

31

Joan Brown

One of my main interests is archeology and anthropology, and in the last ten years I've traveled to archeological sites in Egypt, India, South and Central America and the Orient. In the art I saw, the thread running through all the ancient cultures is the symbolism of a golden age—whether represented by the yin and yang or by men and women shown as the sun and moon.

Classically, a cat-like Sphinx represents the animal or lower side of man's nature, but my interpretation is that the animal-self can be about introspection.

• • • •

My work is representational but also very symbolic. When you work with symbols, you leave yourself open—naturally, to people's interpretations, unless the symbols are real cut-and-dried universal symbols that we are all familiar with.

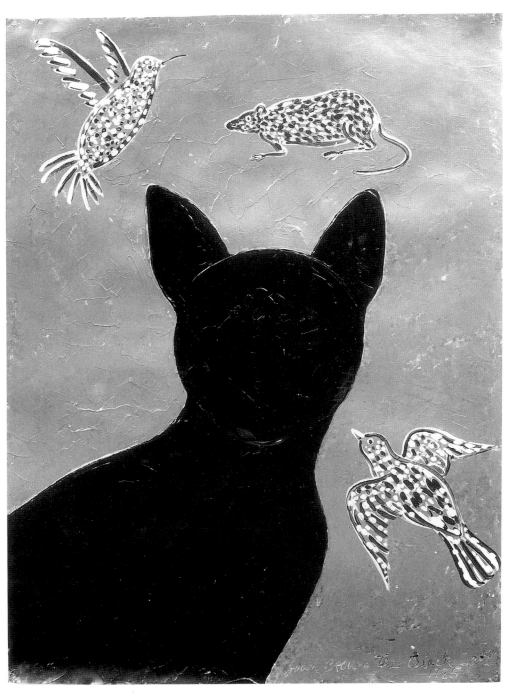

The Black Cat, *1985, enamel, 30½ x 22½ in.*

Vivian E. Browne

Charcoal and acrylic on Arches paper are the materials used for *Tuolumne*. The charcoal grid (a preconceived arrangement of lines) emphasizes the mark and a sense of movement and energy that I try to achieve in my work. This underlying grid has also been used in an attempt to "find" subject matter and to maintain a linear counterpoint, a network of linear elements intersecting with each other and the limits of the picture plane.

As a child growing up in Queens, New York, at a time when it was still possible to walk through small orchards and open fields, I became fascinated with trees. This compelling attraction, combined with a growing concern for environmental issues, has led to references to plant life in much of my work over the past ten years. In a world fast becoming stripped of its natural resources, the forms of big trees seem to me symbolic of power, strength, and endurance.

Tuolumne is one of a series of ten drawings resulting from on-site observation of the Yosemite conifers. All are studies for paintings. They permitted an exploration of line and form which made it possible to transform subject matter.

That a drawing exists as an aesthetic experience goes without saying. But drawing for me in this instance has a decided purpose—that of exploration, investigation, and development—in other words, note taking.

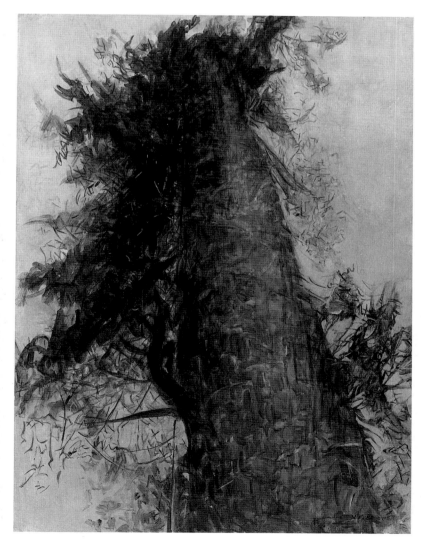

Tuolumne, *1985, charcoal and acrylic on Arches paper, 36 x 28 in.*
Collection Vida and Ken Hackman, Los Angeles

Beverly Buchanan

Drawing has never been used by me to sketch for more "serious" work. I don't make sketches for models and don't like to contemplate drawings as anything other than individual works. Recently, while drawing on eggs for Easter, I realized that a large part of my enjoyment was the fact that these drawings were spontaneous and that nothing would remain after a brief look and possible enjoyment by three dozen people.

Growing up in the South, my friends and I drew pictures and images of ourselves in sand and dirt with a stick and erased them with the heels of our shoes.

I was, in retrospect, interested in the look of marks in dirt or on blackboards. Wandering through a nearly deserted classroom building in the early 1950s, I began putting numbers in columns, adding what I thought looked interesting rather than what mathematically was the truth. Thus,

$$\begin{array}{r} 99 \\ \underline{99} \\ 46 \end{array}$$

looked wonderful. A parental colleague informed me that 99 and 99 was NOT 46. I knew that. The whole looked good, and the rest was irrelevant.

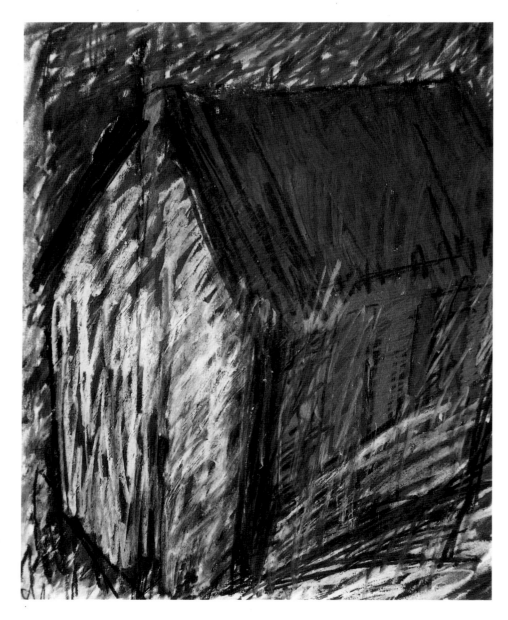

Red Window Shack, 1987, oil stick, 25 x 19 in.

Cynthia Carlson

For me, drawing is more about the spirit of investigation than resolution. It is not about any particular material. It is the way in which artists research and think. The product is actually a by-product that remains closest to the source of the original idea. Modern artists have long prized an ability to integrate the acts of drawing and painting to the point where defining their differences becomes either impossible or irrelevant. I do my best work when I can sustain a drawing sensibility, whether the work is ultimately defined as painting, sculpture, or installation.

Belly Roll, *1980, acrylic and watercolor, 22 x 30 in.*

Paloma Cernuda

I use charcoal sticks, erasers, and my fingers to draw on paper. Marks are put on and taken out in searching for the quality of the image, the sense of space, light, and mood that visually represents my idea.

After an initial layer of drawing, I erase or half-erase parts of the drawing and draw in again. Repeating this process several times creates the layering seen in my work.

Being a painter, I developed this additive and subtractive approach to drawing from my familiarity with oil-painting techniques. I am interested in making drawings that have the density and richness of paintings.

The scale and format of the paper I work on are also important in my drawing. Whether images are compressed and narrow or present in an expansive space, whether small and intimate or larger than life, dimensional relationships support and address the intention behind each piece.

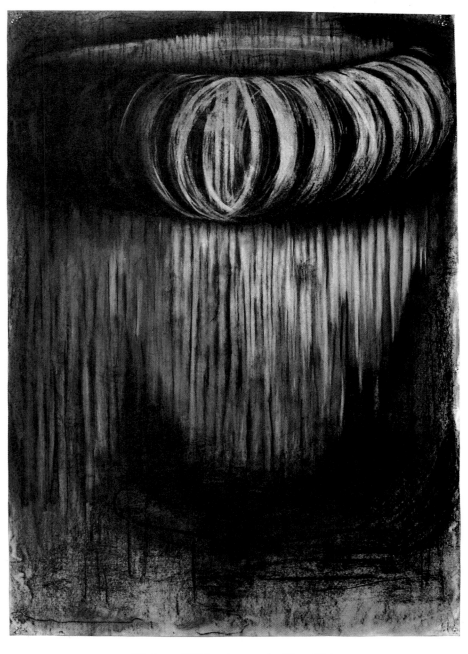

Rising, 1984, charcoal, 60 x 42 in.

Emily Cheng

My paintings and drawings attempt to explore the terrain between the rigors of abstraction and the semiotics of representation. I am interested in the ability of pictures to provoke questions and induce a contemplative experience. The work is a result of constant revisions. The process of finding an image makes a particular correlation between the internal and the external.

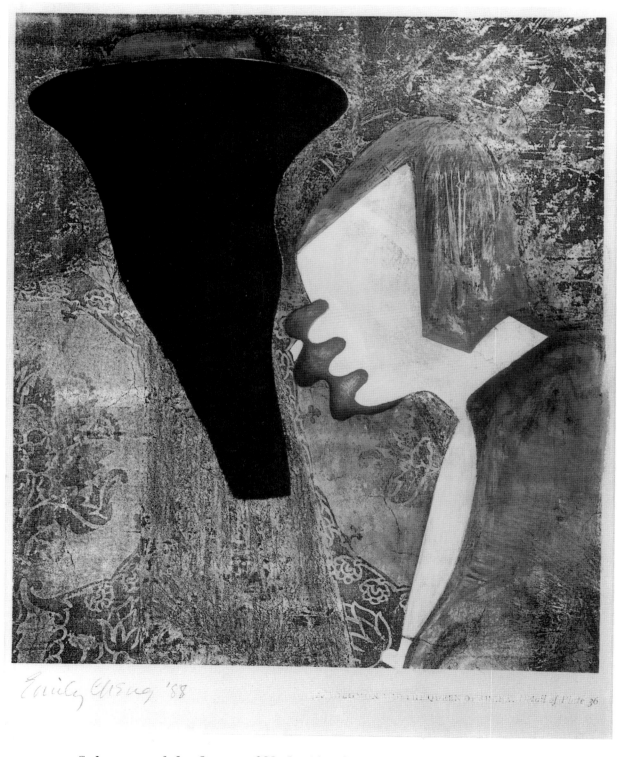

Solomon and the Queen of Sheba (detail), 1988, gouache, 16½ x 14½ in.

Eva Cockcroft

My drawings attempt to record history as it is written on the faces of ordinary individuals, each of whom is like a precious thread caught in the maelstrom of social change and war. In the struggle against apartheid in South Africa there are important leaders like Nelson and Winnie Mandela or Bishop Tutu who display great cour-age. There are also thousands like the woman in this drawing, whose courage is no less. Her role in the struggle, however, like that of the great mass of women everywhere, is crucial to victory but unrecorded by history. The essence of her suffer-ing and her strength—woman's history through the ages—is inscribed in her face. It is this that I try to express.

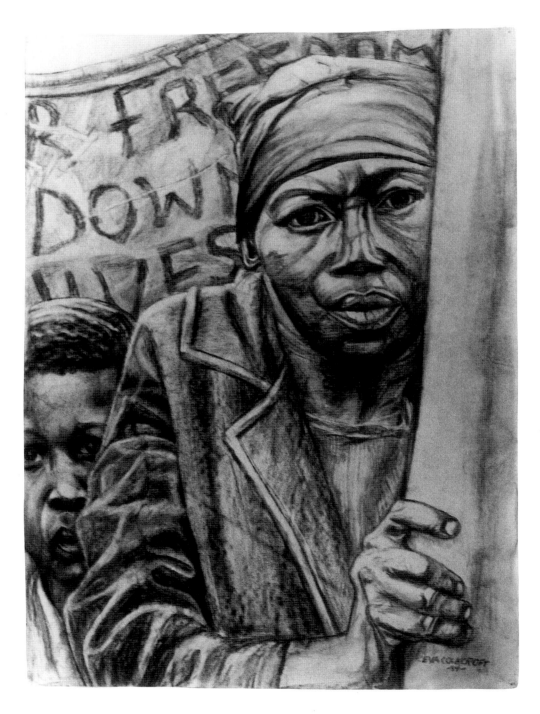

Anti-Apartheid Drawing: For Freedom We Lay Down Our Lives, *1984, charcoal, 26 x 19 in.*

Clyde Connell

I am usually not so definite about the Why of any series of work, but in the 1985 series drawings were made to help me better understand the close relationship of the moods of nature and man and of man's home and place in the universe.

During our short Louisiana winters, in the early morning at Lake Bistineau, small swirls of fog dance over the flashing current of the lake. But often just before dark, a dense fog creeps up to enclose the house and woods. It seems even to come through the closed windows and doors. Within the gray dimness, the trees and moss suggest fragments of human forms passing through.

This series of drawings was made to help me better understand the close relationship of nature and man. Of course, I am still searching and know only fragments of understanding will be possible. Yet, how great is the ponderance!

Earth People #18, 1985, ink on Mulberry paper, 22 x 17¼ in.

Petah Coyne

The following is a description of the public sculpture that resulted from this drawing.

I built the sculpture *Nun on the Highway* during the spring of 1985 in Houston, Texas. The public's fleeting impressions of viewing a nun on the highway—particularly at night when headlights isolated her image—intrigued me. Due to the placement of the sculpture on a particular curve in the road, drivers and passengers feel as though they are going to hit the nun. At the last moment, however, the road veers away and cars continue around her. Viewers on foot can experience her as I knew the church as a child, so small in the presence of such holiness.

The front, facial image is a portrait of Sister Elizabeth Throckmorton painted in 1729 by the French painter Nicolas de Largillière. The back is the same shape but is bound in mummylike swathing. Two doors hidden in the swathing can be opened, exposing twelve hundred dead and mummified fish intertwined among hay, sticks, and tar. Open, these doors form a triptych, the fish alluding to the Body of Christ. Viewed from the front, the opened doors give the quiet portrait of Sister Throckmorton black wings.

The viewer can climb a stairway between the front and back and, on an observation deck, peer through the nun's eyes at passing traffic. In this position, the viewer stands tenuously between the life-giving front image and the corpselike back. Her quiet glory is diminished by the drone of traffic and exhaust fumes.

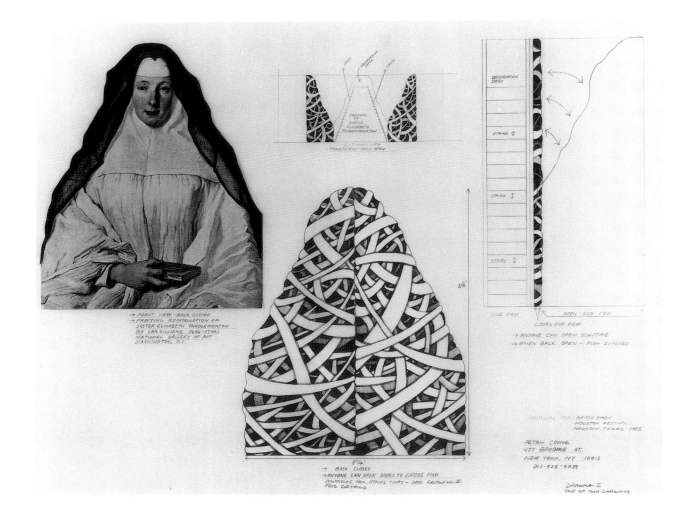

Proposal for "Sister Elizabeth Throckmorton," *1984, pencil and collaged photograph, 18 x 23½ in.*
Collection Gary and Meg Melillo, New Haven, Conn.

Elba Damast

My ritual begins with bathing the paper, removing excess water, and laying it down on foam. According to my imagination, I place weights on top, pressing down to mark traces. I cover the paper with plastic and leave it for twelve to twenty-four hours, until I get the volume I want. Then comes the color—acrylic paint, pastel—black pencil, the chalk line, gold leaf, and the window screen.

Window screen has an important role in what I create. I paint it with different colors—a yard and more yards. It is used in combination with paper pulp and placed on paper or canvas, building up what I believe is drawing. I enjoy the texture and transparency of screen. To me, understanding the language of materials is mandatory, so as to have a viable dialogue.

Drawing is a point converted into a line that brings us to realize what we wish. My hands are slaves to the endless outpour of my eyes, my Medusa-mind. Born in the deepest self, the heart itself draws deliberately with its own knowledge to identify the unknown.

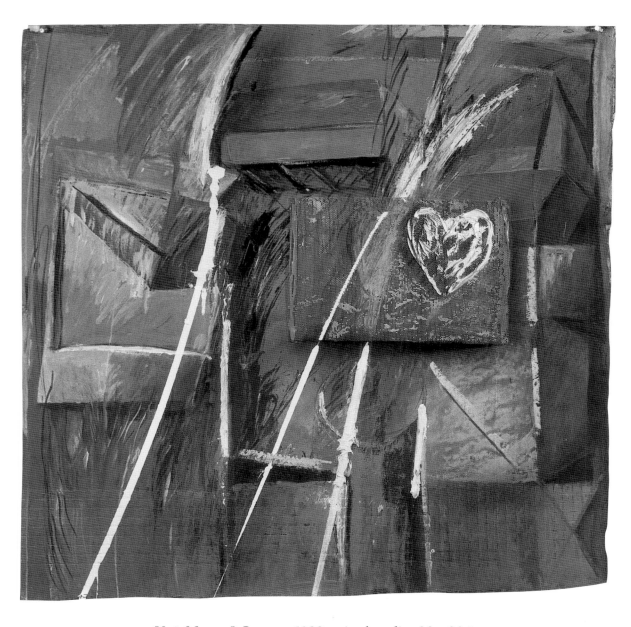

Neighbors & Lovers, *1988, mixed media, 30 x 30 in.*

Elisa D'Arrigo

Drawing serves multiple functions in my work. It is a way to work through specific ideas for sculpture. I examine how a work in progress might look from various angles and explore ways to resolve it. Drawing also enables me to "brainstorm" possibilities and variations for new pieces.

The spontaneity and immediacy of drawing allow me to invent forms and images not yet imagined. It is a way of tapping the unconscious—the hand and the mind are directly connected. Very often I approach a drawing without a preconceived idea and follow where the first lines or marks take me. This "free association" approach leads to surprising, sometimes unfamiliar territory—an exciting and fertile place to be.

Drawing is a way of opening up—of expanding ideas and generating new information. By drawing, I explore possibilities for sculpture without the concern of technical constraints. Anything is possible on paper.

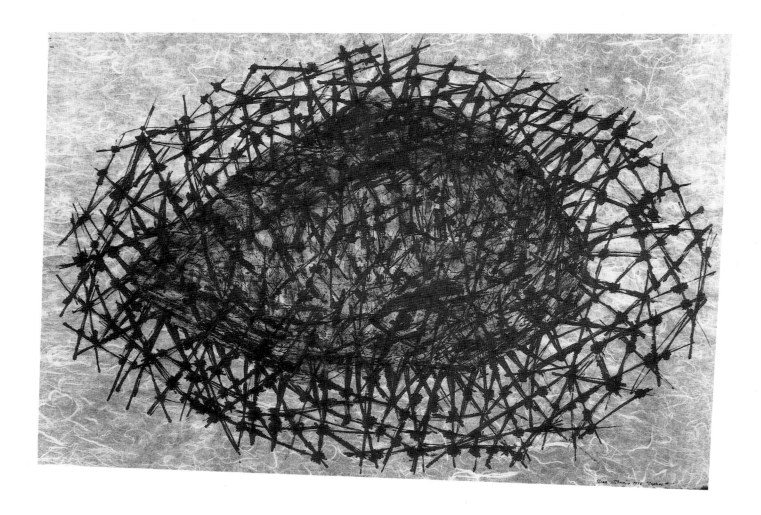

Captive #1, 1988, ink on rice paper, 17 x 24 in.

Carol Becker Davis

Drawing is an integral and necessary part of my work. It is the format by which my ideas are gathered. It is the event that ties elements together. Drawing bridges the gap or place in time between my sculptures, both before the three-dimensional work is realized and after. In relationship to a particular piece, ideas are sketched, notations are made, and previous drawings are referred to, making the renderings a component that formulates the whole. After a sculpture is complete, I often see more in it that needs to be recorded. A drawing that is derived from a finished work is most exciting to me because it is here that I can begin to see my next step. The drawing included here is more of a mystery—not as factual as a preliminary sketch, but related to the subconscious part of the mind.

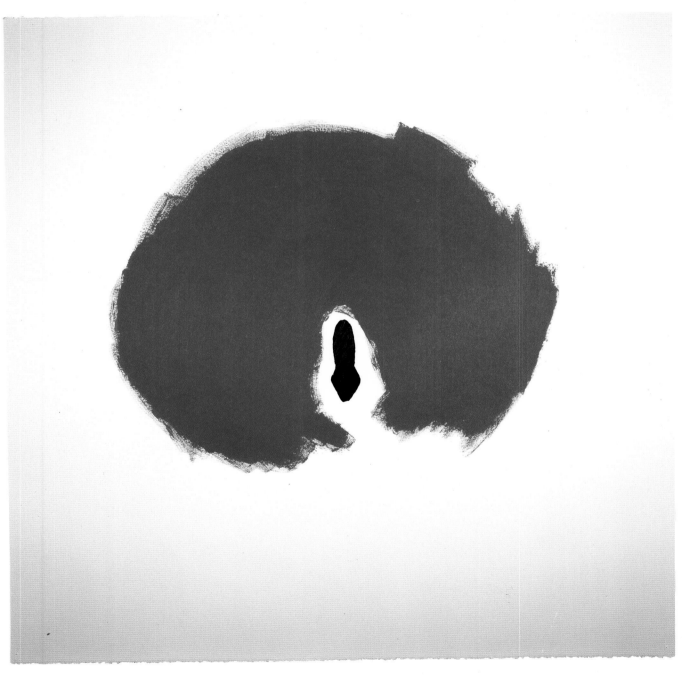

Untitled, 1988, acrylic, oil, and graphite, 22 x 22 in.

Agnes Denes

The drawings are dramatizations or visualizations of analytical propositions; they are words, sentences, or paragraphs in a language of seeing. When ideas and phenomena are pared down to their core or essence, superfluous information falls away and new associations, connections, and insights become feasible.

My concern is with the creation of a language of perceptions that allows the flow of information among alien systems and disciplines—a language in which essences carry pure meaning into pure form and all things can be considered once more simultaneously.

I strive to overcome barriers and preconceived notions as to the nature and form art should take.

I believe that art is the essence of life, as much as anything can be a true essence. It is extracted from existence through a process. Art is a reflection on life and an analysis of its structure. As such, it is a great moving force shaping the future.

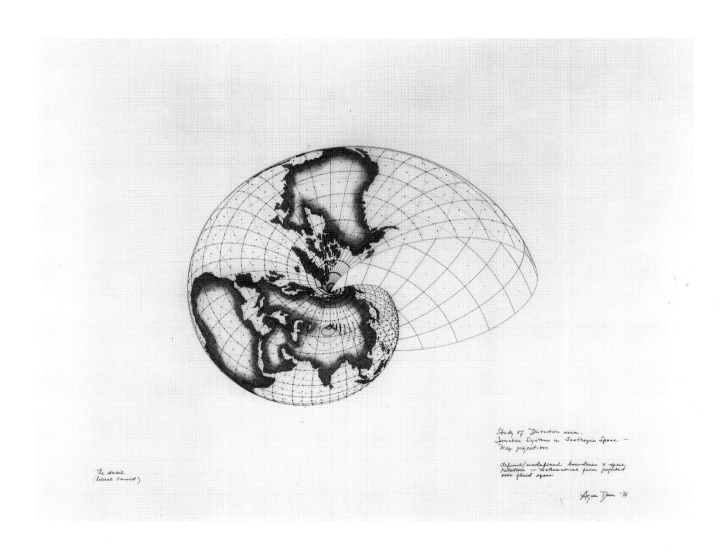

Isometric Systems in Isotropic Space: Map Projections—The Snail,
1974, ink and charcoal on graph paper, 24 x 30 in.

Donna Dennis

My drawings are nearly always done as a means of investigating ideas for my sculpture. This drawing helped me to envision what my first outdoor sculpture might look like.

Here's the story.

In 1980 I was invited to Dayton to look for a sculpture site. I asked to see sites along the Mad River, since it flows through both Dayton and Springfield, Ohio, my birthplace. At the end of the day, I was taken to the steep levee that has kept the Mad River in bounds since it flooded, nearly destroying Dayton in 1913.

The blustery November day had turned into one of those glorious nights when dark, ragged clouds race across a bright full moon. The 1960 gold Cadillac pulled up to the edge of the levee, and my host and I got out and explored the site. Then, satisfied, we turned around to head back and discovered to our horror that the car, no longer parked on the levee, was plunging, headlights ablaze, down the embankment hell-bent for the river, which, as we watched stunned, it shortly entered. A beautiful sight, it spun and settled midriver, headlights shining up through the water, illuminating the opposite bank.

Back in New York, I couldn't get the image out of my mind. I decided the car had been looking for a tunnel under the Mad River and so my sculpture would be *The Mad River Tunnel: Entrance and Exit.*

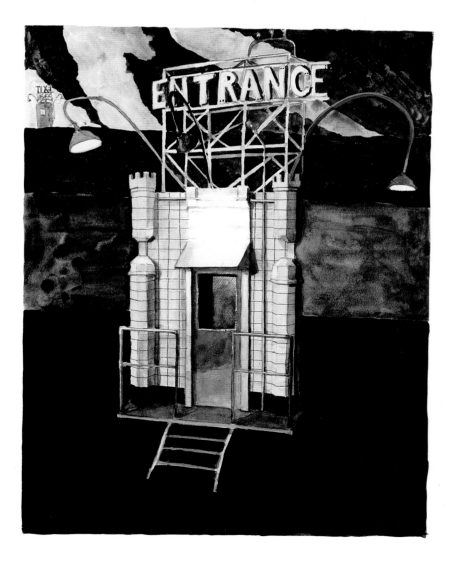

Imaginary "Tunnel Tower" Outdoors in Dayton, Ohio (Mad River) at Night,
1980, pencil and watercolor, 17 x 14 in.

Jane Dickson

I choose subjects that are problematic for me—situations that make one uneasy. Certain subjects appeal to me because they mirror the psychological states I am feeling at the time. A lot of times I work from fear.

My work deals with people who want to be entertained and yet remain unfulfilled, the failure of entertainment. I am also interested in falseness. Living in Times Square, observing that world, resonated feelings I already had. In New York—maybe in life in general, but certainly in city life in America today—to live you must have blinders on much of the time. We look at and perceive certain things while other things—

sounds, smells, sights—we try to blot out. I am interested in those blind spots. I am interested in looking at, considering, understanding the things that people choose—we choose—to ignore in contemporary life.

I am hoping that my personal fears, anxieties, my fascinations are more than personal. I am not aiming for a specific personal feeling that's not relevant to anyone else. I am interested in the ominous underside of contemporary culture that lurks as an everpresent possibility in our lives. I am trying to explore this about my own psyche in situations that reflect upon the contemporary American condition.

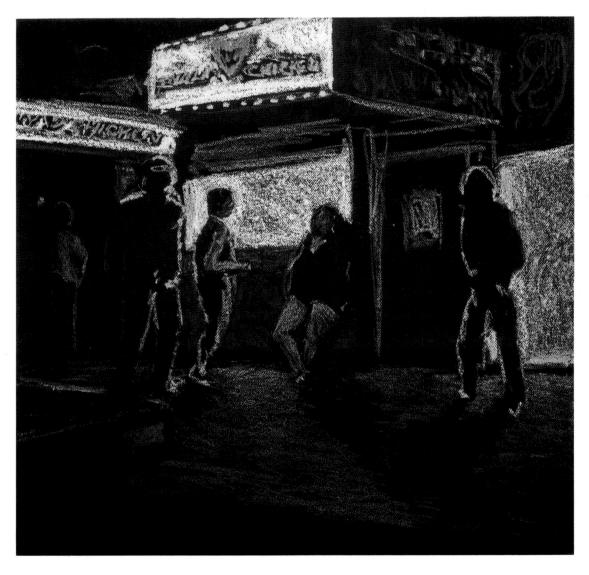

Study for Sizzlin' Chicken, *1986, oil stick, 27⅜ x 28¾ in.*

Lesley Dill

I think of drawing as a single line or edge. It's a solitary, wandering, nervous thing to me, counterweighted by black space or a shape. I prepare a surface of black oil paint over a gessoed ground and then scratch in a white line that describes a figure. Sometimes it's wire that becomes the drawing, overlaying a shape. I see line as a boundary between the press of the world and the expansion of the body. Line is charged and eroticized for me, like an electric fence.

For me, as a sculptor, drawing is the touchstone. In much of my work, the edge of the sculpture is a drawn line, a sharp boundary defined in space. My work is about psychologically informed images impressed through the framework of the human form. This imagery, first realized by the act of drawing in my notebooks, is at the heart of each sculpture.

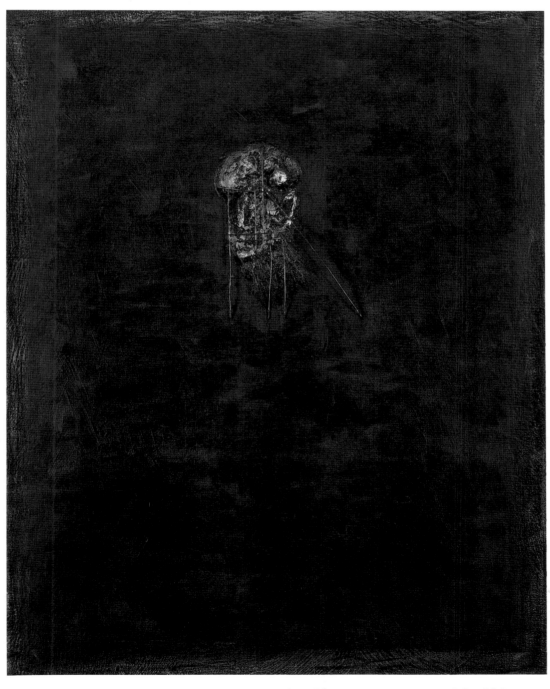

Man with Head Support, #3, *1987, oil and brass wire on canvas, 26 x 20 in.*

Judite Dos Santos

For me art is a field of inquiry, an area of research like other fields of study. I am interested in understanding the processes that construct and produce meaning, directly affecting consciousness and culture, be it by traditional/historical means or by contemporary mediation of information. The relationship of art and life, the dialogue that occurs in a circular form between these two fields, is an important issue in my work, which refers to the production of meaning. The processes of naming and identification that create or impose systems of beliefs, in life as well as in art, introducing and often maintaining absolute theories of "truth" or standards of behavior, are for me a continuous area of study.

Even though I am interested in formal issues, my main concern when working on a piece is that the language used is appropriate and in tune with the concept of the work. I use painting when painting is the best vehicle, likewise sculpture, photography, or video. It is not important to me that my work have a consistent appearance or fit any one predetermined category; it is important that it be understood as a vehicle of my ideas and that it show a continuum of my interests, perceptions, and inquiries. Through my work I am interested in evidencing the willingness to maintain an ongoing.dialogue with my contemporaries, rather than attempting to make absolute statements.

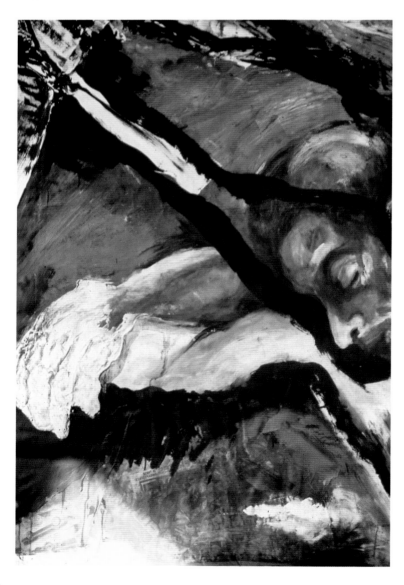

The Fallen Man—El Salvador, *1984, acrylic, 52½ x 40 in.*

Mary Beth Edelson

Until recently all my drawings were on jute tag, a tough surface that could take any medium and last forever. I could not, however, get the effect I wanted with watercolor. After experimentation, I found a paper with the same warm color of the jute, a beautiful Rives that accommodated the watercolor.

Drawing is my first medium, not only because I spend more time drawing but also because I first draw on paper the concepts and images for painting, bronze sculpture, wall painting, artists' books, photography, and performance. Drawing and thought process stimulate each other as I work through which possibility will be the most interesting to produce.

Aside from working drawings, there is a large body of finished work created on Rives paper. Two processes are used in this new work: watercolor and a technique I invented last year that allows me to transfer photo imagery directly onto the paper. This newly discovered process adds structure and richness to watercolor.

Another aspect of drawing that I appreciate and feel comfortable with is that it tolerates pluralism, making it possible for me to express all my sides—political, spiritual, humorous, my private eccentricity and public universality.

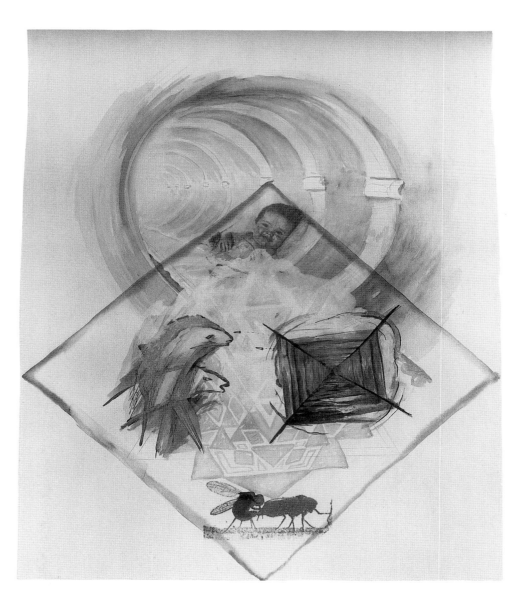

Tunnel, 1987–88, watercolor and transfer on Rives paper, 30 x 22 in.

Margery Edwards

Works on paper have become my personal journal and a record of the experiences to which I respond on a spontaneous and immediate level. Some are the bases from which my paintings grow, while others transmit transitory thoughts, ideas, or events.

Texture is important to all of my work. Cloth, papers and twines, Mylar and plastic are torn and sometimes burnt before being glued or knotted onto a base paper. Subsequently, the surface is worked with charcoal, pastels, paint, and graphite. The process is one of building, growing, and changing. The completed work leaves various levels visible.

I find it possible to be more intimate and direct in works on paper. This is partly due to their smaller size in that they can be easily handled and seen in one glance. I enjoy this personal relationship as one enjoys a conversation with a good friend.

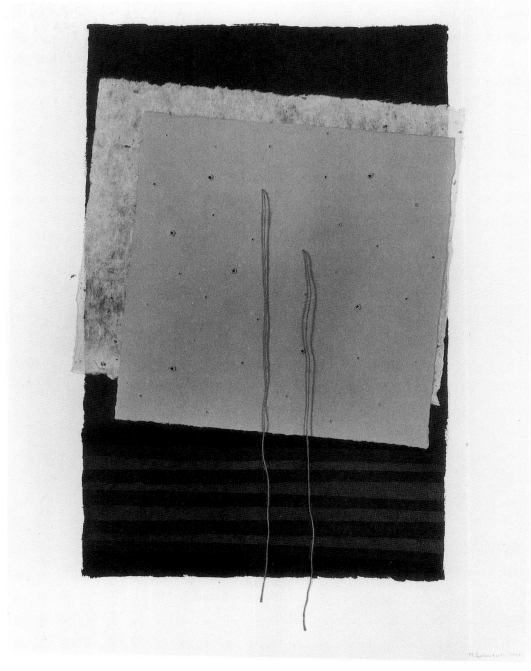

N. Y. 802, *1988, mixed media on Saunders paper, 32¼ x 22¼ in.*

Elizabeth Egbert

At this point in my career and for some time now, my drawings have been almost exclusively generated during the development of ideas for sculptures. They range in appearance from almost indecipherable scribbles to meticulously drawn, technically accurate renderings designed to aid in the construction of a piece. I actually use the medium of drawing for two distinctly different aesthetic purposes: for spontaneous exploration and for analytical studies. The rough, early sketches are not intended to be "shown," yet they are by far the most crucial for me. They are an attempt to grasp, in a concrete fashion, the "idea," the feeling, the initial impulse to create a new work. Usually these first sketches are on disreputable scrap paper, nothing either "artlike" or presentable. Later drawings are executed when the idea is far more resolved. Their function is to clarify (without flourishes and grand, unbuildable gestures) what the piece will actually look like (not in one's fond, hopeful imaginings, but in practical reality). These precise, technical drawings, much like architectural blueprints, aid me in terms of construction, installation, and explaining a proposed piece to a potential client. During the development of sculpture and throughout the technical phase of renderings, I constantly refer to the original "scribbles," the first drawings that captured the initial impulse to create something new. The continuing dialogue between early and late drawings insures that the spirit of that first (and fragile) moment is not lost along the way.

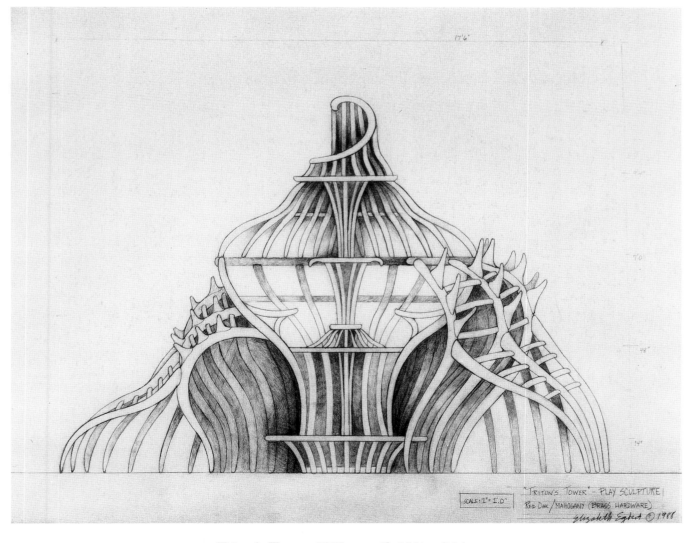

Triton's Tower, 1988, pencil, 16 ¾ x 24 in.

51

Camille Eskell

Drawing lies at the root of my creative process and spreads its influence through all phases of development, from the point of inspiration to the "finished" state. For me, it can be both a means to an end, like a building block to better understanding, or an end in itself, a vision complete.

With drawing comes a certain spontaneity. The valuable quality of being less precious allows me to be more free, daring, and willful. I find drawing more responsive as a medium and more dynamic, due to rapid interplay between decision and execution.

My goal is to interject more drawing into my paintings, because I feel a greater unity and strength, compositionally and emotionally, when drawing is more visibly present. Through integration of the immediacy of drawing and the monumentality of painting, I believe my work can better reflect the universal quality of my subject—the deeply emotional effects of the psyche.

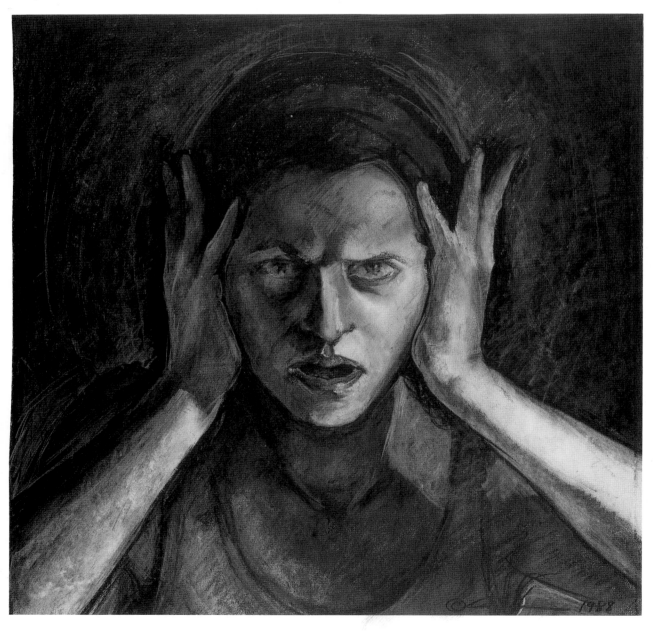

Shutting Them Out, *1988, oil pastel, 17½ x 17 in.*

Lauren Ewing

As I draw I previsualize, prefigure, think and dream, travel the total surface of the thing to be made. In this series of drawings it was necessary to see the whole before I began. I did so by closing my eyes. *Pure Vision of the Ideal Lady* came from the inside of my eyes. It is one of a series of drawings that act as images capable of provoking an imaginative journey of the eye and mind. These drawings are also visualizations for large-scale sculptural constructions in which an actual physical journey could take place.

The astral configuration of this fantasy drawing gives it an appearance of otherworldliness. The form builds up in jewellike fragmentation, constituting a whole resembling the mystic rose, a castle, or a many-faceted crystal. Visually one can detect that this molecular husk surrounds and protects an inner space. The sheer multiplicity of the variously shaped cells inundates the mind with a multitude of possible choices calling the will into service. A vertiginous path winds through this geometric maze into the inner chamber. The deeper one penetrates, the higher the surrounding walls become, until the body literally disappears from sight. The form rises up around the participant, swallowing him/her in a dark galactic tracery as access to the center is pursued.

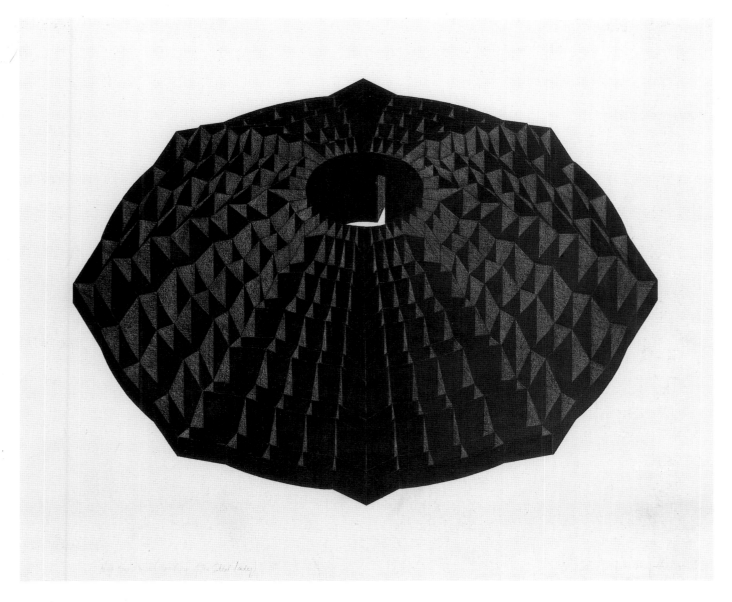

Pure Vision of the Ideal Lady*, 1978, crayon on vellum, 30 x 36 in.*

LORETTE WILMOT LIBRARY
NAZARETH COLLEGE

Heide Fasnacht

Art is what happens when you cannot possess.

Looking at the pictures in a book upside down, they suffer a loss of identity. I want it. I want this book. But it's not mine. In lieu of ownership, I begin to notate some of the more desired and initiating images, transforming them in the process. I record their actual image as well as my projections, and out of this conjunction develops the desire to invent. Only this heated, pulsing excitement, the rightness or wrongness, the deeply felt accuracy of these contours, proportions, and forms, only this lived conviction can replace owning the book.

This newly built desired and/or initiating image is the product of my own invention. I have touched it everywhere. It is believable only because I have maintained a genuine excitement throughout the process. Its imagery recalls easily and profoundly, in a staccato rhythm of remembering, forgetting, and remembering again. It is believable because it came about through an active process of building and destroying and rebuilding until it attained the indelibleness of an image easily evoked in memory.

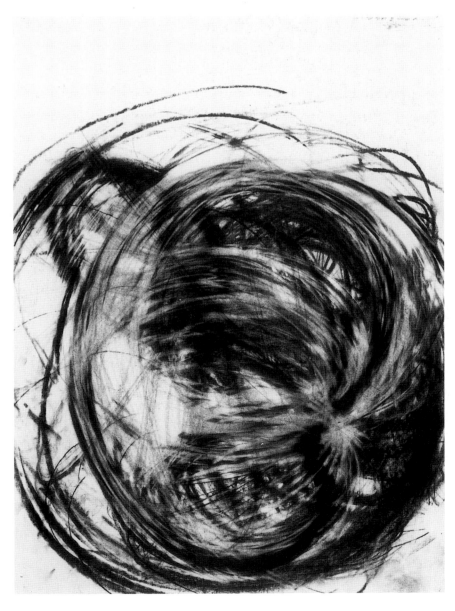

Two-Fisted Head II, 1986, *charcoal, 33½ x 25¾ in.*

Harriet Feigenbaum

Out of the Llewellyn Corridor is a series of drawings and sculptures that grew out of my reclamation projects for mine-scarred land in the anthracite region of Pennsylvania. The source of inspiration for the series was a group of topographic maps prepared by the Bureau of Mine Hazards (Harrisburg, Pennsylvania) that constituted a necessary prelude to the development of my work.

Working with topographic maps changed the way I look at the physical landscape. These maps reduced the visually bizarre and disjointed topography of reality to an elaborate skeletal description of a damaged environment. I began using them as a supplement to reality and discovered a landscape unimaginable by any other means. I saw not only how erosion occurred but why and where it would begin very soon. I could see impending landslides, future moonscapes, and deep holes through the earth that were otherwise visually camouflaged. It was an entirely new landscape—more unstable, unhealthy, and terrifying than I would have thought possible. When I look at my drawings, I see no location that seems to be stable or free of impending turmoil.

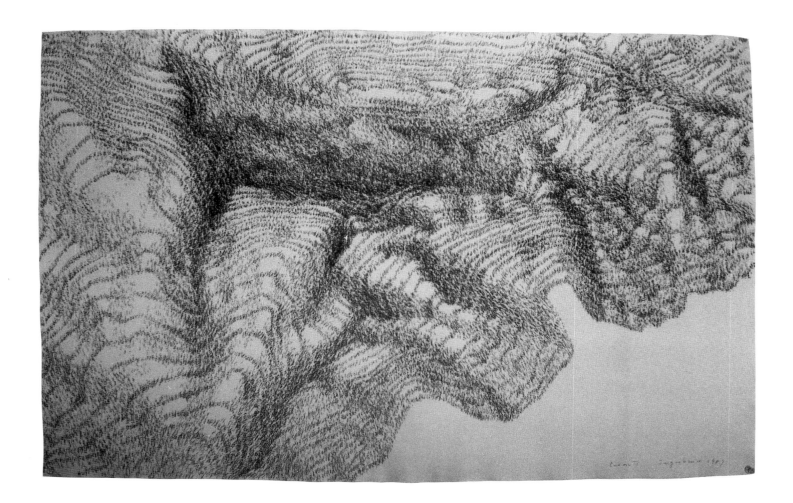

Out of the Llewellyn Corridor—Erosion III, 1987, charcoal, 22 x 34 in.

Jackie Ferrara

Red House is primarily about:

1) the process of building form;
2) internal and external rhythms derived
 a) from the inherent structure (counter-positioning of blunt-ended wood pieces, a constant recurring dimension);
 b) by "drawing" on the surface (spacing that produces gaps and/or slats of light and dark); and
3) a look of timelessness so the works can sit comfortably (but not specifically) in any time period, past, present, or future.

Form is determined by the site and the knowledge that the piece will be "used," that is, entered, climbed, sat upon. Materials are standard construction items available at lumber and stone yards.

The drawing *Red House* is of a maquette for an imagined work. At full scale its dimensions would be roughly 9 by 21 by 9½ feet.

The slit between inside the house and the outside floor is too narrow to be a door. One stands and looks out—or in, but cannot pass through.

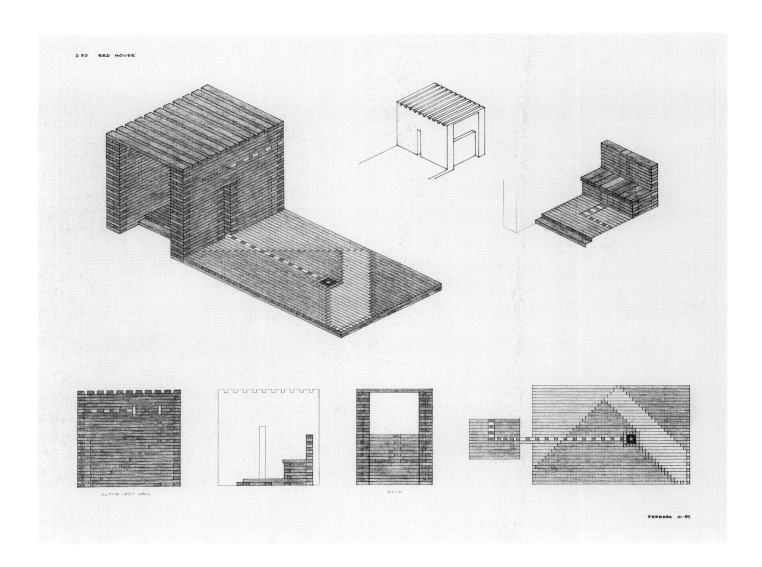

Red House, *1984, ink and colored pencil on graph paper, 17 x 22 in.*

Janet Fish

My drawings are part of the same process of thought that gives rise to the paintings. They are discrete entities in themselves and not sketches or plans for another work.

Thinking of still life as life not still but alive in the movement of color and light, I decided to introduce persons and creatures that were themselves in motion. This drawing is part of a series that made use of an intrusive and nasty cat who always pushed into and often destroyed setups. I had not worked in black and white for many years. This cat, herself black and white, seemed a quite appropriate model for experiments in the different mediums. I finally settled on ink wash for its fluidity, the possibility of an energetic mark, and the strong tonal contrasts that could give the particular light I was seeking.

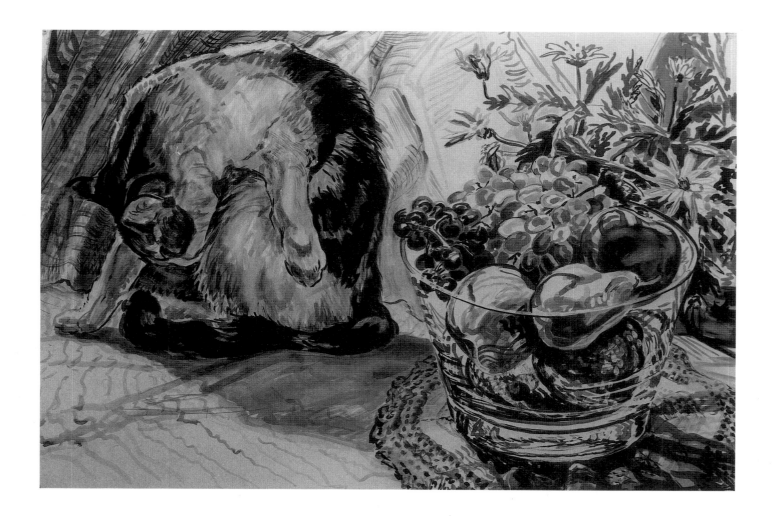

Cat and Fruit, 1987, watercolor, 27½ x 39⅞ in.

Mary Frank

Drawing, for me, aside from any of its other aspects, is very much a taking-in process, a kind of absorbing. It was a way of relating to the world, to draw. A kind of breathing.

Drawing is so many different things. It can change from day to day, depending not only on the subject but at least as much the material I use, let alone the mood I'm in and the weather—all those things. The act of holding a pencil, pen, brush, charcoal, whatever—is a kind of focus.

And so if I've made a sculpture and then draw it, I see the sculpture differently, for the truth is I rarely look at my work very much after I've done it. I occasionally draw it by walking around it, and that somehow forces me to see how it is instead of how I might wish to think it is. Although the drawing may not convey that, for me it creates a kind of learning. And then, from that, sometimes I may make other sculptures, even years later.

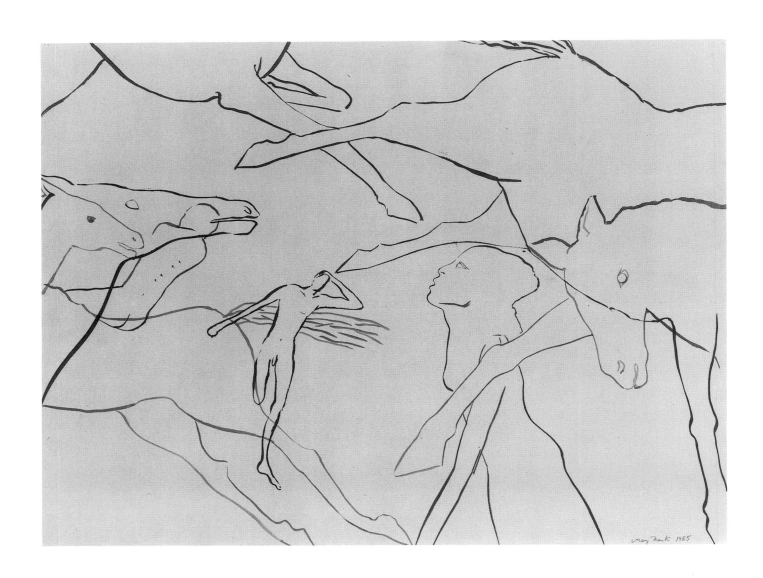

Horses, Humans, 1985, watercolor on brown paper, 19 x 25 in.

Sandy Gellis

For the past seventeen years I have been making art that explores boundaries between order and chaos. My diverse yet interrelated body of work has taken various forms in presenting issues of time, space, the elements, and processes of change. Simultaneously, I have been involved with drawings, site-specific installations, models, and conceptually based print projects. Common to all of my work is an emphasis on the interaction of specific materials in producing an environment responsive to a particular site.

My drawings are exploratory and express "mind-states," or they are related to specific places and/or projects. The latter are diagrammatic, incorporating photographs altered through a use of powdered pigment, graphite, and, at times, various metals.

Site-specific installations evolve out of curiosity about a place and its mystery—its hidden levels of information. Study of the site allows non-verbal information to surface, and eventually this data crystallizes into a new form.

Models are related to specific projects I have originated. With these, I experiment with and develop ideas and materials to create a visual and tactile sense of space.

I have also been making a series of print projects that are conceptually based records of time and weather cycles. I have concentrated on etching, which by its nature enables me to use metals, water, earth, and fire—materials present in all my other work—in new ways.

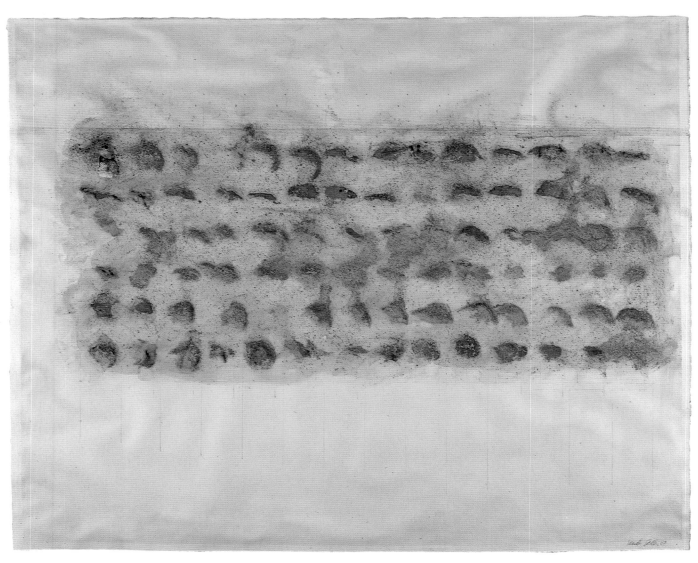

Dream Band, 1980, graphite, powdered iron, and gouache, 20 x 25 in.

Gina Gilmour

I draw from wherever I find myself and from the memory of these places. I draw from my drawings and from the mind. I draw figures in landscapes that evolve together as form and metaphor.

With charcoal I slowly draw a rectangle or several on a page. Then I wait. The mind is quiet as it scans inner and outer worlds to come up with imagery that will be the visual equivalent of a chord of ideas and feelings for which there is no ready verbal counterpart. At a moment when the mind is without intention, an inner sensation stirs and the charcoal moves like a hand on a Ouija board. One mark and one image lead to others.

Drawing is both thinking and relinquishing of thought. It is a way of letting out and finding forms to match experience. Sometimes the image is born whole, and the drawing is a quick notation. At other times it grows slowly like architecture.

Drawing is the heart and soul of painting. There is a sense in which the painting is but the drawing bejeweled.

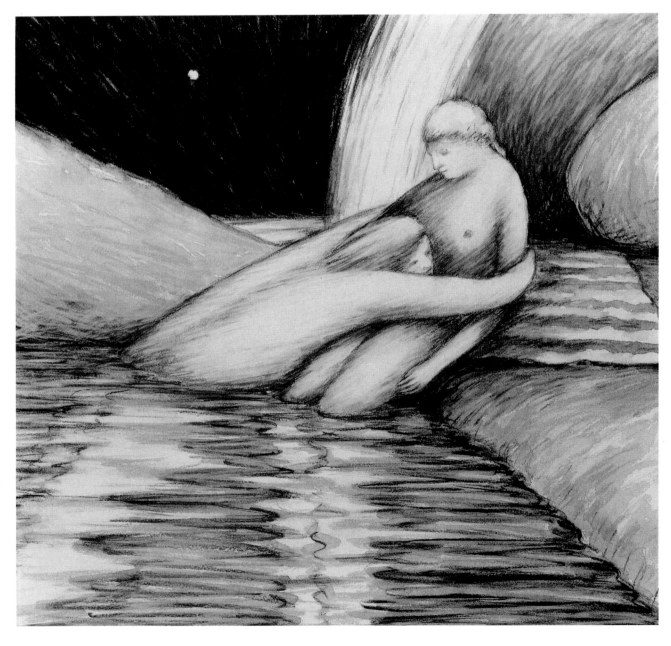

Rescue, 1984, charcoal and ink, 27½ x 26 in.

Grace Graupe-Pillard

My work consists of large pastel-on-canvas drawings, cut out and affixed directly to the wall. The subjects are people—sometimes friends and acquaintances, but mainly anonymous individuals whom I encounter and photograph on the streets of the city. I look for diversity of body type, age, class, and vocation. These all affect the design of my wall installations. I also incorporate architectural elements, fragments of urban life, and other signposts of culture. The vitality of contemporary society is conveyed through a barrage of images varying in size and scale, and juxtaposed to create the dizzying and overwhelming effect of street life.

I always try to carry my camera with me in case an intriguing subject appears. This was the case with Reggie. I rushed over to him and asked if I might take some black-and-white photos to be used as "studies" for a future pastel drawing.

Aesthetic considerations often determine my choice of subject matter. I am particularly drawn to solid and sculptural heads. The outline of shapes and resulting patterns of negative space play a major role in my selections. Moreover, I value the more subtle, expressive elements, the turn of a shoulder revealing the vulnerability and fragility of a person. The strength and honesty of a straightforward gaze, a look, body language, other indications—these can tell us something of both the beauty and sorrow of the human condition. I feel that Reggie embodies these elements.

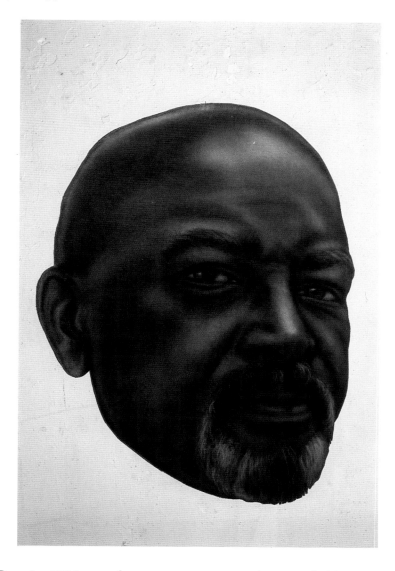

Reggie, 1984, pastel on canvas, cut out and mounted, 33½ x 26 in.

Nancy Graves

Warramanga (Australia Series) is a black-and-white drawing after the 24-foot painting *Aurukun (Australia Series)*. In the latter, the top right form is cast aluminum projecting from the canvas. Each of the spatial planes contains imagery from earlier paintings or sculptures, such as the section of palmetto leaves at top right. A change in gesture, scale, marking, and color denotes each section.

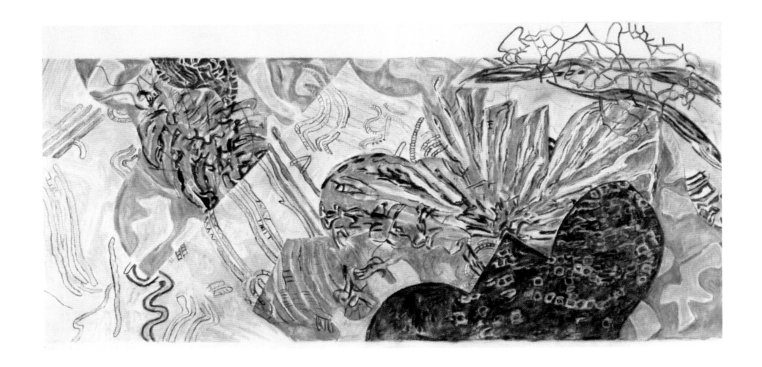

Warramanga (Australia Series), *1986, charcoal, pastel, and pencil, 21½ x 44 in.*

Renée Green

The variety of ways in which the world is ordered and the way things and people are named are of prime interest to me. Who decides what is named and what that name will be? These are questions I examine in my work.

Since it is an ongoing investigation involving large groupings, arrangements, and classifications, much of the work on paper appears in open-ended serial or book forms. My imagery represents fundamental concepts of science, technology, philosophy, and mathematics from widely disparate eras and cultures. Sometimes images appear alone, presented as specimens in small black frames. These are hung in clusters, one separated from the other by black boundaries.

Each image becomes an entry in a sort of skewed classification table or an odd taxonomy. The whole is a visual text consisting of suggestive connections, bold contradictions, and tense juxtapositions. Images range from prehistoric measuring devices to Leonardo da Vinci's blueprints for war machines, from computer flow charts to medieval speculations on the upside-down natives at the bottom of the world. I am calling into suspicion our assumed notions of fact, of comparison and classification. Indeterminacy is my goal. A kind of vertigo is desired which can undermine prejudices by examining order—who creates it and how its accumulation gains authority—so that we will be better able to discern and dismantle some of the absurdities.

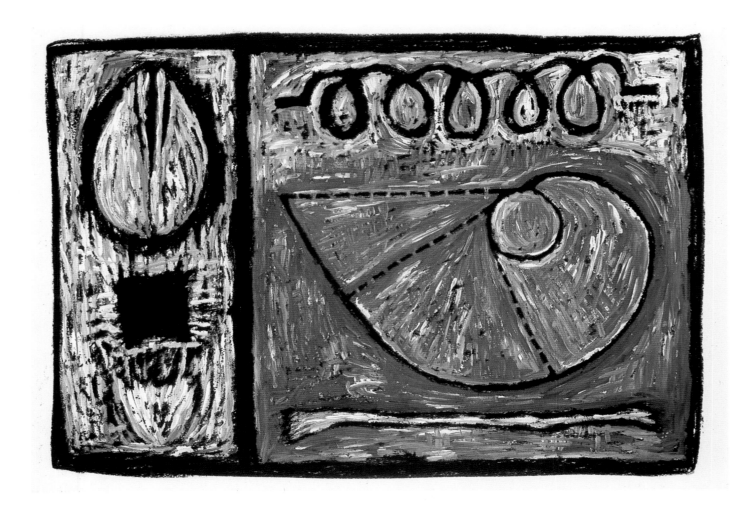

Involute, 1988, gouache and charcoal, 21 x 30 in.

Chris Griffin

The activity of drawing, of articulating a surface of paper with color and shape, has always been a central concern for me. I have always felt that drawing sets up an authentic dialogue with the artist herself—there is no place to hide.

Most of the drawings I do are done after a particular object has been created; they are not working drawings for a sculpture. Most often, the drawings have different colorations, proportions, and emphases depending upon the object/subject, yet the drawn work exerts its own presence. It is as if these drawings are a different manifestation of the same frame of mind, but informed by the object as illusion rather than as real.

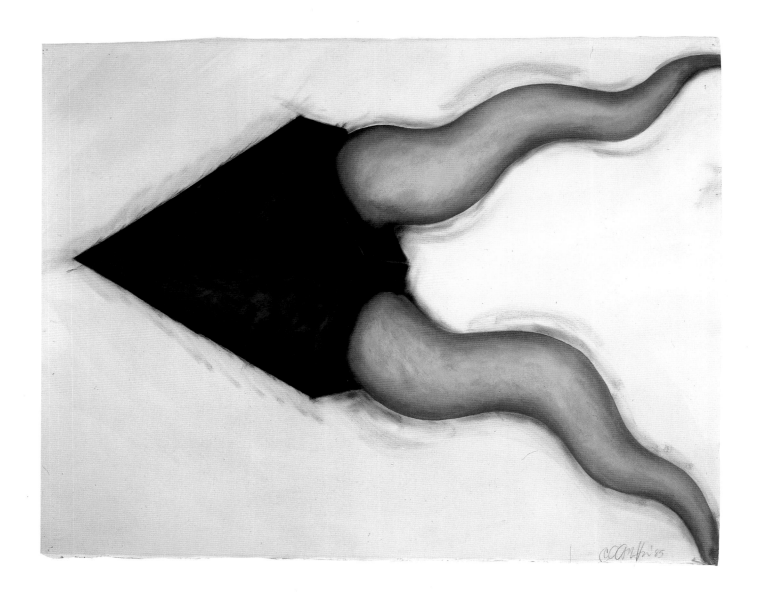

Untitled, 1985, oil, 20½ x 26 in.

Nancy Grossman

The importance of drawing in my work—in my life—addresses both the philosophical and the physical. Drawing is always the skeleton and structure of my attempt to discover my own meanings.

The Hebrew taboo against making graven images still reverberates, because the bringing into existence of something that did not exist before by simply imaging it, drawing it, remains so seductively compelling.

At various times in the past I have experienced drawing as magical, the bringing to life of what was not there. The vision of something with all its associations and repercussions, imaging an object or an event, is probably related to the earli-est known drawings on cave walls.

I have made things whole that were not whole. I have taken possession of and mystified the most common, pedestrian, beneath-attention objects of everyday life—a book of matches, a walnut, a pebble. Through looking at the object —looking so carefully at the thing itself—it blooms into fuller meaning. So, there is nothing beneath attention—there is no boredom in the world.

The act of drawing exists somewhere between reflection and action. For me, there is at times an ecstatic synthesis of the two—a feeling of being and doing, of awe and affect—a true disappearance of boundaries between myself and the object, myself and the other.

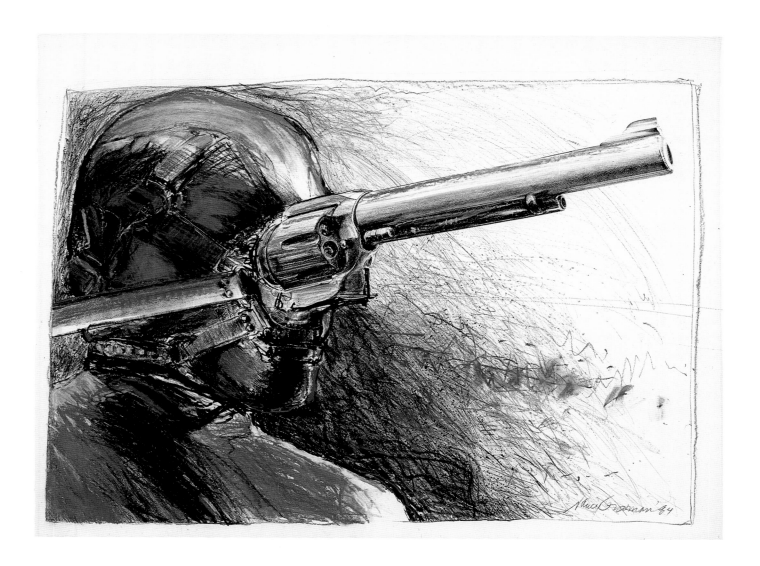

Gunhead, 1984, mixed media on gray paper, 20 x 26 in.

Marina Gutierrez

I remember drawing as a little girl—faces, eyes (too often blue). I remember making houses of sand and leaves and metamorphosing paper bags into generations of puppets. I remember toys —old enameled metal printed out of register revealing rainbows, the aroma of new pink plastic babies. I remember pins and threads and scraps of fabric on wooden floors. . . . And stories, drawing infinitely unwinding stories that spread off the edges of paper.

The stories continue evolving, infinite and complex, the images of my vision in frozen moments. Tableaux inhabited by familiar people (that I or we know or might know) in places and spaces where perspective is ordered by content and intent and the representation of time. They are narratives of memories, comments, connections, explanations, instigations, revelations, and analytical distillations.

In *Get Back* the border of words comes from a song, a rhyme sung while children jump rope. It is a naïve and cynical recitation of racism, repeated and internalized by generations of African-American children—"Black, black, get back. If you're brown, stick around. If you're white, it's all right."

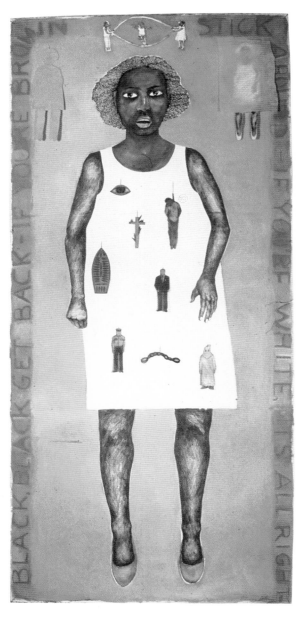

Get Back, 1984, acrylic, pencil, crayon, and metal, 66 x 30 in.

Susan Hall

To me, drawing expresses the poetic; it is a place and time to unlock the secrets and depths of painting. It is a pathway to experience the divine and innocence. Drawing allows me to chart and test new territory, to activate and explore the unknown and mysterious.

My drawing has developed into a holistic enterprise. On the one hand, it is logic, analysis, and the translation of three-dimensional space into two dimensions. On the other hand, drawing is a receptive medium for expressing the irrational, mystical side of life. It is a useful tool for amplifying the world of dreams and the unconscious. Atmosphere and mood grow without technical overload.

Drawing has been the continuous thread that has woven the different aspects and facets of my experience into a lifelong and deeply personal artistic tapestry. I have often used drawing as a way to remember and invoke experiences that are half-forgotten. Drawing affords me the space and time to discover and arrive at my own truth.

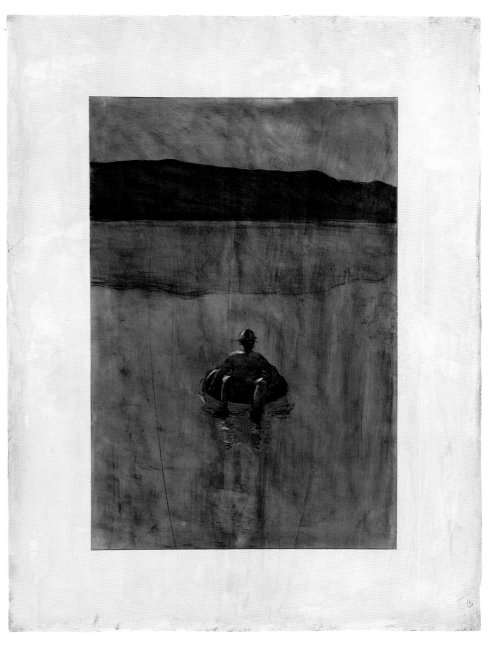

Man in a Tube, 1988, charcoal, pastel, and watercolor, 30 x 22 in.

Harmony Hammond

Most drawing is too neat for me.

I love paper, expensive ones like French butter. But when it comes to journals, I have always preferred drawing on paper towels, napkins, or brown paper bags—even butcher paper. I buy beautiful sketchbooks and imagine them full of my notes and sketches, but I am unable to use them. There is something about the bound edges that gives me great difficulty, makes me claustrophobic.

My recent discovery of black and white through lithography has led me back into drawing. Charcoal allows me to be messy and retain a handmade look as I call out the image. I can subtract or add without the seduction of color.

There is an archeology of drawing.

When I draw I do not cover up my tracks. I do not build a surface as in painting. Instead, I involve the paper in a way that I can never involve canvas.

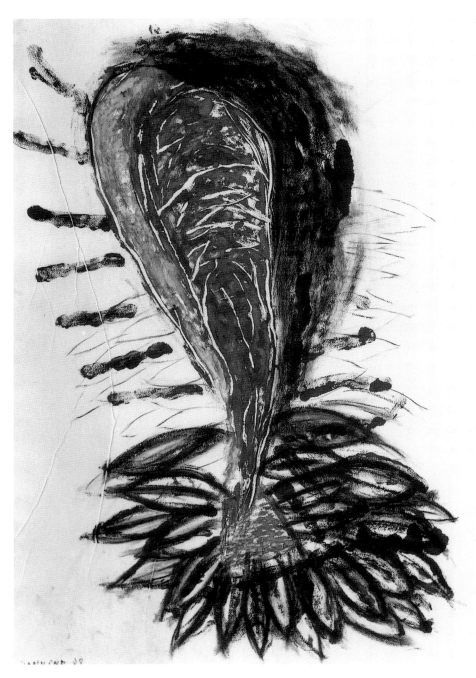

Las Animas, 1988, charcoal over monoprint, 40 x 27¼ in.

Jane Hammond

My drawings are constructed—they are largely defined by a particular process of making which despite visual differences between drawings remains the same. Two things are key. The first is accretive layering, which I see as fundamentally about structuring time, not space. The second is the information itself, drawn from a variety of sources: the sciences, anthropology, pop culture, and personal experience. The latter is no postmodern lexicon, but rather an authentic urge to deal with the complexities of experience, the degree of order and disorder in the world and within us.

I think of my drawings as metaphors for the structure of consciousness—the way images and ideas cross-reference and free associate in the mind in present time and are drawn up from the past as well. The reading of the elements of the drawing occurs in time, although the sequence is intentionally variable and floating. The drawings are not narrative; I've always seen them as abstract drawings about the relationships and structure of relationships between fragments and systems of information.

Historically, the drawings are related to the Jungian, pre-drip Pollocks and the tradition of psychic automatism established by such artists as Joan Miró and André Masson. They do not, however, depend on a particular mythology or psychology but wrap together inherently dissimilar and frequently far-flung bits of information.

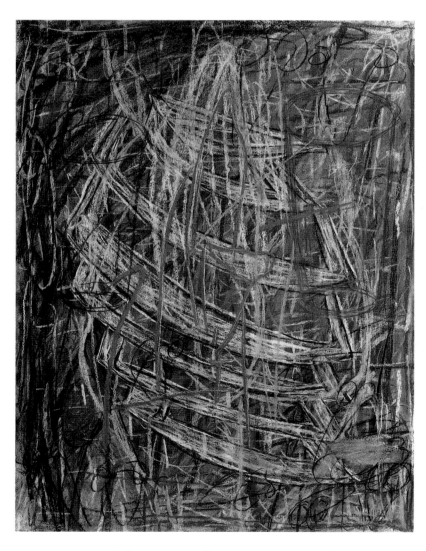

Untitled, 1987, pastel on rag paper, 24 x 18 in.

Maren Hassinger

All my work is inspired by nature, and most of it is site specific, influenced by the character of a given locale. With each piece I attempt to reveal physical and other qualities of a particular space.

The part of the work that is large, public, outdoors, consists of site plantings often juxtaposed with wire rope. Nature and art are meant to blend. The wire rope imitates and merges with nature in an uneasy coexistence.

Another portion of my work is indoor installation and drawings made from natural materials, recalling an absent nature. The drawings are created from leaves arranged on paper. This process of placement on the page is drawing. They are reveries.

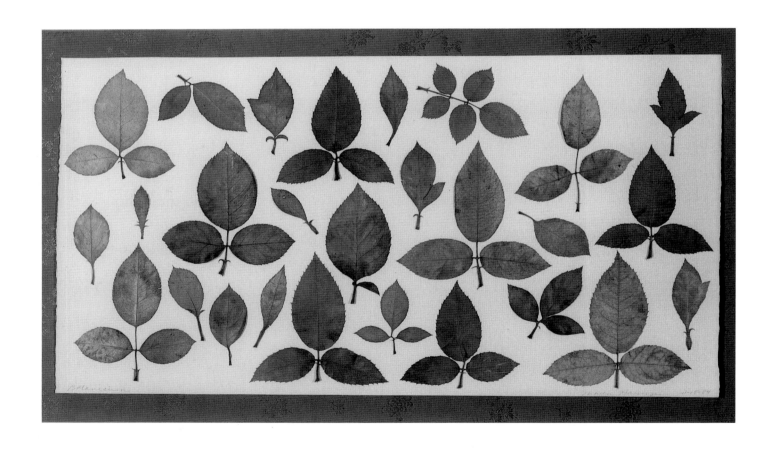

Botanicum, *1984, preserved rose leaves on paper mounted on silk, 14½ x 25¼ in.*

Phoebe Helman

My work is about the fragility and resilience that coexist in life and in art. It is about the tragic, and moving through the tragic into wondrous, magical realms.

I continuously question proscribed language, boundaries, and orders in order to be able to see anew.

The mazes, entrances, and paths of my work trace connections, checkpoints, and painfully built-up places. I attempt to reveal what once was —the shards, fragments, lost and sadly remembered spaces and dreams. The blackness represents strength and willingness to change. In erasing and blotting out, destruction finds a voice.

I love the immediacy of drawing, the process of making and losing marks. A language and dialogue are established with those marks.

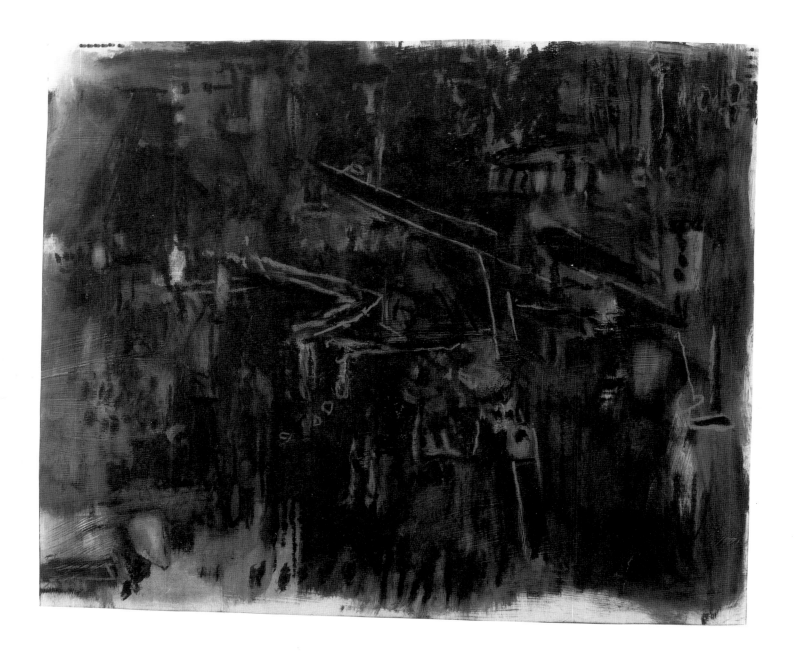

Dark City, 1988, paper, oil stick, and map tacks on foam core, 28 x 33 in.

Janet Henry

When I draw I immediately go into a trance. Even though I can only make art intermittently these days, it doesn't take long to get warmed up or pulled into building the image.

I'm helped by the fact that I don't feel that my work is precious. Sure, everything I do is "inspired," but all that does is set up possibilities, with attendant problems needing solutions.

When appraising how effectively I've solved these problems, my only criterion is whether or not I feel successful. I don't qualify, justify, or make excuses.

All this ties in well with the propensity I have for seeing the ironic and/or irreverent aspect of most things. This drawing is one of a series of self-portraits chronicling my various hairdos. The drawing was done from a photograph taken by Frank Stewart in 1978 at the Studio "Mausoleum" in Harlem. Funny thing is that ten years later I still squint.

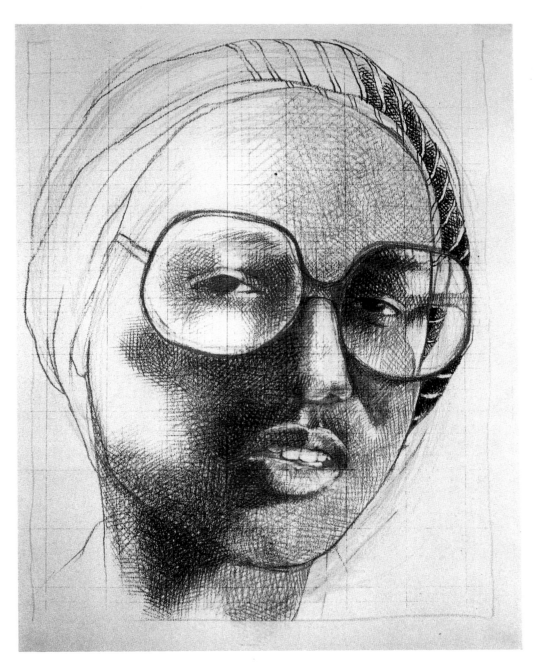

Self-Portrait, 1988, mixed media on graph paper, 11 x 8½ in.

Carol Hepper

My drawing is an essential tool to access possibilities with sculpture. I am interested in using the two-dimensional medium to tap the essence of sculpture via a different approach, as well as to explore possibilities that are only available with drawing. These options allow me to set up problems and examine solutions that may not be practical in three-dimensional reality. The options available through drawing generate a need to find answers in a more probing and unorthodox way than could be arrived at through sculpture alone.

While working in my studio, I make notations of ideas in my notebooks on a day-to-day basis, and at the same time I go through the process of working out problems in my sculpture. My notebook drawings can start with a sculptural concept, which in turn evolves so much in actual sculpture that the original drawing appears to have no tie with the final piece. Drawing and making sculpture simultaneously allows several alternative possibilities. Drawing is for me a way to keep open the channels of development and change.

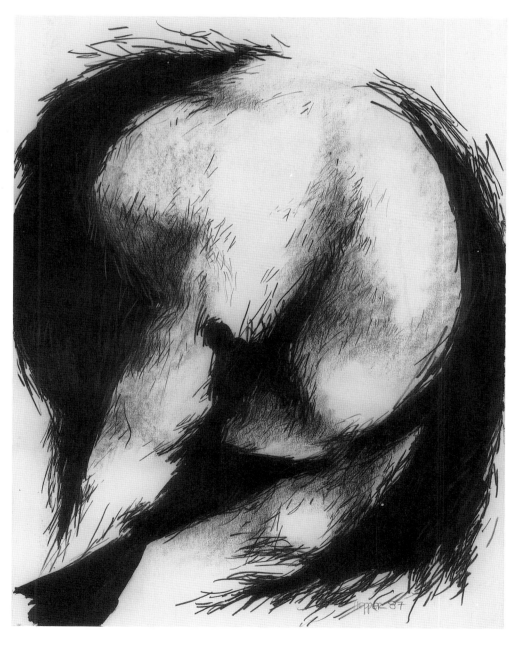

Untitled, 1987, gouache, Conté crayon, and graphite, 30 x 22 in.

Eva Hesse

I would like the work to be non-work. This means that it would first find its way beyond my preconceptions.

What I want of my art I can eventually find. The work must go beyond this.

It is my main concern to go beyond what I know and what I can know.

The formal principles are understandable and understood.

It is the unknown quantity from which and where I want to go.

As a thing, an object, it accedes to its non-logical self.

It is something, it is nothing.

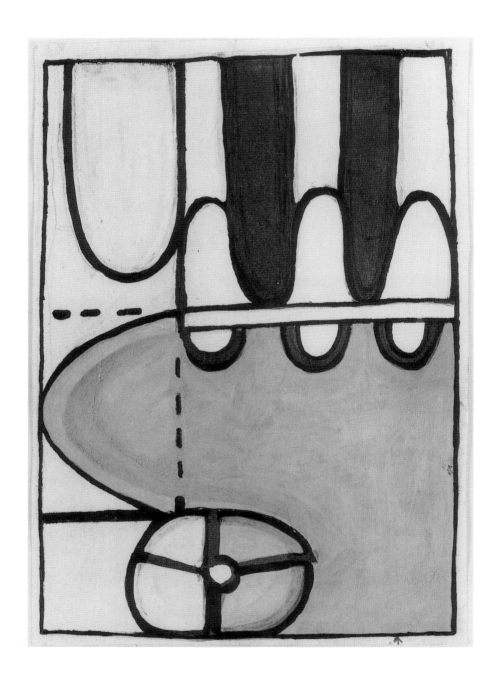

Untitled, 1965, ink, gouache, and pencil, 6½ x 4½ in.

Robin Hill

At its most utilitarian level, drawing has served as a tool for working out technical problems related to my sculpture. Until recently these diagrams constituted my total drawing involvement and were completely private. Lately, I have been making drawings that are independent of the sculpture, involving a completely new set of guidelines. Unlike the diagrams, these drawings are not attempts at illustrating mental pictures, but they do involve a kind of "Ouija board" brand of chance. My hand *finds* the picture in the graphite. The freedom and spontaneity of this kind of image making is a welcome tangent to the technical and ordered qualities involved in making sculpture.

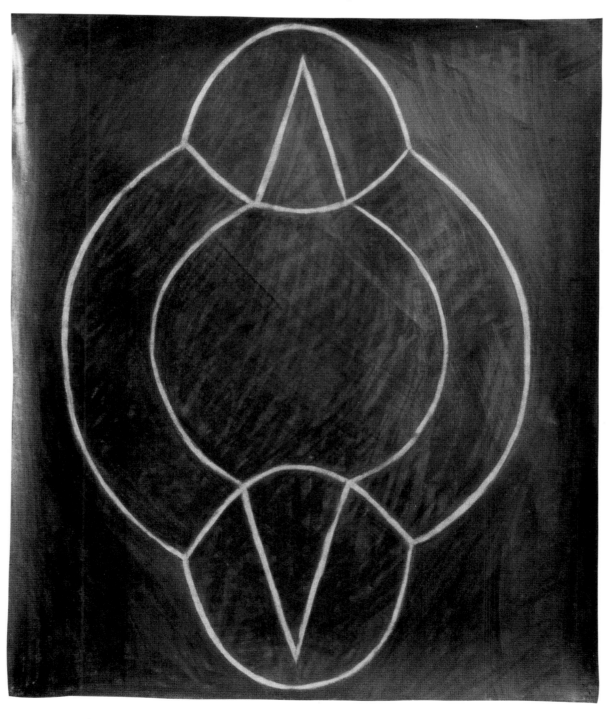

Untitled, 1988, graphite on vellum, 14 x 11 in.

Nancy Holt

I DRAW

to work out ideas

to present an overall concept

to give a feel of a work through rendering

to make a master plan for blueprints

to map out a work in a site

to show contractors and engineers what I want

to give a sense of placement

to give a sense of scale

to indicate alignment of elements

to show changes in plan

to plan out patterns

to detail elements

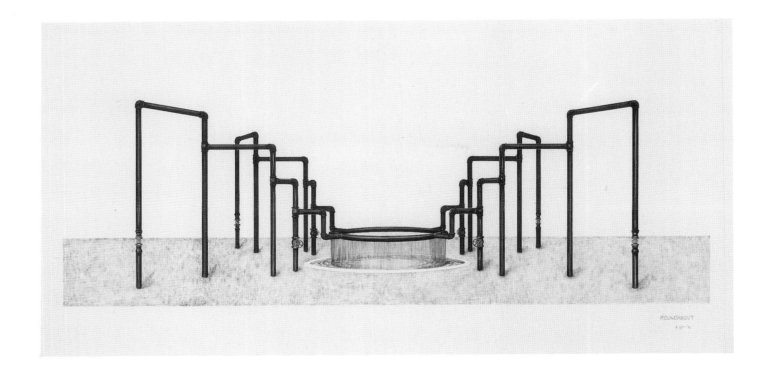

Roundabout, 1986, graphite pencil, 26 x 54 in.

Nene Humphrey

I consider drawing to be an intensely physical act. When I think of making a drawing, I think of getting down on the floor on my hands and knees—hovering over a sheet of paper and digging in. Most of the time I use charcoal and oil sticks, and always my hands more than any implement. Making the marks involves my whole body—scratching, swirling, crushing up the charcoal. My hands move across the paper as I dip the oil stick into turpentine until it's greasy and smear my fingers up and down, around and over the white surface. Often I draw early in the day when my energy is high. It can take the whole morning or only a few moments, but the best drawings always have a built-up sense of emotion and energy.

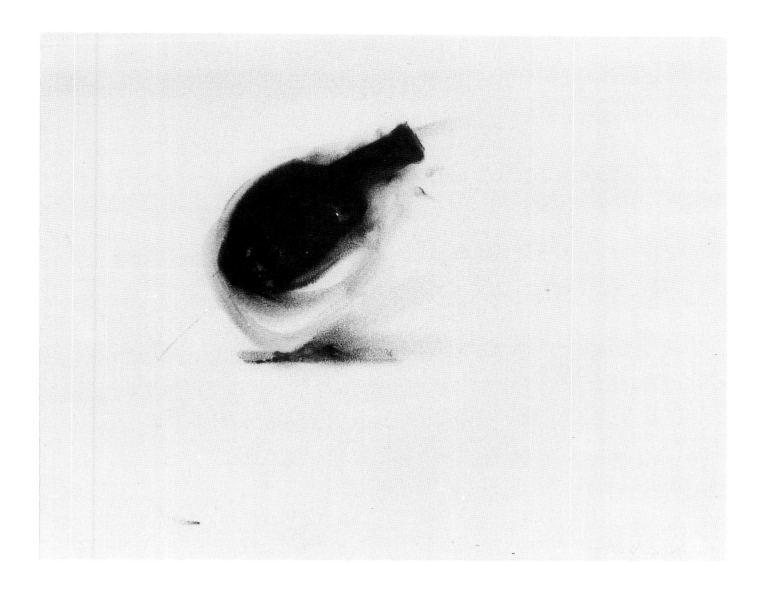

Soft Roll #2 (Somatic Spaces Series), *1987, oil stick, 11 x 14 in.*

Patricia Johanson

I had never considered drawing particularly important—until the birth of my first child. With no time, no money, and no energy, it became painfully clear that I would not be able to build large-scale environmental sculpture as I had in the past. Just to keep going, I began to make tiny sketches in a pocket notebook. Dead, contorted leaves, bodies of water in tire tracks, the architecture of melting ice, the remains of the cat's last hunting expedition became elements of a world waiting to expand. Instead of struggling to produce great "monuments," it now seemed more important to try to understand the world through the medium of drawing. Anything can be sketched in a minute or two—in order to capture the moment and move on to a vast catalogue of ideas. Eventually, I began to transfer some of these tiny sketches by means of a grid to larger, more elaborate drawings encrusted with thoughts from my notebooks.

Projects like *Endangered Garden*, combining the design of a new California state park with a "baywalk" superimposed on a sewer facility, are the direct result of this process. Typically, a multimillion-dollar project would evolve and develop, yet my design remained rooted in the ideas and the minutiae of the site, conceived through endless sketches. The two largest images—the snake and the butterfly—would be explored in the mind rather than seen, due to their expansive size. The real focus of *Endangered Garden* is that endless succession of fleeting moments, ephemeral effects, and tiny fragments of the life of San Francisco Bay.

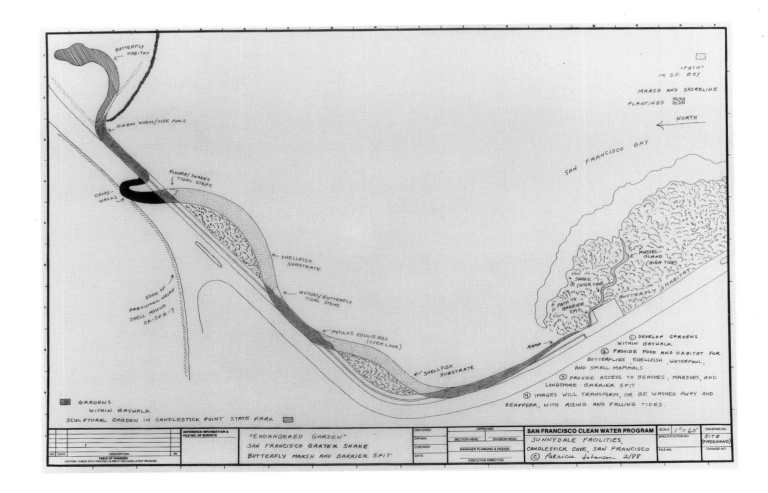

***Endangered Garden, Candlestick Cove, San Francisco**, 1988, ink and charcoal on vellum, 22 x 32¾ in.
Collection Gerrit Hull Goossen, Buskirk, N.Y.*

78

Anne Griffin Johnson

Making these recent charcoal drawings has been like searching for lost objects. I began each one with a single reference—a twist of rope, a tool, a plant, a diagram of the human heart, a jar. During the process other associations evolved. The final images are hybrids of uncertain origin and purpose. They exist in a space of indefinite dimensions. Although clear in outline, the forms shift between the scale of architecture and the scale of hardware. They can look both leaf-sized and tree-sized. What I want to take from these drawings into painting is the idea of a fixed object reaching for several identities.

Implications of movement appear in the flicker of tones erased, lines drawn twice, blacks made blacker. In the tension between the restless process of drawing and the centered, specific image, there is something of the everyday difficulty of remembering, of sustaining an intuition, of projecting an emotion or thought into the future. These things are echoed in the tenuously sculptural quality of the images as well: ambiguity of structure—a flatness at the base, a vagueness about the way two parts connect—suggests these forms can be stable only in the space of the page.

If the objects drawn could be said to be doing anything, one could say they are balancing against the pressure to mean several things at once. They are trying to stay fixed and whole, trying in spite of their complications to be simple.

Waltz Time, 1987, charcoal, 30 x 22¼ in.

Carla Rae Johnson

There was a certain type of drawing done in the fifties. On TV. A huge wire drum contained hundreds of optimistic cards from across the USA. Wholesome young women would, weekly, interrupt its constant turning to draw out a handful of lucky cards. A postcard from Mrs. Zimmerman of Florida could appear with one from Mr. Kendall of South Dakota. Winners!

There is a stage in my creative process when many ideas, images, and visual ironies are drawn out. I record their appearance in a large number of small jottings, working sketches, and visual notations. Optimism prevails. Random and unexpected juxtapositions can develop into fertile metaphors. I save the cards for future drawings and sculptures.

There is a Rolodex on my desk, a tool to aid in communications. Alphabetical, categorized, the logical system provides access when I know whom/what I want, but the Zs remain far away from any Ks.

There is a type of drawing I do when my intention is to communicate with someone else. I make use of our mutually organized sense of expectations as a tool. The Personal Joinery series, for example, begins with systematic representation of fitting solutions for joining wood. The insertion of a *Village Voice* personal, however, thwarts the logical system. Successful drawings, for me, subvert our arbitrarily categorized knowledge. I did this series because I enjoy getting Mr. Kendall and Mrs. Zimmerman together for the sweepstakes.

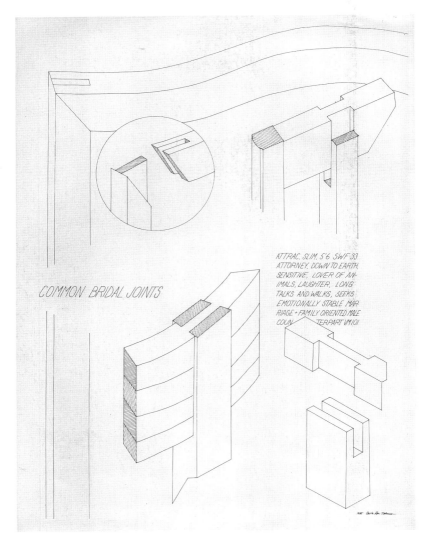

Common Bridal Joints (Personal Joinery Series), 1985, ink, 30 x 22 in.

Shelagh Keeley

Since 1980 my work has consisted of large-scale drawings and temporary wall-drawing installations. My concern is the archetypal image of the wall and its structure as an emotional piece of architecture. To me the wall is a refuge of willed silence, an act of enclosure, monumental yet at the same time speaking of an introspective attitude of privacy and seclusion.

In my installations I am concerned with the recovery of space through gesture. There is an awareness of the body in my work process, and my installations become psychological extensions of the body. Concerns are: body gestures, gestures of the site, an architecture of emotion, the body and architecture.

My work-in-process is elemental, instinctive drawing that exposes a raw, psychic condition—a state of nonknowing involving the psychological and physical structure of walls.

My room installations are concerned with the memory of space and a sense of displacement. I am a detached observer of architectural spaces.

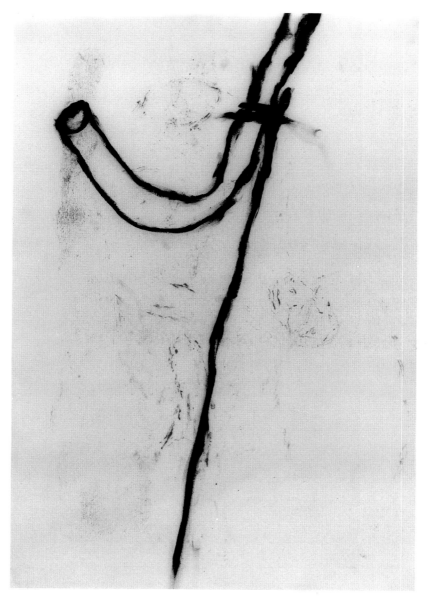

Objects of Daily Use, 1987, *oil stick on waxed Masa paper, 31 x 21 in.*

Vera Klement

Drawing has always been a separate activity for me. When I draw, I don't paint. By drawing I don't mean the kind of thinking, talking-to-myself, ongoing activity in the notebooks in which my ideas are formed. Drawings are like paintings, only in a different medium. Because I value the intrinsic characteristics of a given medium as becoming part of how the image is made and looks, my drawings have always looked very different from my paintings. And because of the variety and flexibility of means, they have always been somewhat ahead of the paintings.

Recently, however, the two modes of work-ing have come to resemble one another more as I have come to grips more specifically with finding images that can serve as metaphors for the personal events of my life as well as acting as more universally comprehended symbols. Imagery consists of selected objects, each realized in a medium chosen for its expressive intention. Thus the image of a tree is juxtaposed with smaller landscape and figurative drawings. My aim has been to isolate the forms from their common context and place them in a new relationship, so that in the space between the two a glimpse of something other can reverberate.

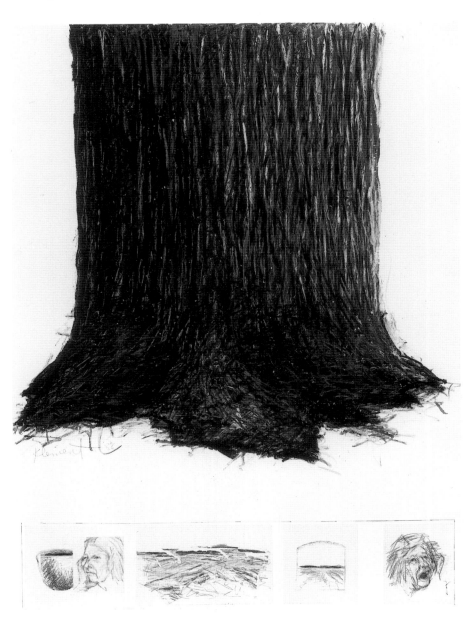

Trunk and Story, *1988, crayon, graphite pencil, and collage, 30 x 22 in.*

Alison Knowles

Jem Duck, a performance environment, is an homage to Ariadne and her thread to an inner and outer world that seems to be lost. In this manipulable labyrinth environment, a route or pathway leads one to discrete stations where real objects and drawings await the perusal of a spectator. With this engagement of sounds and images, one is put in touch again. The objects seem "inspirited." They have been selected for certain sounds and image qualities that await discovery.

Performance Notation from "Jem Duck," *1975, pencil on vellum, 40 x 20 in.*

Grace Knowlton

For many years I have been making spherical sculpture. In the beginning it was the closed form's sealed-in space that fascinated me as it suggested hidden-away mysteries. Then it became the form itself that interested me. I began to place the pieces in groups that could be moved around, changing relationships. Sometimes the surface seemed most compelling, and I started making paintings in the round. Eventually, I began opening up the spheres, using sections or shards as wall sculptures.

My series of Culvert drawings is part of this opening up. I am interested in contained, but not closed, space. Are these entrances or exits? Mysterious tunnels? Passageways leading to hidden destinations?

Technically, my Culvert drawings are made with a combination of photography and mixed media, mostly pastel and acrylic paint. The photographs are taken with 35mm film, enlarged onto 4-by-5 negatives. These are projected onto photomural paper through an opening in a sheet of paper masking out part of the image. After developing the prints, I complete the images with drawing.

I feel that the photograph and the drawing each represent a different interpretation of a "reality," ultimately blending into a fiction for the viewer to enjoy. This particular drawing is the first in a series and relatively simple; as the series progresses (there is a total of twenty-five drawings), they become more complex, with layering and interweaving. As the first, this work is also the smallest and represents my jumping-off point.

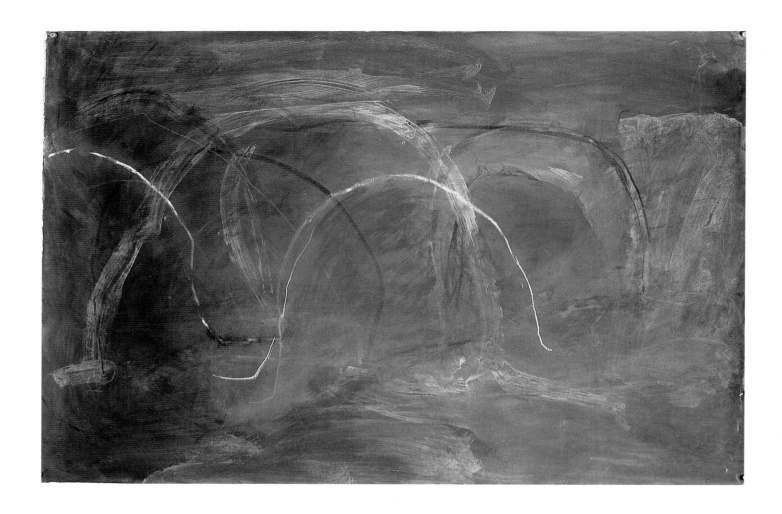

Culvert, 1988, pastel, acrylic, and photographs, 32 x 48 in.

Ellen Kozak

The process of getting a drawing to work is, ironically, in large part a technical exercise. Ironically so, because in the end I care little about technique, nor is this a criterion that draws me to works of art I find extraordinary. I am always conscious of balance to the extent that my relationship to the drawing seems itself to have a physiological as well as a visual balance. At times I feel a visceral hint or clue that informs me of how to pull the drawing into the right condition.

I want the figures to be energized. But the energy should not come strictly from the fact of the figure, that is, not through illustration. The energy comes through the fact of the paint, as it records the intensity of its moment.

I do not want the figures to seem awkward, and I do not care for them to be accurate. They signify a state or circumstance. I want a surface unity that bridges figure and ground, breaking down those boundaries. These terms have importance for me. I walk a tightrope, not allowing figure and ground to be isolated from each other so as to cause their complete disappearance. What I am after is a materialization of the figure out of charged ground and a reiteration of edges using line. These lines then become another kind of matter coursing through the ground. Hopefully, the equilibrium is just about undone.

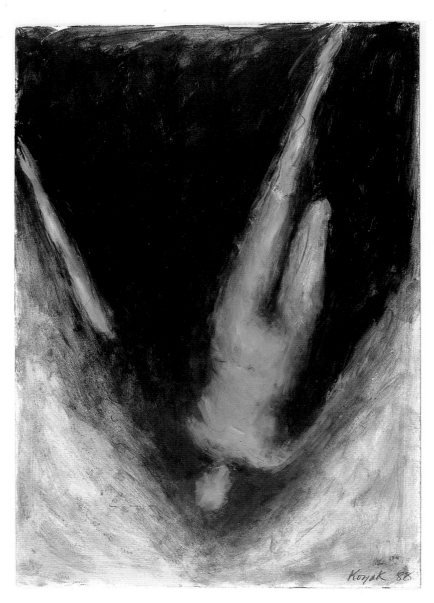

Inversion, 1988, oil and pencil, 15 x 10½ in.

Lee Krasner

My studio was hung with a series of black and white drawings I had done. I hated them and started to pull them off the wall and tear them and throw them on the floor and pretty soon the whole floor was covered with them. Then another morning I walked in and I saw a lot of things there that began to interest me. I began picking up torn pieces of my own drawings and re-glueing them. Then I started cutting up some of my oil paintings. I've got something going there and I start pulling out a lot of raw canvas and slashing it as well. That's how I started my collaging and the tail end of it was the collaging of the paintings in the Betty Parsons show. I showed these collages in '55 at the Stable Gallery.

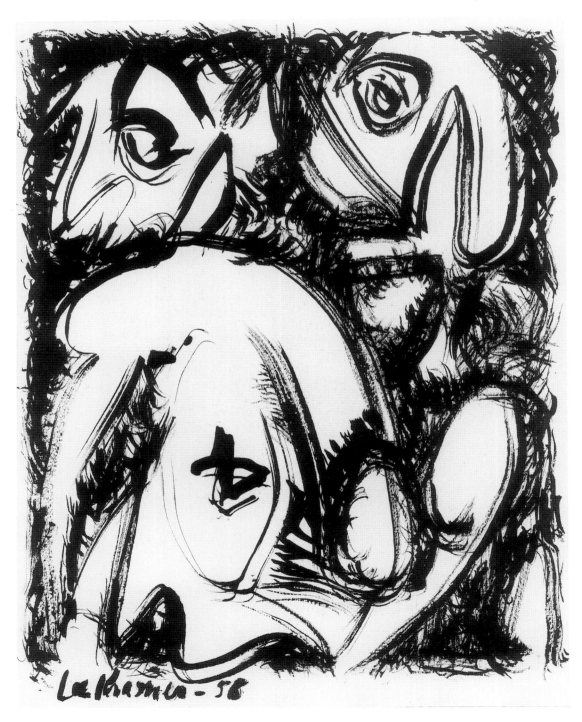

Untitled, 1958, pen and ink, 11½ x 9½ in.

Lois Lane

The symbols don't always link up the right way for me in a painting as they do in a drawing. It's very different because the drawings utilize photographs. How do you make a painting of something that's photographed:

Somehow the literalism works better in a drawing because of its scale. When it's larger, it has to become simpler.

It's noncommittal. It's not about a specific surface. I don't want the surface to be an element that detracts from what the image is. In the dark paintings, the surface is very shiny and the image is usually matte. The figure and ground become almost one thing.

It's also totemlike. Somehow I got a sense of what images are culturally important or had some significance. Basic to the culture, or basic to the past or present. That's how I set things up. I thought that was important if you're making symbols. It should be some symbol that has significance, even if others don't pick up on it. You know, in a funny way, I always thought that it didn't matter even if symbols weren't seen, as long as they were created. Just the birth of something is significant.

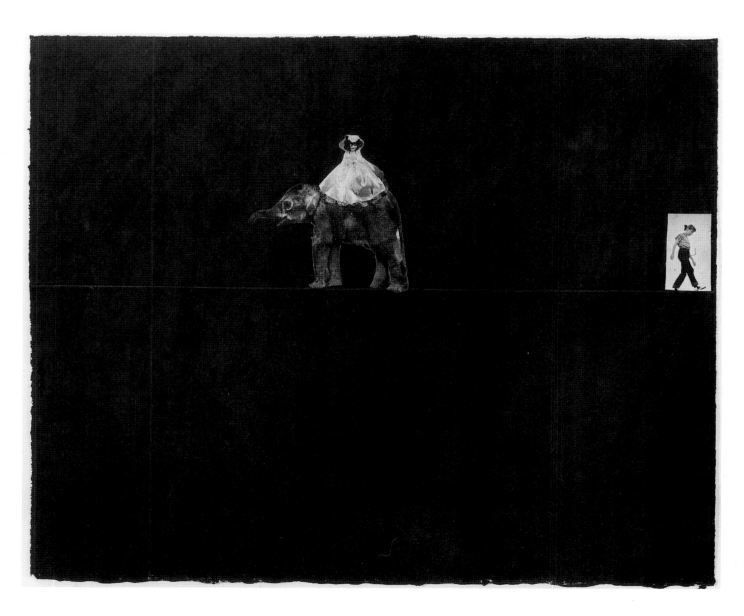

Untitled #65, *1978, Craypas and collaged photographs, 12¼ x 15 in.*

Ellen Lanyon

For me, drawing is immediate. It records fleeting notions as well as substantial ideas. It explores and establishes a sense of communication, and I depend on it to clarify whatever image I am involved with at the time. Tools mean pencils, a brush, pastels, or pen and ink. One holds the tool as a quill, as a needle, as a knife to determine the character of the mark. Multiple marks orchestrate the image and bring it into focus.

For long periods of time, drawing can become my major occupation. Then, when I return to paint, the quality of the stroke and surface is enhanced and made more universal.

Drawing remains a legacy from the earliest mark makers. It has managed to transcend the rapid change of art à la mode as it continues to serve as a vehicle of invention for diverse sensibilities. Somehow it is possible to grab a graphic "lifeline" and to comprehend the structure of a new complexity.

Drawing is the foundation that stabilizes, but it also stands victorious as its own device.

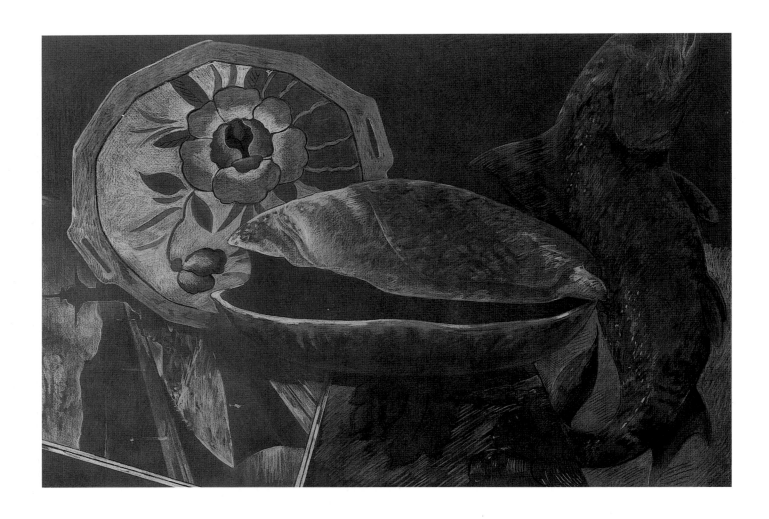

Panama, 1987, colored pencil, 22 x 32 in.

Susan Laufer

Drawing helps me understand the relationship of air and breath in my work.

I always draw. When I was a kid, drawing transported me to another place. It still does that. It is the way I continually reinvent my interior language and quickly act upon impulsive energy. Drawing is the most direct and powerful way to find the "point of departure," the place that instructs and directs my paintings' beginnings. I consider drawings isolated fragments of my paintings. The sum of these fragments sets up a dialogue and tension necessary to the life of the painting.

When I begin a drawing, I start with a dark smudge on a toned charcoal field. I use my fingers to smear the form until it emerges into a shape that has a strangely pleasing reference. This slow and gradual emergence from chaos to order, from darkness to light (and back again), is what keeps me going. The "field" becomes a seductive metamorphosis.

Later, for my paintings, I cut these fragments out of plywood, which I then set into a thick layering of paint. Then I pull the plywood from beneath the surface, revealing shadows, craters, and fossils of the original idea. This "field" contains layers of hovering images—like the drawings except that now they seem to be set in rock.

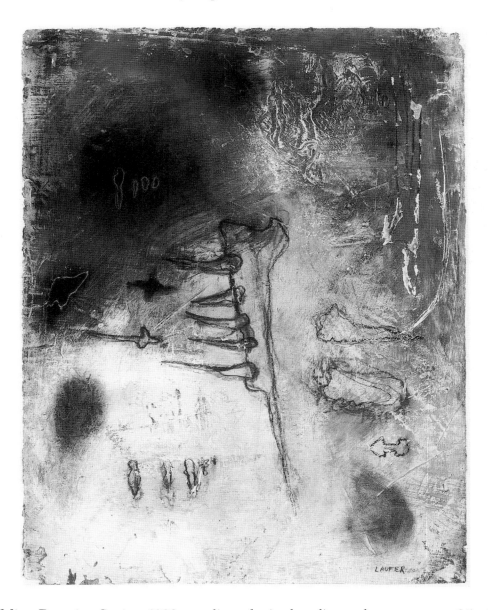

Lifeline Drawing Series, *1988, acrylic and mixed media on plaster on paper, 25 x 19 in.*

Stephanie Brody Lederman

Drawing is my first language. My earliest memories are of being three years old and making drawings in the kitchen of my grandparents' Bronx apartment. I would intently make marks on scraps of paper that they found for me, while my mother and grandparents sat at the kitchen table speaking to each other in a foreign language. These memories are mingled with the sweet smell of meat and fruit simmering in a big, white, chipped enamel pot on a small, white, chipped enamel stove. I used a pencil stub that was sharpened in the sink with a bread knife as my drawing implement. I was supremely happy in that kitchen with the "Jackson Pollock–spattered" linoleum floor.

Now I make oil paintings on canvas along with the drawings. But I feel freer when I approach a piece of paper than I do when I approach an empty canvas. There is something so natural and ordinary about paper. I just jump right in and draw with the same pleasure that I had a long time ago in that Bronx kitchen. Drawing connects me to my truest feelings.

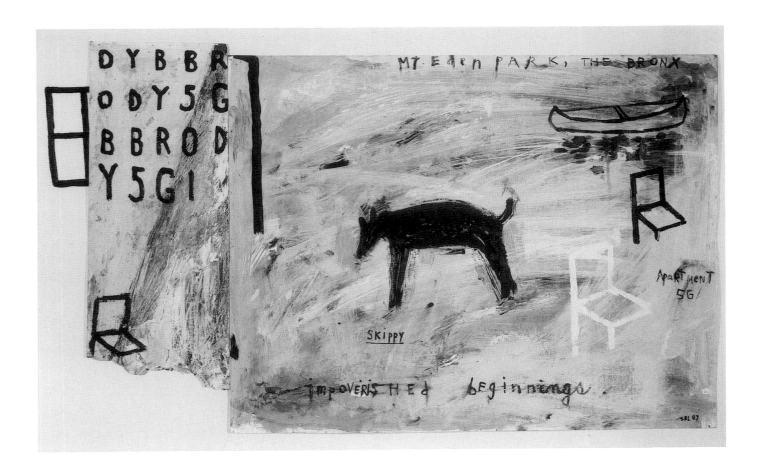

B. Brody and Skippy, *1988, oil, acrylic, and graphite, 22 x 33 in.*

Claire Lieberman

The making of art can be an attempt to locate a place, not only a physical point but a way of establishing a connection to one's surroundings. In my work this place is not static but expands and contracts. Similarly, the shapes in my drawings emerge and recede out of a fluid and filmy atmosphere that is punctuated by black marks and a penetrating blackness. This blackness arrives out of an interplay of lines, a breathing blackness that exudes a sense of weightlessness. My drawings are intimately connected to my sculpture created from black marble. Intersecting lines are created in the deep black of polished stone by chisel and saw.

There is a group of objects I particularly like to draw from: a pepper with its fleshy lobes; a skull fragment of an unknown animal; a twig from which the bark has partially peeled, giving a draped impression; a respirator; and a pair of worn, clumsy work gloves. I rearrange these elements to see how the light hits them, how they relate to each other, and to elicit abstract forms from the groupings, in charcoal on paper. Subsequently, I put these away and make ink-transfer drawings from memory. It is this imagery that is eventually transmuted into three dimensions, wherein the hard, massive physicality of the stone reexerts itself as a tangible link to a sense of place.

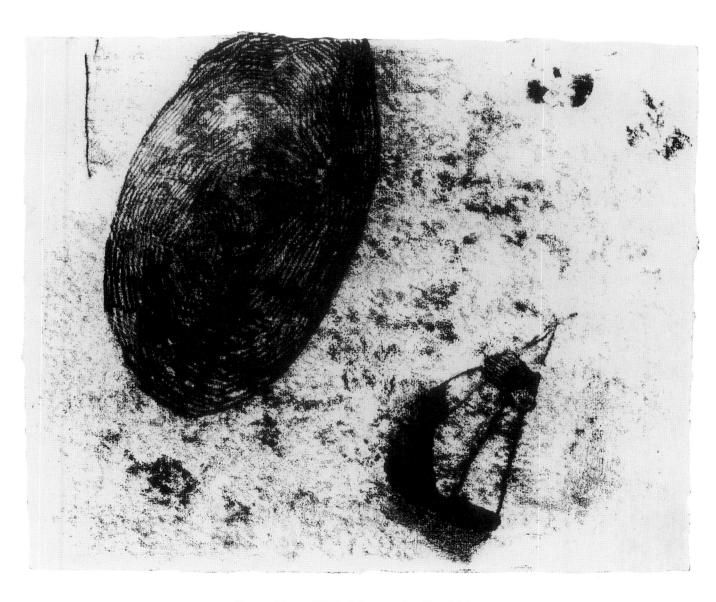

Breathing, 1987, ink transfer, 11 x 13 in.

Li-Lan

In my recent drawings I have been using objects and symbols from everyday life—at this moment focusing on a postage-stamp motif—and transforming these ordinary items into contemplative icons. Sometimes I draw a whole sheet of stamps separated by perforated lines, sometimes a section of one. Much of the perforated sheet is devoid of stamps, leaving large areas of tranquil, empty space.

Some of the stamps are fully reproduced in every detail; others are only partially represented by a fragment of a bit of the picture, as if a suggestion or an indication of the whole; still others are blank space. The latter portions, or "negative spaces," heighten visual tensions. There is an ambiguous balance of form and empty space, of the symmetrical and the asymmetrical, of the familar and the unknown, that intrigues me.

In this pastel two rows of stamps have been torn off the sheet of one hundred, and I have drawn *Eighty 22s*. In this image the printer's color registration is a yellow square and a red line running across the top of the sheet. In other drawings the color chart may consist of triangles, squares, or circles of color used by printers in the process of creating the printed stamp. I am fascinated by these easily overlooked symbols—modern hieroglyphs from the mundane world of the everyday.

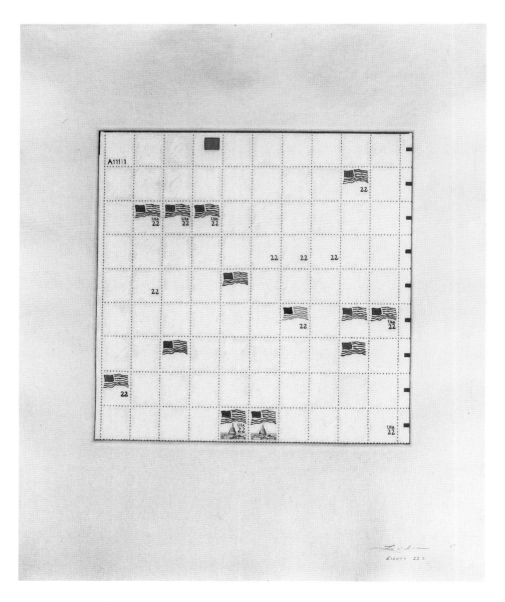

Eighty 22s, *1987, pastel and colored pencil, 24½ x 21 in.*

Jane Logemann

My drawings have their own logic. They are personal statements based on intuition. The drawings are skeletons, baselines, and forecasts of future work.

I work with radical and traditional materials. The drawings constantly change into new forms and orders. Introduction of new materials becomes a factor in these changes.

Use of oil paint on aluminum screen with scratching or writing a linear form through the paint is an odd combination. In a way, the lines complement each other, that is, the line drawn within the oil paint and the circular lines or holes of the screen. At the same time there are contradictions realized by placement of rough, thickly textured oil paint over a smooth, easy surface.

My references are poetry, hieroglyphics, calligraphy, and language.

Begin, 1988, *oil, pencil, and cement on aluminum screen, 16½ x 7½ in.*

Winifred Lutz

About this making. . . .
Someone said,
"It's like a stone skipping on water . . ."
Spreads rings of force
Which launch each leap,
And dissipate
Themselves eventually
Absorbed in the fluid body.
The skipping always stops;
The stone sinks,
Is bottom-rubbed
To particles eventually
Dissolving into the fluid body.

The fluid evaporates to find the sky.
What's left congeals
And is the earth,
Might skip again,
Sink again,
Dissolve again. . . .
Eventually completely changed to sky,
Which expands
Until no skipping remains
To propel it outward and
The empty is filled.
The imbalance balances.
Thus action is self-absolving.

Vesica, 1987, ink on sycamore bark, 22 x 9 x 1½ in.

Margo Machida

In *Self-Portrait as Saint Sebastian* I "quote" from Eiko Hosoe's book *Ba-ra-kei* (Ordeal by Roses), an infamous portfolio of photographs by Yukio Mishima, the controversial Japanese novelist whose obsessive interest in images of erotic martyrdom led him to mimic the pose of this saint as an early object for his psychosexual fascination. In the West, Mishima's persona has become emblematic of the Japanese artist-warrior-hero whose dark, internal compulsions caused self-destruction. I especially relate to the implicit suffering and confusion expressed by this self-image of an Asian in the guise of a morbid Western cultural icon. By impressing my image on his, I assume the guise of the martyr/Mishima figure/artist while remaining a cross-cultural tourist, observing everything while hidden behind dark glasses.

As an Asian-American and a woman, my constructed persona is charged with contradictions: male/female, Asian/other, animal/human, child/woman. Triggered by a need for immediate and direct expression, these drawings operate as emotional "Polaroids," auto-journalistic snapshots that embody my fragmented sense of self.

Self-Portrait as Saint Sebastian, 1987, acrylic, 30 x 22 in.

Marisol

I can never remember a time when I wasn't drawing. I won art prizes at every school I went to. You spent months doing one drawing. They had to be exactly like the original. They were very realistic.

Of course, every artist puts himself into his work. But the truth is, I use my own face because it's easier. When I want to make a face or hands for one of my figures, I'm usually the only person around to use as a model.

***Black Bird Love**, 1979, colored pencil and charcoal, 31½ x 24 in.*

Kathleen McCarthy

"Play is the exultation of the possible."
—MARTIN BUBER

For me, drawing is free play. It allows unrestrained expansion of images and themes, releasing me from the tangle of technical issues. I can physically push images around the plane of the page: shifting, turning, shrinking, cutting, enlarging, overlaying one and then another until I achieve the visual resonance I am looking for. The joy is in the mutual speed of the action and idea. In drawing, gravity doesn't exist—I can venture into the realm of the impossible.

Drawing is the first concretion of the image. As strong and real as my mental image may seem to me, it is uncommunicative and amorphous before drawing gives it substance. It is one-dimensional. With each step toward concretion, there occurs an additional layer of visual, conceptual, and emotional complexity. Drawing begins this process. Finally, in the corporeality of sculpture, I find the fullest expression of my artistic concerns: the mutability of images as they interplay and their evocation of poetic reveries.

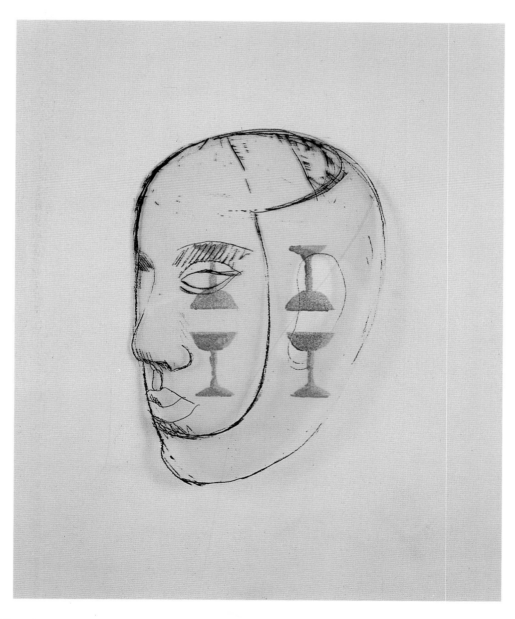

Head with Cups, IV, *1988, photocopy on acetate and mixed media on paper, 13 x 10 in.*

Ana Mendieta

My art is grounded in the belief in one universal energy which runs through everything from insect to man, from man to spectre, from spectre to plant, from plant to galaxy.

My works are the irrigation veins of this universal fluid. Through them ascend the ancestral sap, the original beliefs, the primordial accumulations, the unconscious thoughts that animate the world.

There is no past to redeem: there is the void, the orphanhood, the unbaptized earth of the beginning, the time that from within the earth looks upon us. There is above all the search for origin.

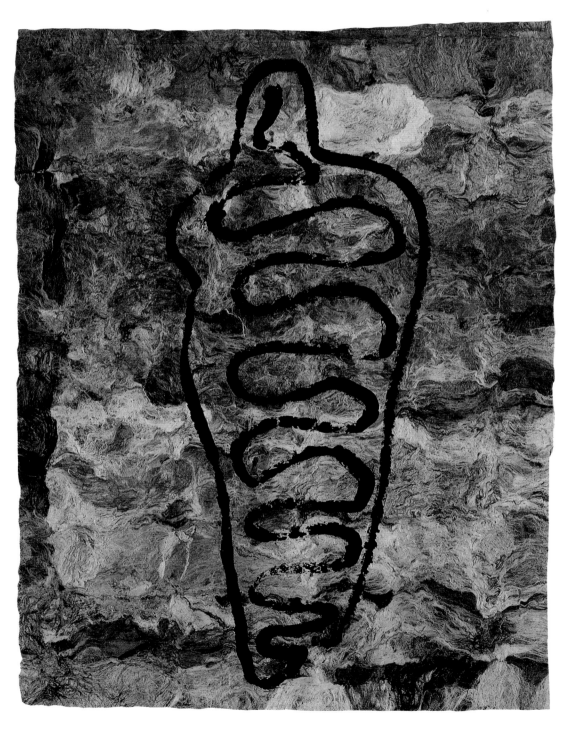

Untitled (Amategram Series), *ca. 1982, acrylic on amate (bark) paper, 16 x 11 in.*

Melissa Meyer

"We should talk less and draw more. Personally, I would like to renounce speech altogether and, like organic nature, communicate everything I have to say in sketches."
—GOETHE

This drawing went through many changes before arriving at its final configuration. As a result of these changes the surface is quite physical. I attempted to stretch the vocabulary of the black-and-white oil stick by giving the lines different weights and thicknesses, by putting light over dark, and by using slow and rapid lines. I see this drawing as a foundation, a skeleton—yet one capable of standing on its own, complete. It is a composite of some things I have been looking at: dance, the construction of a large building outside my studio, Japanese ukiyo-e prints, and certain of my own paintings.

To me drawing and painting are closely related activities, each feeding the other. I cannot imagine doing without either of them; they are both vitally necessary for me to "communicate everything I have to say."

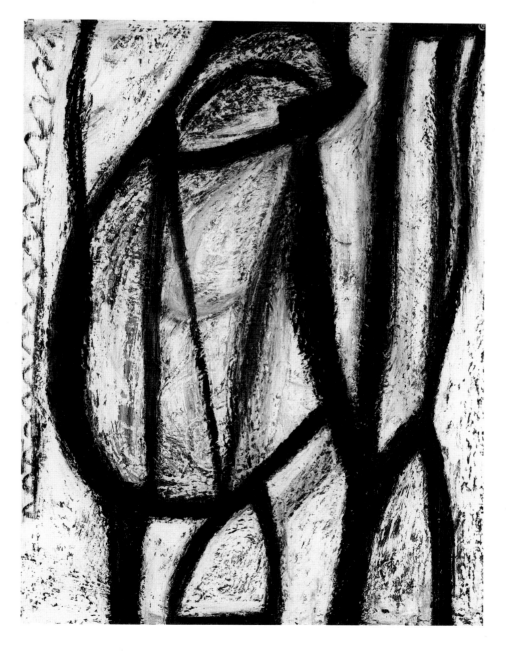

Untitled, 1988, *oil stick, 30 x 22½ in.*

Yong Soon Min

Susan Sontag wrote in one of her early essays ("Theater and Film" in *Styles of Radical Will*) that "art in all its forms . . . is first a mental act, a fact of consciousness." The drawing illustrated here is from a series that sought to accentuate this "mental act." The prominent presence of language (words) in these drawings creates a milieu of verbosity, a kind of thinking and pondering aloud. This suggested talkativeness is for the most part an internal self-reflexive dialogue among the elements in the drawing itself. It is a narrative of a timeless moment, of solitude and measured silences in the secluded ambience of a studio. It constitutes a moment before taking action, before becoming involved, before opening the windows and doors to the outside world. These drawings predate my coming out.

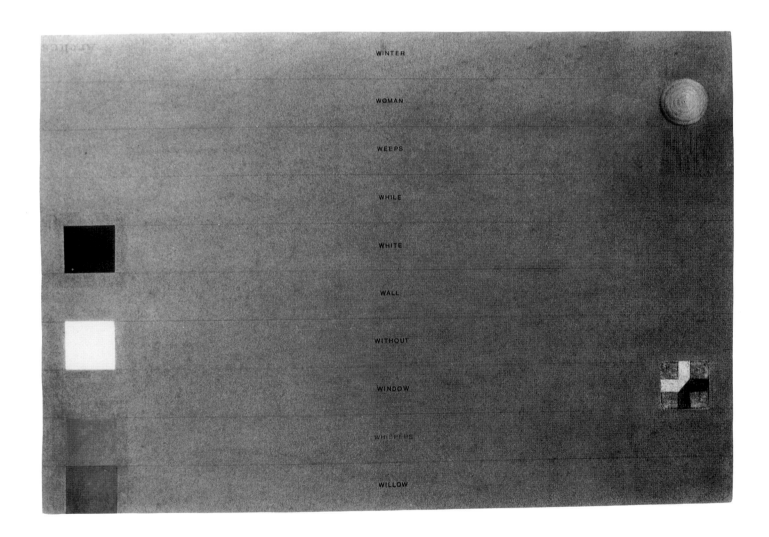

WINTER

WOMAN

WEEPS

WHILE

WHITE

WALL

WITHOUT

WINDOW

WHISPERS

WILLOW

While, 1980, mixed media, 20 x 28 in.

Mary Miss

Two of the strongest influences on me visually have been fortifications and gardens. I'm interested in the way each of these elements, although built with very different intentions, interacts with the landscape, and in a single piece I will draw freely from both sources. They're polar opposites but they're also related. *Field Rotation* [a site-specific sculpture located at Governors State University in Illinois—ED.] has the outline of a star-shaped fortified structure that's embedded in the ground. But while I was developing *Field Rotation* I was doing a lot of reading about early Persian gardens: what interested me was the kind

of protection and sense of enclosure they provide within a vast, open landscape. The landscape outside Chicago is similar: you're on the edge of the prairie and that open space makes you feel very vulnerable. So in a way a garden provides protection like a fortification does.

When I am looking at structures that interest me I am focusing on the experience I am seeing contained within them—the physical or emotional content. Its initial use is not my main concern. I *am* interested in the connection with the environment, the kind of physical connection that's taking place.

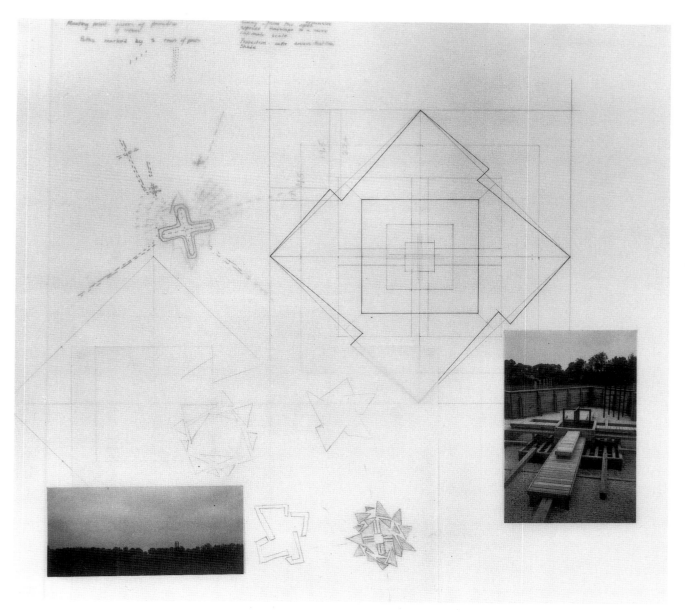

Study for "Field Rotation," *1981, pencil, colored pencil, ink, and photographs on vellum, 22¾ x 29 in.*

Joan Mitchell

I am very much influenced by nature as you define it. However, I do not necessarily distinguish it from "man-made" nature—a city is as strange as a tree.

My paintings are titled after they are finished. I paint from remembered landscapes that I carry with me—and remembered feelings of them, which of course become transformed. I could certainly never mirror nature. I would like more to paint what it leaves me with.

All art is subjective, is it not? I like to look out a window or first walk in it—nature—and then I paint, which is making something—an "object" and a rather "objective" activity.

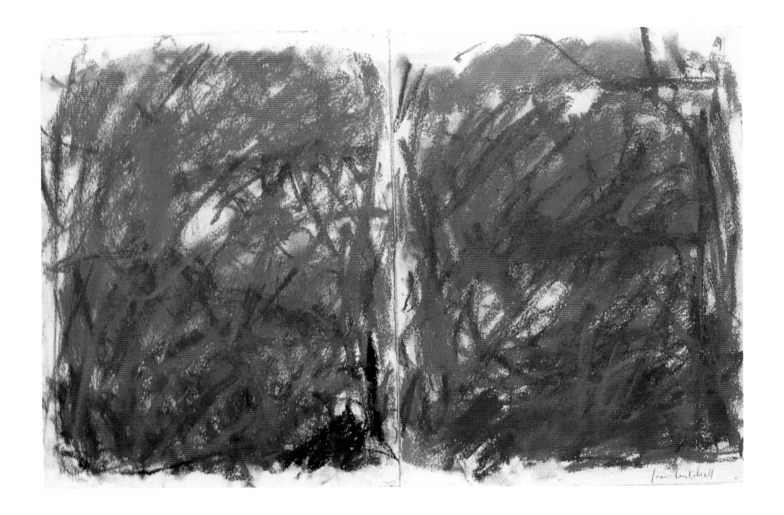

Untitled *(diptych), 1980, pastel, 15⅜ x 23 in.*

Ree Morton

Drawings based on the mating habits of lines—
 mating season
 the orgy
 psychic attraction between lines
is there an abstract voyeurism?

The world may be organized around a set of
focal points, or be broken into named regions,
or be linked by remembered routes. (Lynch)

Do a series of drawings
 Remembered routes
 Named regions

parting of the ways
stand in one's way
on the right road
around the bend
right of way
 right away

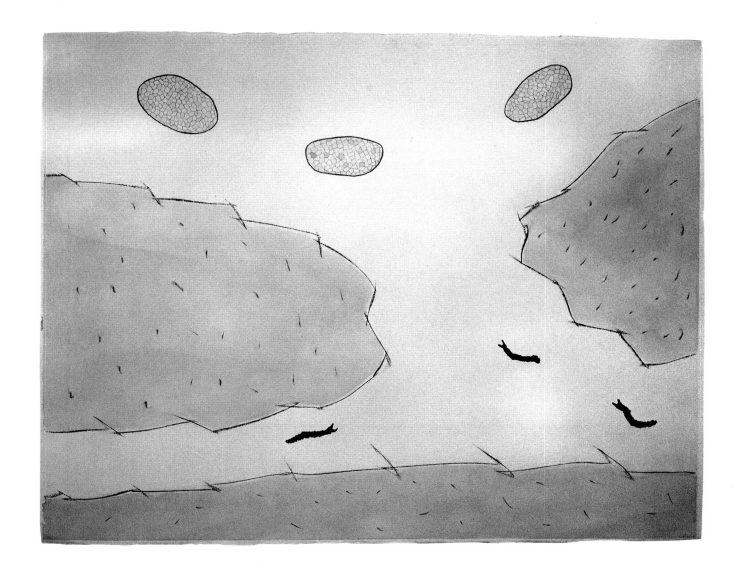

Line Series #3, 1974, crayon and watercolor, 22 x 30 in.

Judith Murray

Once begun, drawing is for me a seductive ritual.

I build a drawing in a linear way, a single line from start to finish, as if the drawing were complete with the first working lines, only needing a matter of concentrated time before the image completes itself. Another way to describe it is that quite often it seems the entire drawing process is about focusing. It begins with only vague and distant clues and shadows, then slowly, as if a lens were turning, the drawing comes into being.

By limiting my drawing materials to pencil and charcoal, I am able to concentrate on form, space, and light in a direct way, without having to consider the chemistry of painting and the multitude of possibilities that painting provides me. For example, I don't have to consider drying time, the surface weave, brushes, mixes, glazes, overpainting and underpainting. When I make a pencil drawing, I work with a range of grays allowed by the intensity control provided by different kinds of graphite. It is a process of evolution that develops as the feel of graphite to paper manipulates and describes the surface. This theater of surface is a microcosm where I lose myself to the drawing as it becomes vast, moving, liquid, and sensual.

And as with many rituals, the more the drawing is articulated, the greater sense of freedom I have in making it.

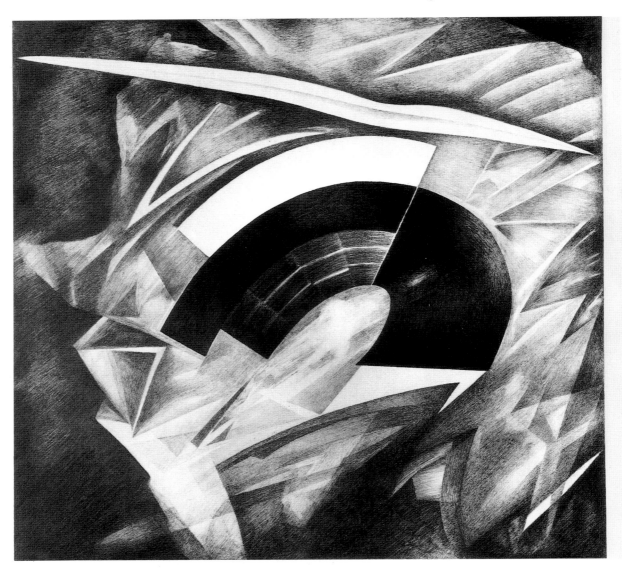

Obsidian, 1988, *pencil on Arches paper, 22½ x 30 in.*

Alice Neel

Like Chekhov, I am a collector of souls.

You know what happens to me often, after someone poses for me for a couple of hours? When they leave, if I'm in the apartment alone, I just feel awful because I have really been living in them. I feel like an untenanted apartment. I feel frightful, because I have exercised such empathy, that in a way, I leave myself and feel as though I have no self.

I don't know how I do it, I just do it. That's what I'm famous for, being able to see beneath the skin. It's a sort of psychological understanding. I think if I hadn't been an artist, I could have been a psychiatrist. But then I wouldn't have known what to tell them to do, but I don't think psychiatrists do either, do you?

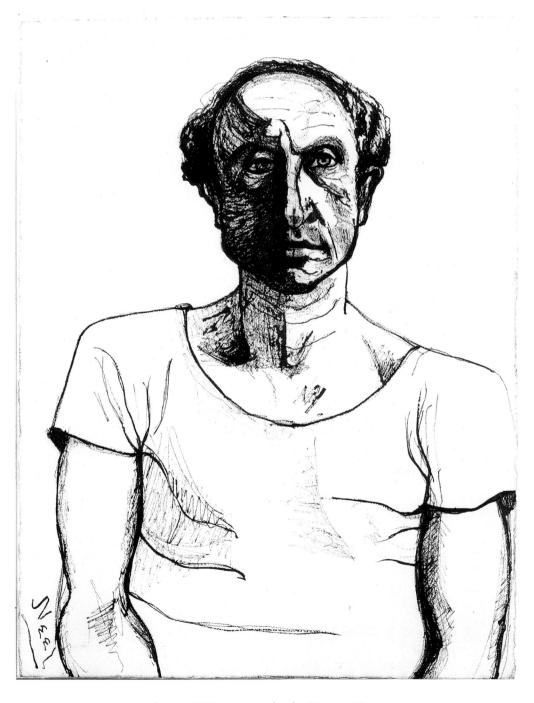

Sam, 1958, *pen and ink,* 29¼ x 22 in.

Terry Niedzialek

As a surrealist artist, I work with a concept translated through an understanding of the intrinsic qualities of medium and method. For me drawing is simply another vehicle to realize my concepts. Unlike all the other art forms in which I work—photography, mixed-media sculpture, hair montage—drawing plays a twofold purpose as a study and as a work that stands on its own. Hair montage is sculpture built on a person's head or wig with hair and other media such as clay, paint, Styrofoam forms, and hair gel. The idea for hair montage (given to me by artist Julius Vitali) was initially worked out in a series of drawings. Creating the first visual images with collaged photographed faces helped to clarify my vision of how to build a sculpture as an integral part of the human head. The emphasis changes from the drawing to the live hair montage as it enters the realm of performance art, incorporating sculpture, dance, and body art. The initial mental image was part of a landscape—this stemmed from the conceptual basis of the hair montage as an expression of oneness between people and earth. Drawing seemed the appropriate medium to realize this. The intent is to make one believe that the landscape on the head is part of the background rather than the foreground.

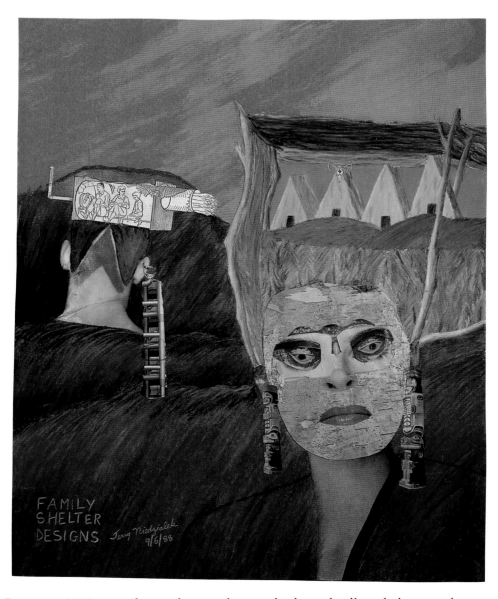

Family Shelter Designs, 1988, pencil, pastel, gouache, tree bark, and collaged photographs on paper, 22¼ x 18 in.

Helen Oji

I am compelled to translate my feelings primarily through painting and drawing. The gestures of image, color, texture, and material are all important components in evoking these feelings. A combination of many experiences—a daily event, a daydream, a shape, a memory, or just something I need to say visually—is involved. I think of images as being charged and activated as I work. What appeals to me is the concept of taking an image, animating it, transforming it, and then physically working the surface to create art with movement and a life of its own.

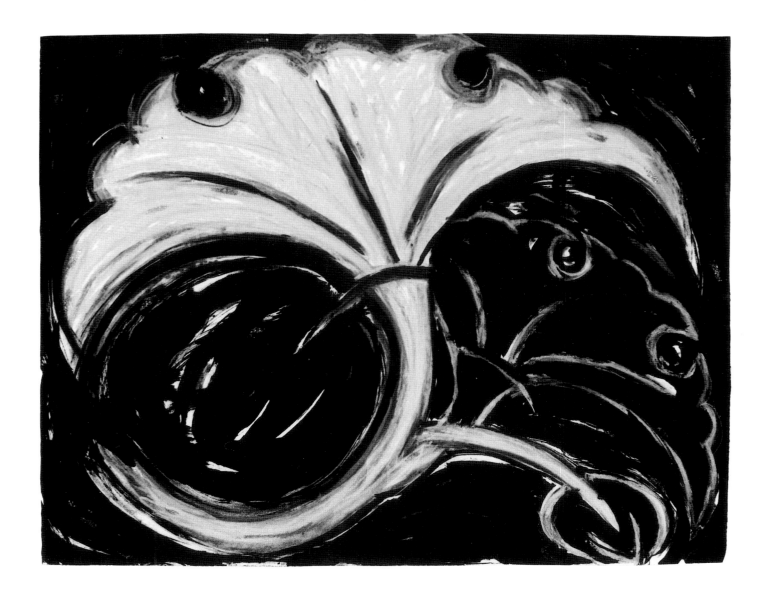

Fall Ginkgo, *1988, pastel and ink, 16 x 20 in.*

Beverly Pepper

The nature of drawing is one of immediacy. It clears my mind to find solutions, to affirm imagery; often it leads to undiscovered territory. As a result, it plays an enormous and ongoing role in my creative process. I draw on airplanes, in front of television, in restaurants. It's a way of keeping my pores open—of releasing ideas.

I sometimes intend a drawing to be just that and nothing more—neither a sketch, nor a search for ideas, but complete unto itself. This usually occurs between one body of work and another.

I also confess to a psychological problem—to a barrier between me and an expensive piece of paper. My sculptures and paintings cost far more than drawing paper, yet my approach to paper is much more reverent. Perhaps it's because once you've started there's no turning back—no overpainting or painting out—no recycling. There is permanence. I like the double-edged challenge.

Yet I also draw for the sheer pleasure of it, sometimes preliminary to sculpting, but not necessarily. Inevitably, I must do many working drawings—armatures for the plaster, rough sketches for fabrication, variations in ideas.

I tend to be a bit careless with my drawings. I lose them in drawers or notebooks. Sometimes I come upon them again years later. Often this brings a surprise that a current body of work in which I may be deeply involved has had its origins in earlier notebook sketches.

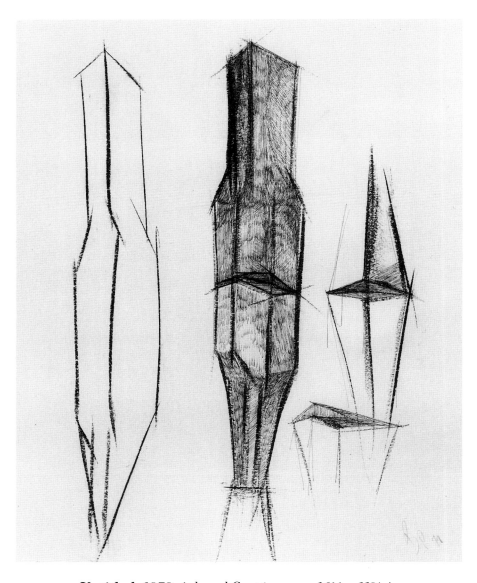

Untitled, *1979, ink and Conté crayon, 16½ x 11⅝ in.*

Judy Pfaff

The drawings are the first form—the first way of thinking and figuring out where I am going, what I am doing.

In the flat work I move more freely, in a way that I can rarely duplicate in the three-dimensional work.

It has taken a long time to recognize how much information is inside the drawings.

There is a shifting of dimensions. In the flat work I see three dimensions, yet in the three-dimensional pieces I visualize flat work.

Untitled, 1978, Con-Tact paper collage, 11 x 17 in.

Ellen Phelan

I'm a realist at heart.

When you play with dolls, you project your imagination onto them. As opposed to the material projected by a child, the material I was projecting was adult. It really had to do with emotional relationships between men and women, mothers and daughters, gender definition and how it comes about, the female sense of the self.

I didn't see any way to draw my academic skills into my work at first, so for years I didn't draw at all, in line with the whole Minimalist school, which was where I made my entrance into New York. You had to justify what you did—for years I made black, freestanding objects, because I couldn't justify color and line. The beginning of being free of that was in my landscape drawings. Now—maybe with Post Modernism—anything goes, absolutely. These drawings exist in the scale and format that I want them to exist in. I certainly don't want to make oil paintings of dolls.

Beth as Diva, 1986, watercolor, 19½ x 12½ in.

Howardena Pindell

In the early 1970s I started a series of works on paper that utilized pen-and-ink drawings of numbers on hand-punched papers, mounted with acrylic medium on graph paper. Making these works caused enough eyestrain to propel me back into painting on canvas. I had always been fascinated as a child by my father entering what appeared to me to be meaningless numbers in small notebooks. When we traveled, he made note of odometer readings to track distance. (One of his master's degrees is in statistics.) My fascination with his recording numbers during the family trips could have been an outlet and an attempt to focus my attention away from the fear and rage that I felt as we encountered segregation across the country at restaurants and motels. We often cooked our food over a kerosene stove in the woods in order to eat because we were turned away or not given service. We were refused accommodations, but I do not remember if we slept in the car. Although I stopped utilizing numbers on paper around 1975, I still use them in acetate overlays placed over a television screen and photographed for my Video Drawings series, which has continued off and on since 1973.

Parabia Text #5, *1974, pen and ink on punched paper, spray adhesive, powder, and thread on board, 9½ x 6¾ in.*

Jody Pinto

When we were children, my mother would tell us a story drawn on paper about a traveler lost in a snowstorm. The traveler would go this way and that, leaving a trail of confusing marks. Suddenly, recognizing where he was, he would rush to his destination. In his haste he would connect all of the lines revealing—a bird!

Drawing is a physical way of thinking. My drawings tend to be large in scale to accommodate gesture and the process of utilizing watercolor. Sometimes in areas as large as 5-by-9 feet, this medium is allowed to puddle, run, and seep. This process, in turn, brings the paper to life as it rises and settles, channeling the watercolor. The size and physicality of most of my work challenges the assumption that watercolor is only a small-scale, intimate medium. Color is often the catalyst for a situational structure in drawing. Body parts, their function and attendant language, also inspire forms. All these elements are included in the drawings, giving them gestural and informational content. Drawing is a bedrock for site-related work; it is done for projects real and imagined.

I use the word "drawing" because it is the gestural use of materials rather than the medium that gives the work its definition. Drawing has an existence of its own. It is done for pleasure —unfolding muscular thought, expanding, contracting, flexing. Neither chart nor script, it is an extraordinary journey of its own.

City of Lies, 1987, watercolor, gouache, and crayon, 20 x 20 in.

Rona Pondick

At first glance some of my sculptures appear to be random piles, but on closer examination they unfold slowly as formally drawn and shaped sculptures. Some pieces take the shape of sprawling forms on the floor or of thickly knotted pilings. I'm very concerned with weight, so it's important to me that gravity shows itself as a force in my work.

In my drawings forms can take on any shape and behave irrationally, because they don't have to respond logically to gravity the way sculptures do. A shape in a drawing doesn't have to hold itself up or really do anything structural in a physical sense. Drawing is open-ended and that freedom allows me to look for forms in an unencumbered way.

A few years ago big, black, weighty shapes started to appear in my drawings over and over again. I found the shapes highly suggestive psychologically, and they began to show up in my sculptures as dense, black, floppy pillows. Then the pillows turned into resting places for other forms of mine, and finally they evolved into beds.

I use drawing to scout out new territories for my sculpture.

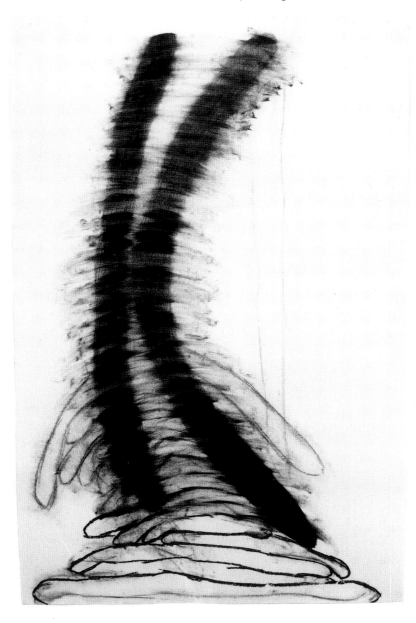

Untitled, 1986, charcoal, 39½ x 25¾ in.

Kristin Reed

No one taught me to draw. It was an activity that came naturally at an early age—spontaneous, emotional, instinctive. As the first knowledge about the world begins to accumulate, along with first moral notions, one's creative directions undergo change. As the educational process begins and you learn to read, write, and enrich your knowledge about yourself and the world around you, there begins a process of constant evolution in your art. You add technique and consciously develop a style and substance. Naturally, you absorb various influences from existing ideas, opinions, and conceptions, both intellectual and cultural. Every concept, principle, and ethic that inspires you is reflected in creative expression.

Where drawing was once a primary endeavor for me, it gradually became a way of mapping out ideas for later execution in color and texture. At a certain point, I became more concerned about expressing what I was thinking about rather than what I saw (or had seen) in front of me. In retrospect, I realize that this came about largely as the result of developing political ideas through analysis, reflection, and awareness of society. A synthesis began to occur among what I saw, what I thought, and what I had learned to do with materials. The instinctual drive toward visual and emotional expression was augmented by and inseparable from a personal commitment to struggle for social change.

Who Are the Terrorists? *1988, gouache, Krylon, and photocopy on bristol board, 17 x 26 in.*

Deborah Remington

Drawing for me is not an adjunct but rather a parallel to painting. It is always related to but never derived from ideas governing my painting. Therefore, it is really a separate art with a life and vitality of its own.

Whenever my work undergoes a drastic change, I turn to drawing for clarification. Exploration into unknown territory, working with new ideas, becomes more accessible through drawing. In 1984 my work started to change and evolve dramatically. At this point, I began the Euros series. These drawings were to have an enormous impact on the development of new paintings a year later.

The way drawing looks—the magic, the illusion, the surface—matters to me. The path the drawing takes is unexpected. Time is important in allowing careful exploration of many alternative solutions.

Paradoxes and juxtapositions interest me for their impact, excitement, and energy. In the Euros drawings these factors are embodied by a play of large, white areas against rougher, more animated ones and different kinds of line. The contradictions and absurdities result in unresolvable tensions.

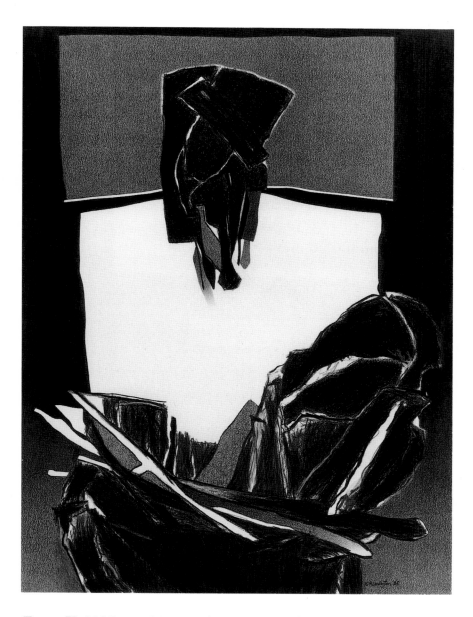

Euros X, *1985, graphite, acrylic, crayon, and mixed media, 30 x 22 in.*

Edda Renouf

You strike a match
There is a spark
There is energy, light
So it is with drawing

Drawing is to get close to the intensity from which the creative moment springs forth. This instant is sparklike, and the act of drawing reveals the energy of the spark on paper. Drawing lays bare the life, light, and energy of line and plane by marking, incising, scraping. It is to get to the essence of what line is with total directness.

Drawing makes visible the hidden, intimate qualities coming from the imagination, from thoughts, emotions, and focused looking at an object. Through drawing I learn to see in depth, to listen to the life of materials. There is a mixture of logical mathematical structures with the organic randomness of the media. As I draw, the means make me aware of archetypal forms, both structured and random. Materials speak to me, and unexpected things happen. It is from a silent conversation between materials and imagination, from intuitive listening, that the drawing is born.

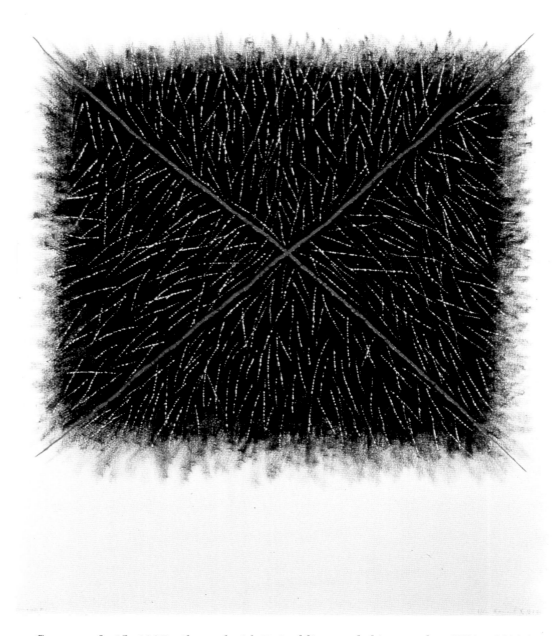

Crossroads #1, *1987, oil pastel with incised lines and china marker, 25½ x 22¼ in.*

Faith Ringgold

This is a drawing for the Echoes of Harlem Quilt. *It is the first quilt I ever made and the last collaboration I had with my mother, Willi Posey, who died in 1981.*

The quilt was our great work together. We had great gossip! We didn't do any kitchen-talking. I can't think of anything we didn't say.

I couldn't have done it alone. I needed my mother. And she would never have collaborated with anyone else. With me, she had a chance to go on being what she was—my mother.

She must have had a certain quilt in her head, maybe the one her grandmother had done. All "art people" have images in their heads, images that can't be put into shape easily. I didn't understand, then, that she had that kind of idea. Well, at the end we got the top done, and she lined it. Her eyes were filling then. She wanted big stitches and she took off on her own, stitching right across. I'm glad that at the end, I could feel free enough to say to her: Okay, yes, go ahead. *Do it your way.*

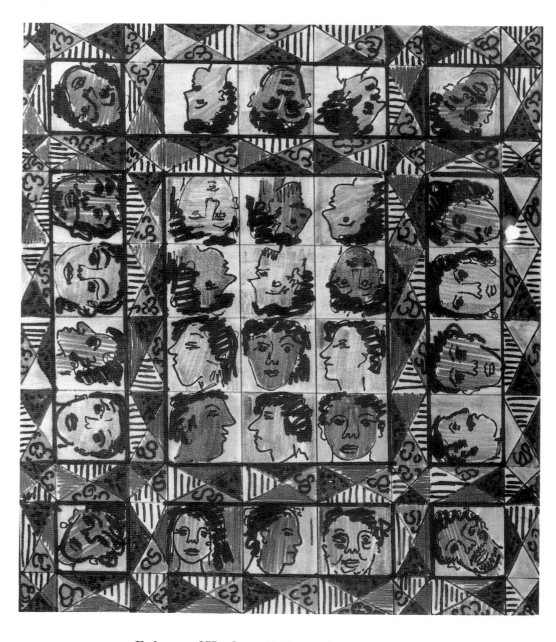

Echoes of Harlem, *1980, marker, 8½ x 7½ in.*

Sophie Rivera

The feeling of black lead moving against white paper has always been a sensuous experience. Reproducing an image exciting to my imagination has been crucial for the development of my artistic sensibility. Gradations of light, the interplay of form and color, and the nexus of line and space have always intrigued me.

Drawing is a method of integrating personal fantasy and reality into an amalgam of idea and form. The act of taking what I see in life and transmuting it to the size of a page has always been an emotional and intellectual challenge. Creating colors and shapes from my imagination and sharing that experience with others is gratifying. It is almost as though while drawing one is transported to a child's world with the discipline and technique of an adult.

Drawing is connected in many ways to my other major area of artistic endeavor—photography. These two art forms have similarities; some might say they are symbiotic. The rigid discipline and technique required for drawing is crucial for success in photography. Notwithstanding the connections of the two fields, they eventually diverge into their own relatively independent areas of cognition.

Electra, 1970s, charcoal, 24 x 20 in.

Dorothea Rockburne

Personally, as part of my creative process, I always title a work *before* I make it. Then from the outset I know exactly what it is. Next I research it and I feel it and I put everything I have into making it. I try to work with inspiration, intuition, knowledge, and magic. It is a journey, inward and outward. Deeply personal and yet sharing a commonality—and when I am through, there is a painting or drawing, an object with dimension, and yet the real object is the experience I have gained in making the piece. A work of art itself is a kind of residue.

Haloed Angel, Dome, 1983, watercolor on vellum, 18 x 24 in.

Miriam Schapiro

This is a work of art in which a literal examination and surgery are taking place. As the artist, I see this as a metaphor for my examination of the world around me, beside me, and in back of me. Not only does a George Grosz cinematically appear in the work, but also a hint of a part of a bowl from an African society. All of the images are united by a maelstrom of black ink, which reinforces the black-and-white tones of the piece. It also provides a chaotic matrix for the images, reminding us that historical events, as they take their place, meld into and unify memory.

It is strange to see a woman performing surgery with the instruction book open at her side. It is also strange to see depressed Germans being marched off. At the same time, it is delightful to see the art of Africa delicately poised in the darkest, grimmest setting. A geometrical figure encloses the ghastly view of the woman performing the operation, as if to isolate and heighten life's anomalies. At the same time other unrelated experiences occur in the collage of randomness, beauty, danger, and tragedy that makes up history.

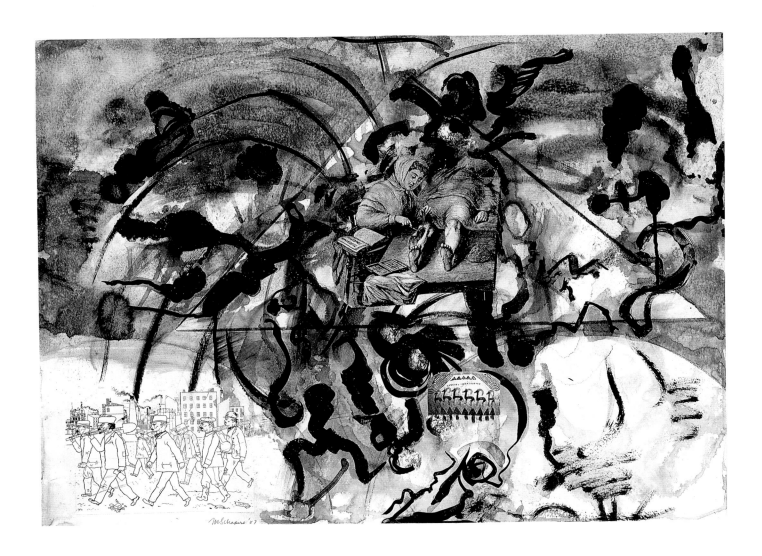

Purpose and Examination, 1987, india ink and photocopy collage, 22 x 30 in.

Maria Scotti

To write about drawing seems ironically convoluted.

Drawing is a primal act, a natural result of human anatomy. It is a simple act, direct and technically unevolved. It is elemental, instinctive, universal.

It is drawing that formed the characters that make up these words. Drawing needs neither translation nor illustration. From the first lines scratched on stone or traced in the sand, to the symbols used in chemistry or mathematics, drawing remains the clearest way to communicate. Communication, though an intrinsic result of drawing, is not necessarily its purpose.

Drawing is the visual manifestation of thought, conscious and unconscious, and as such is individual, unspoken, and introspective. Drawing reflects, with the simplest means, what man is, what he feels and dreams and knows and half-knows and doesn't know. Drawing can be as unfinished as man himself.

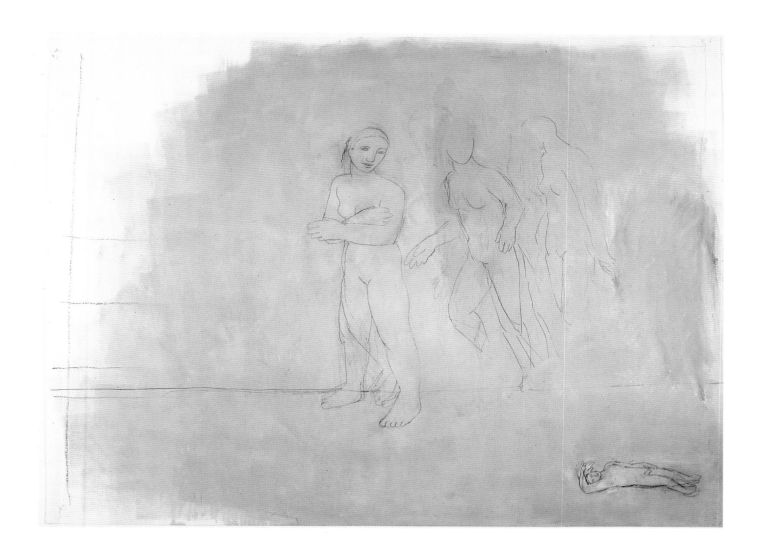

Not Titled, 1987, charcoal pencil, pastel, and oil stick on buff rag paper, 22½ x 30⅛ in.

Carole Seborovski

Paper is an extremely manageable material that can be easily folded, cut, torn, bent, glued, and collaged. Its most endearing characteristic is its unassuming quality. Fabriano Roma is a paper I often choose for its subtle tones and texture. The feathered edges are cut sharply and are squared so that the rectangle is readily readable. Generally, I have greater control when the scale of my work does not exceed the length of my arms. Charcoal is frequently used as a tool to mark; it is hand held and easily erased.

I am involved with the adding and taking away of form—the goal being to find order through disorder. The origin of the work, its process and eventual completion depend on a mental dialogue existing between the intellect and intuition. This associative process allows me to go past any rigid plan, making it possible for a drawing to emerge through the course of working.

Drawing is a thing unto itself. It is not a sketch for a sculpture or painting, nor is it an illustration of a preconceived idea. Drawing embodies a series of decisions both logical and illogical; it functions as an act bringing these seemingly chaotic decisions into a composed state of being.

Art is about life, yet it is different from life because it slows the constantly shifting realities of our world. Therefore, art allows us to experience life and grasp meaning by virtue of its stillness.

Layers and Weave of Drawing, 1985–88, *charcoal and ink on Inomachi paper, 14⅞ x 9¼ in.*

Katie Seiden

Drawing expresses the energy and vitality that explode out of my sculpture. The geometric edges and the rectangular form set strict boundaries. Within the deliberate space of my drawings, distorted and exaggerated shapes burst up and out of the page. It is impossible to stay confined within a flat surface. Heavy, dense, black tar escapes and accretes on the dry, white, pristine paper. The tar acts as a container for different objects—plastic pigs, sheep, tigers, and lions; nails and tacks, brads and screws. Animals swirl in the tar, attempting to climb out and escape. The brilliant shiny surface of lead paint adds reflective pools of luminosity.

The drawings symbolize the ideas and obsessions in my sculpture. Industrial materials, hardware, toys, thrown-away parts—all can be reused. I use drawing to create new explorations and extensions of the visual forms that compel me. Drawings are the challenge and solution involved in working out a rebellious three-dimensional commitment within a rigid two-dimensional cage.

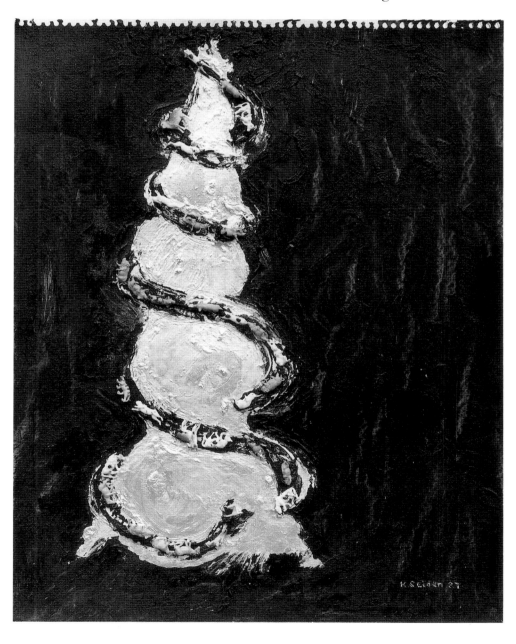

Ascent of the Pigs, 1987, tar, lead paint, and plastic animals, 26½ x 21 x 1½ in.

Joan Semmel

Drawing for me has been a way of visualizing and conceptualizing an idea for painting. My attachment to mark making for its own sake is minimal; however, the greater freedom offered by the format to play, superimpose, collage, and experiment in mixed media has opened up new realms in painting. Photography in certain ways has served me as a form of sketching—a way of quickly and immediately capturing an image. I then transform that image through color Xeroxes. By incorporating those Xeroxes directly into the crayon drawing, I can examine various coding systems and place the mark of the hand alongside the mechanical mark, providing an interesting kind of dislocation. The juxtapositions of gesture and illusion, the mechanical and the manual, shifting scale and focus have opened possibilities for different realities to jostle each other and have provided an enlargement and enhancement of my content. Thus, drawing has been an integral part of my way of searching out new directions and often contains that original excitement of new discovery so essential for an artist to cultivate continually.

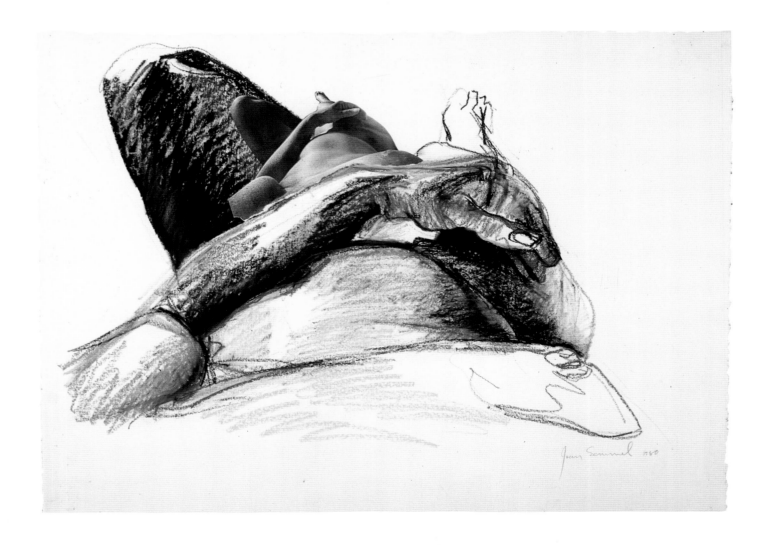

Variations, 1980, oil crayon and color Xerox collage, 22 x 30 in.

Judith Shea

There are many phases of art making, and for me drawing is one that fulfills some of the most important roles. First, it is contemplative, and then it is pleasurable. These two together allow thoughts to run and flow in a jumble, in a rush, and to settle into a steady stream. This good thinking time is probably the most valuable—and unpredictable—of all an artist's activities. It is akin to dream time: thoroughly refreshing, totally creative, potentially upsetting.

The second role drawing plays in my own case is to help me focus on new works I want to make after this great deluge of ideas. I have always kept sketchbooks, but with no pressure to finish an idea—only to record one passing. So more formalized or finished drawings are an in-

termediate stage of working. All my drawings are thought through as potential sculptures and thus require some of the same consideration of practical three-dimensional problems. They get worked and reworked. This kind of drawing helps me to clarify unspecific ideas for new work. It is actually the starting point of a body of work.

Recently I have enjoyed drawing so much that I have gotten trapped into wanting to create a piece just like a drawing I love. But materials other than paper and pencil have their own mind, and some ideas will not happen three-dimensionally. This is not so different from getting caught up in any other unreachable desire. So drawing remains the start but not an absolute for the development of my sculpture.

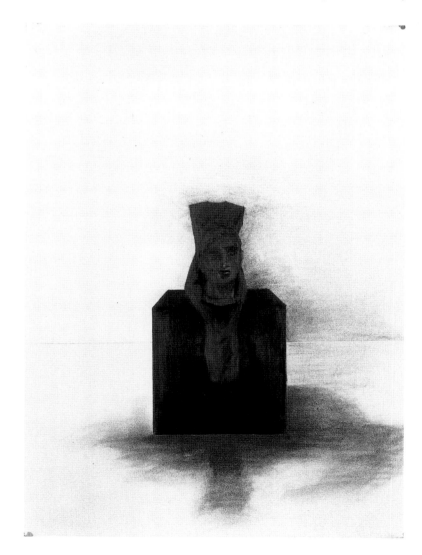

Untitled (Study for "Between Thought and Feeling"), *1988, graphite and colored pencil, 26 x 19 in.*

Maura Sheehan

PICTURE A HURRICANE

Ideas are twisters, with winds racing over two hundred miles an hour. Like a bulldozer leveling obstacles in its path, an idea can invade a city, strip it bare, leave it clean and level enough to serve as an airport.

Ideas are also tidal waves, earthquakes, cyclones, and typhoons. Spinning like tops in a constellation of context and capability.

Oh, but drawing, drawing is what happens in the eye of the hurricane. A calm within the storm of ideas, where concepts are committed to the two-dimensional before returning to the whirling currents of thought or being translated into the three-dimensional.

Drawing is tracking a twister by radar. Like a blueprint that establishes a past and is brimming with promise.

Drawing is the aftershock of an earthquake of an idea. Drawing with its mad orgy of line, dark density of a mob scene, apocalyptic erasure!

3 Gorgons, 1988, pencil, three hinged panels, 21 x 39½ x 4 in. folded, 35 x 72 x 4 in. extended

Hollis Sigler

Drawings for me are like visual diaries. When I draw I'm having a necessary dialogue with myself. Sometimes the drawings are more successful than my paintings at getting to the point. As an activity, they are so spontaneous and short-lived (I usually complete a drawing in one sitting) that I can better sustain my thoughts and feelings.

About ten years ago, via drawing, I discovered my present manner of visual expression. Through use of the simple means of drawing, I found I could abandon technique for spontaneity.

The result allowed emotional content to become all-important. My paintings evolved directly from this experience.

Paintings are precious to me because of the time involved and the materials used. Drawings are precious because of their immediacy. In my mind I have tried to break down the traditional hierarchy placing painting over drawing. In my work I actually handle media of the two disciplines similarly, as I create a light source and completely cover the ground.

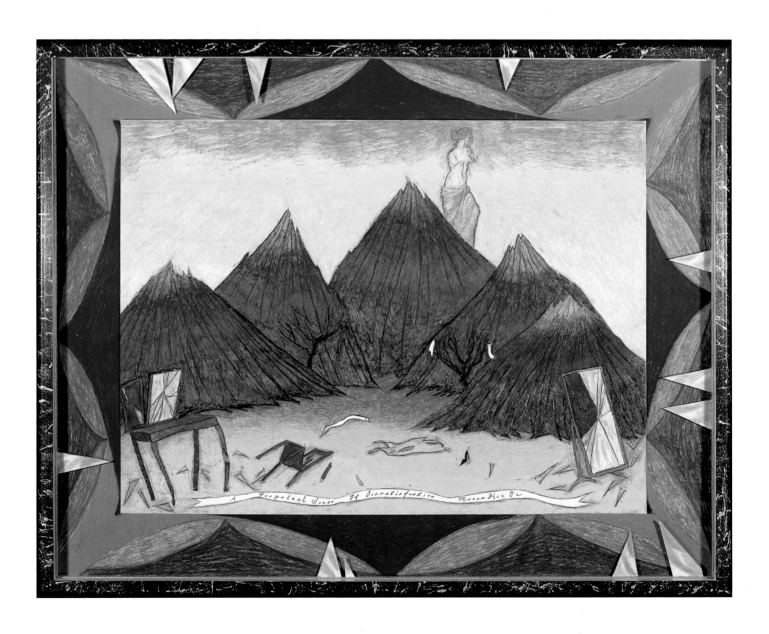

A Perpetual Sense of Dissatisfaction Moves Her On, 1988, *oil pastel, 25½ x 30¾ in. with painted frame*

Sandy Skoglund

The best thing about drawing is that it is fast. I mean the kind of drawing that comes straight out of your head. It often lacks self-consciousness and can give you a direct line to ideas. Sketching in this way is a form of conversation.

As a kid, I drew all over things: the headboard of my bed, my toys, tools, notebooks, and the various school desks I occupied. These drawings were renditions of popular characters from television and comic books. My favorite was Princess Summer-Fall-Winter-Spring on the Howdy Doody show.

It was all so much fun, pretending. The work of remembering and forgetting is so easily done with a few lines on a piece of paper. I am still struck by the thrill of forgetfulness and the pleasure of the pencil as it moves against a surface.

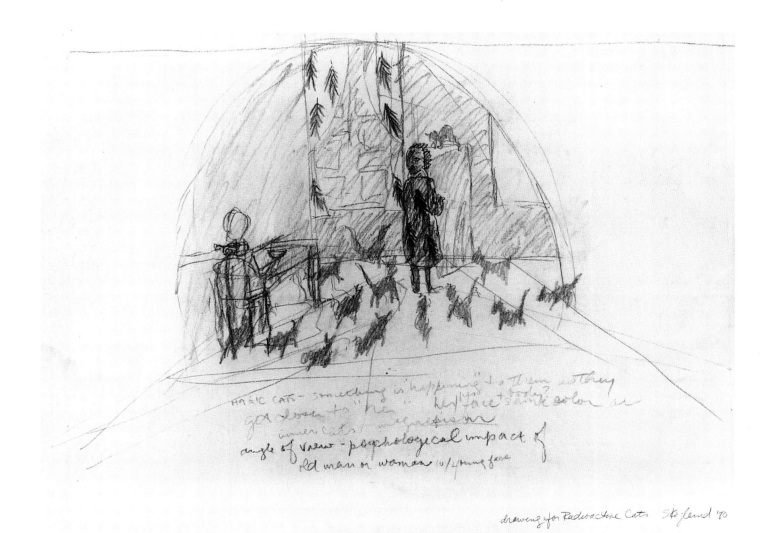

Drawing for "Radioactive Cats," 1980, *colored pencil, 18 x 24 in.*

Sylvia Sleigh

The drawing of Philip Golub reclining is a study for the shepherd in my painting *The Court of Pan* (1973, after Luca Signorelli). Philip Golub was my favorite model for at least two years, and I made numerous paintings and drawings of him until he went to Paris to live. He appears three times in *The Court of Pan,* as Pan himself, as Giuliano de' Medici, and as a shepherd. He is the son of Nancy Spero and Leon Golub. In the AIR Gallery catalogue for my exhibition that included *The Court of Pan,* Leon Golub, writing as "the father of the model," commented on my triple portrait of his son that it showed "three views of mortality and abundance." I hope these qualities are indicated in this drawing.

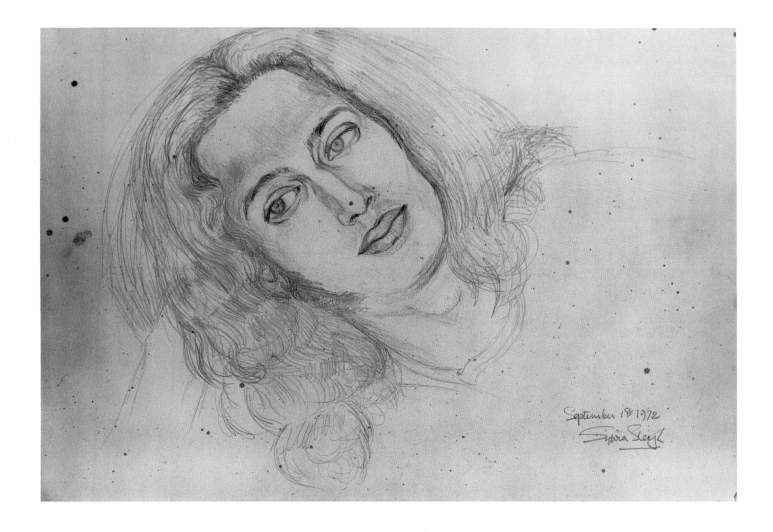

Head of Philip Golub Reclining (Study for "The Court of Pan"), *1972, pencil, 14¾ x 21 in.*
Collection Philip Golub

Jaune Quick-to-See Smith

My work consistently deals with inhabited landscape. Animals, people, and other figures narrate my drawings—not in a complete story, but more like a stream of consciousness. I use a mixture of identifiable images and images left to the viewer's imagination—a collage of sorts.

Like other Native peoples, I was raised in very rural places. I came to regard the land as a living entity, along with the inhabitants upon it. Therefore, embellishing it with movement and populating it with life's annotations seem to be the only way to express my idea of landscape.

Somewhat autobiographical, my work usually includes daily events, my animal companions—my horse, my dogs, etc.—as well as places I've been, especially the western United States and my reservation. Though it draws on Euro-American art history in execution, my work represents a particularly indigenous viewpoint in synthesizing nature and mind.

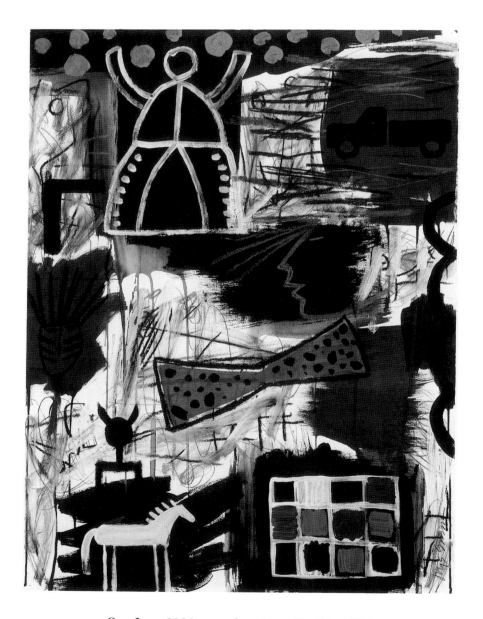

Cowboy, 1988, pastel and acrylic, 30 x 22 in.

Joan Snyder

I think about drawing and realize that for me it is really only a means to an end. I draw to make studies of paintings, to make lists of ideas, materials, and colors, to talk to myself.

I rarely think of a drawing as something that will be displayed. My drawings are the skeletons upon which I plan to add muscle and flesh. But sometimes, because pencil and paper doesn't keep my interest for too long, I add more and more to the simple drawing and it turns into a painting on paper. The drawings, done quickly, roughly, al-most unconsciously, can and frequently do precede my painting ideas by two or three years.

My most important and serious drawings have all been done on small scraps of paper or in small drawing books—little rough jewels that need time to sit around my studio and ferment. The process of making images is always going on on several levels at once, and I know it is important for me to keep scribbling because in a few years those will be the ideas ready to become paintings.

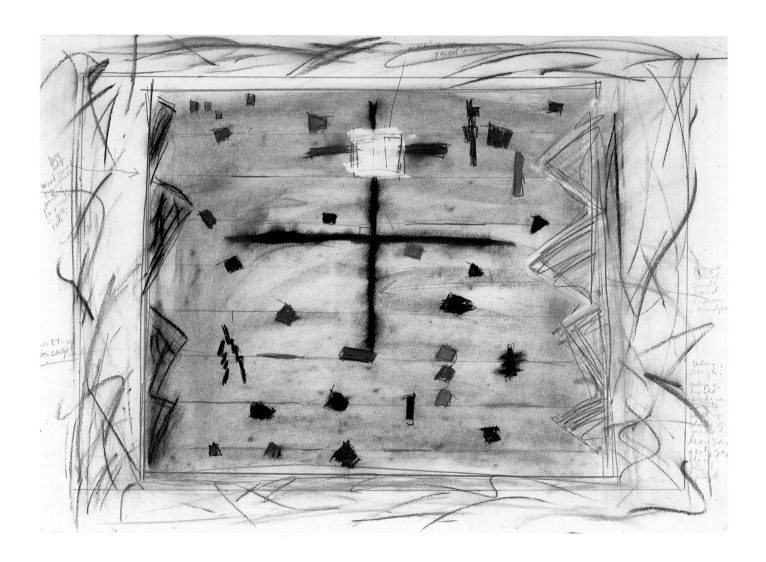

Study for a Grey Painting, *1985, charcoal, pencil, and pastel, 22 x 30 in.*

Kit-Yin Snyder

I approach my drawings in two ways: I use them to document my installations, which are mostly temporary, and I present them as pictorial images when proposing projects. This means that my drawings function either as documentation or as proposals for three-dimensional works.

Early on, I decided that my drawings not only had to be informational, but that they had to stand on their own artistic merit as drawings. I also wanted them to reflect, to some extent, my sculpture. So the method I eventually adopted was to color the paper in neutral dark tones, such as greys or earth colors. On these layers of evenly colored surfaces I would very carefully draw the sculptural forms with silver pencil. I also decided

then that the most accurate way to record my work was to present my ideas axiometrically. This technique of drawing, curiously enough, was what I had learned as an engineering student. And, coincidentally, because of my Chinese background this way of presenting my three-dimensional works seems most natural. Historically, this has always been the way Chinese artists have represented architectural elements in their paintings.

As part of my drawings, I would, just like an architect, include scale and materials for construction and, sometimes, the site. Theoretically, anyone could use the drawing to construct my sculpture at a specific site with the specified materials.

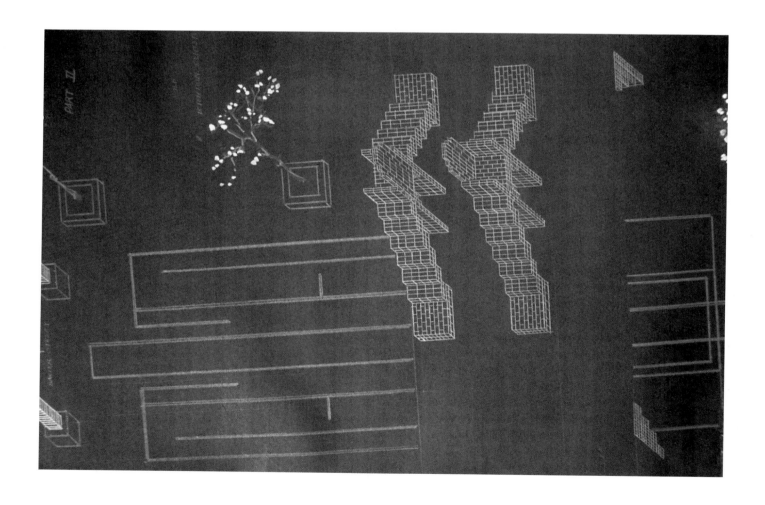

"Solomon's Throne" Proposal, 1985, *silver pencil and gouache, 22 x 30 in.*

Helen Soreff

At times I have preferred drawings to paintings. The immediacy and insight into captured space or held time, a sense of "being held there," can become engraved in my consciousness much like distinctive handwriting. My drawings are entities unto themselves; they are separate from my paintings. Many artists' paintings are generated from their drawings, but for me the paintings are springboards for my drawings. I view paintings as whole universes, but drawings more as exquisite, agonized, or reckless moments.

Once when I invited an artist over to see my paintings, he said, "The surfaces are not all the same," as though he were looking for a universal consistency. Then when he looked at one of the works on paper, he observed, "What a mark will do . . . ," focusing more on individual gesture. The commonly held distinction between painting and drawing is that the former is a more serious, comprehensive, and in-depth experience. I never thought this was true or necessarily relevant. For art to become a viable part of our culture, I feel the separation between viewer and artist must be narrowed through the participation that drawing invites.

Inbound Out, *1987, graphite on off-white paper, 29¾ x 22 in.*

Nancy Spero

DRAWING A PRETTY PICTURE
OR
A DRAWING MANIFESTO FOR ARTISTS

I don't want to draw a bleak picture, but I am drawn apart by the specter of the future as this twentieth century is drawing to a close with world leaders drawing distinctions about criteria for war or peace.

The time is drawing near, drawing closer to the apocalypse, and we are drawing away from reality, drawing toward extinction.

We all must not be drawn in or aside, drawing blinds across our eyes, but be drawn out of ourselves, all drawing together, drawing strength in unity of purpose. Let's not draw a dirty picture, let's draw a pretty one!

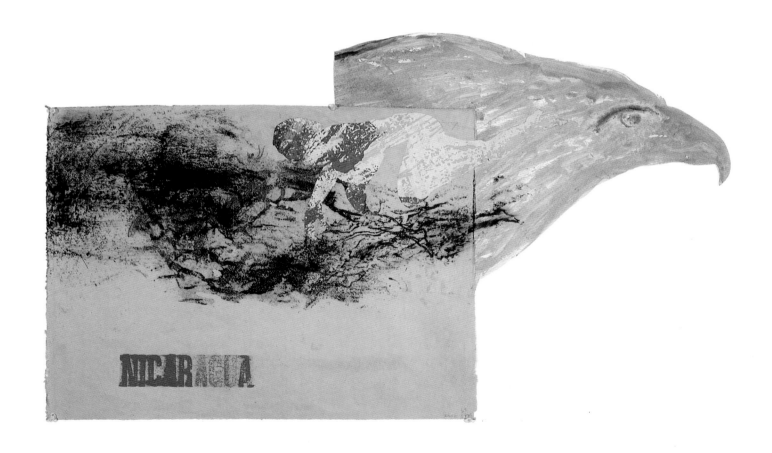

Nicaragua, 1985, painted collage and hand-printing, 24 x 34 in.

May Stevens

Between a line and a smudge lies a bridge-able gap, a shift of the eye. A line is a trajectory; too close or too far, too slow or too fast, it's a smudge and a blur. A smudge is a trace of what was or is to come. But a line is here.

· · ·

I draw in all my paintings and collages, but sometimes it gets buried. It's hard for me to separate drawing from all the other parts. I would rather use drawing as a part of the world I'm creating, the way in the real world it is only a part of the density of things. But sometimes a line alone can break your heart—and you have to leave it.

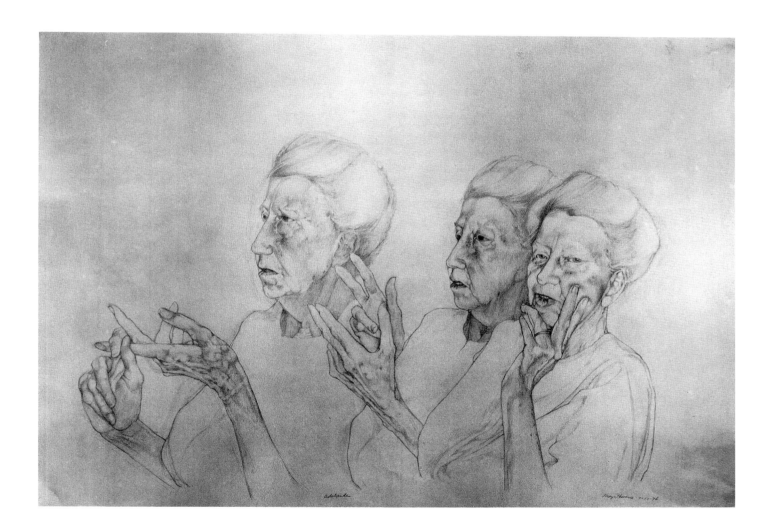

Adelaide, 1976, pencil, 29½ x 40 in.

Lawre Stone

We live in a world where theoretical particles are measured and manipulated in an imaginary space. We readily accept the realities of genetic engineering and artificial hearts.

I think that our idea of Nature must evolve to include the technology that we live so closely with. The engine, the microchip, the missile, and the clone must all be a part of Nature if we are to recognize them as significant forces in our culture.

The objects that I draw refer to this New Nature. They are our cultural artifacts, positioned in the random, fluctuating space of theory. Their systems abut and circulate, resisting reason.

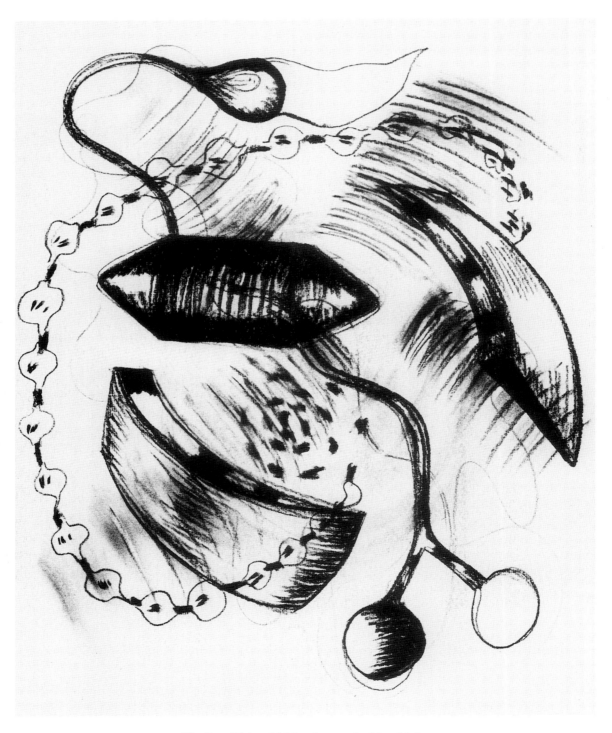

Turbo-Chip, 1988, charcoal, 23 x 19 in.

Marjorie Strider

Although I am primarily a sculptor, drawing has always been important to me. Drawing has been a place to work out ideas, to make sketches for sculpture, and to immerse myself in the sheer enjoyment of drawing.

Up to this point in my life, I have never started a sculpture without a preliminary, sometimes exceedingly detailed drawing. However, my work has changed radically within the last year. My sculptures are now formed from visions straight from my subconscious, and I begin work on them directly with no preliminary drawing. I am afraid that a drawing would reduce the immediacy of forms and perhaps taint them with learned preconceptions. So for the first time in my life, I am not making drawings. What a strange feeling!

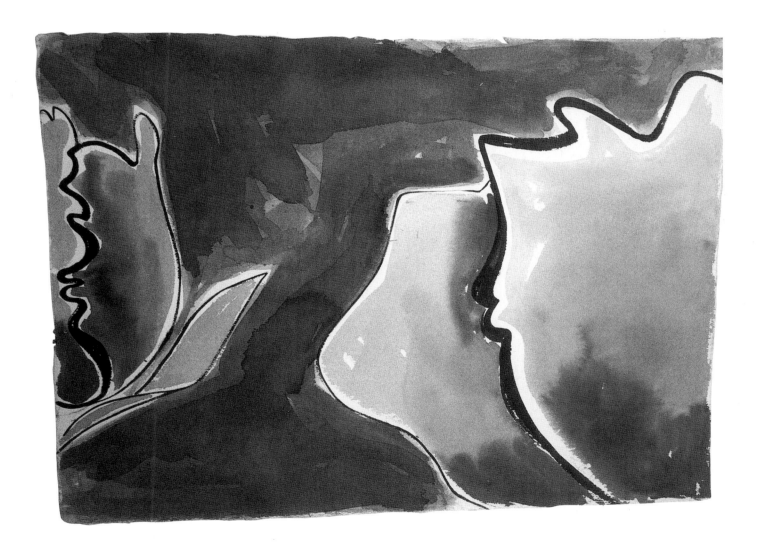

Tulip, 1986, *watercolor, 22 x 30 in.*

Michelle Stuart

Malakut: The Makān Series

The Sufi concept of "place" or *Makān* is composed of both the container (*jism*) and the contained (*rūh*, or spirit). It does not have a tangible existence, but exists in the consciousness of the beholder, who visually perceives physical boundaries while his intellect perceives the spirit as contained and defined within the boundaries.

Malakut: The Spiritual World

Makān is, I feel, finding that one's body and mind are together experiencing something close to amorousness in being unified with a certain place or space at a certain time. Spatial boundaries, or the lack of them, are in perfect harmony with one's body and at the same time with the universe, for the union is not with matter alone, it is . . . it must be . . . with the spirit as well. A sense of cosmic unity is created.

The series of drawings that I call Makān was motivated by such an experience, before I even learned that it had a name. I needed to recapture visually the essence of that experience, which took place during a voyage throughout southern Morocco in the spring of 1982.

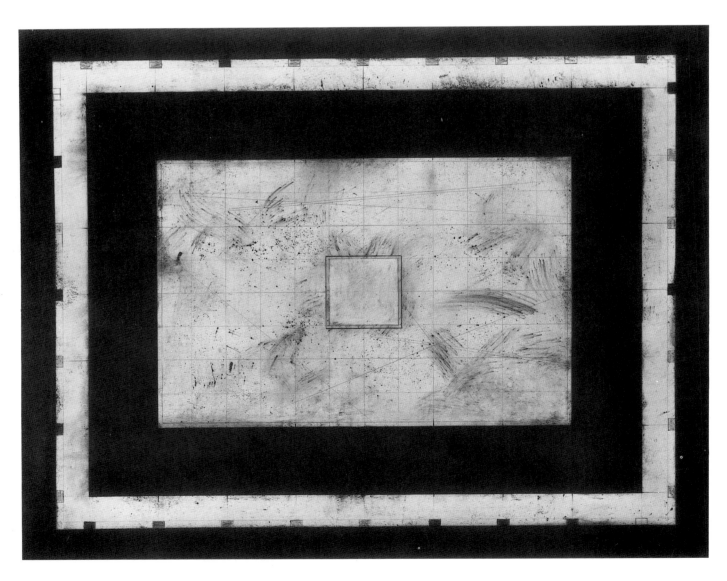

Malakut: Makān Series, *1982, graphite on muslin-mounted rag paper, 24 x 30 in.*

138

Vicki Teague-Cooper

I am concerned with extremes—darkness and light, destruction and survival, strength and vulnerability, seduction and fear—and how these opposites always occupy the same space in a symbiotic unity that would seem to deny their separateness.

In my work I am interested in creating an atmosphere in which to experience an almost preverbal recognition, a primal memory. I work to find a visual code recognized by that part of our mind that remembers instinctive ritual. The solitary androgynous figure is the center of gravity in an evolving landscape of recurring elemental symbols—trees, rocks, water, fire, etc. These are the sources of our greatest fears and desires, the signifiers of original mystery.

Drawing is an early form of magic, evidenced by cave drawings. Drawing is one of our earliest rites, and when we draw we are connected to our past—it gives us origin.

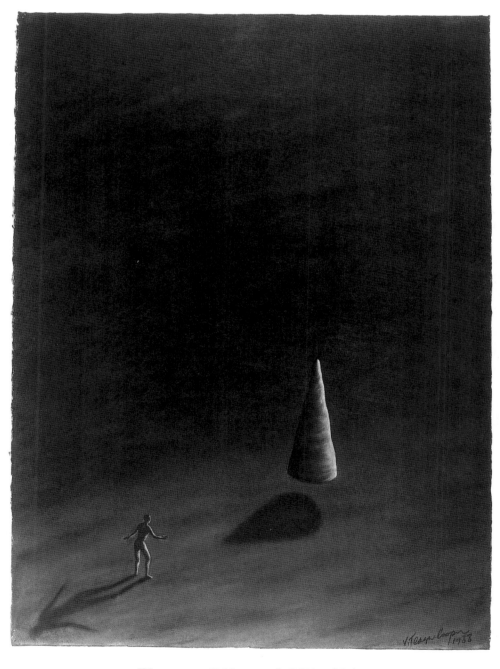

Phantom, 1988, pastel, 30¼ x 22 in.

Gillian Theobald

The images in my work are a byproduct of questioning what we know rather than what we perceive. Since 1983 I have been doing paintings of events involving fire and water in an imagined landscape. I have also been involved in an ongoing project (Diary), which is an evolving installation of hundreds of self-portraits (all but the first fifty have been done without the use of a mirror).

Both the landscapes and the self-portraits are an outgrowth of a meditative process of self-definition through increasing focus, wherein the pieces distill down to their most essential elements. So the work has little to do with landscape per se or my own appearance. It is more about the process of inner focus and abstraction than about the traditions of landscape painting and portraiture.

This piece involves two of several entries from Diary done during a week in May 1988. Each is an outgrowth of simply sitting with myself and paper and drawing a sense of self differentiated from a self I see. I have always been strongly aware of the parallel evolution and connection of the landscape and self-portrait work. They both question: Is outer experience a mirror of inner experience? Is the perceived affected by the perceiver? Can we step back and look beyond perception to the simplicity of that which is known?

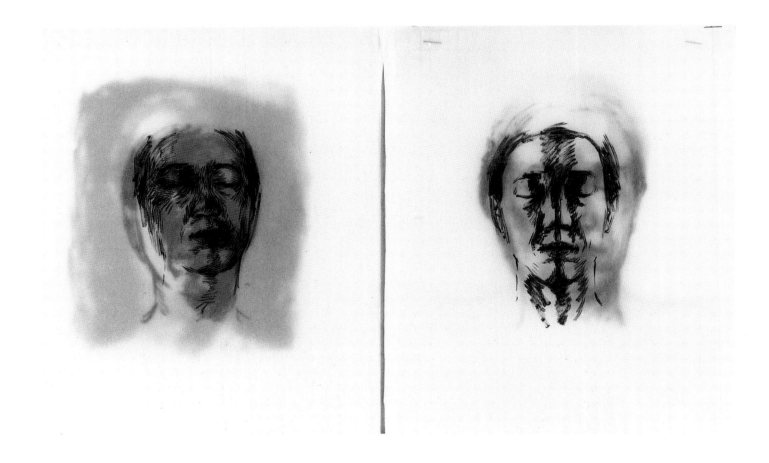

Self-Portraits in Meditation (Six Entries from Diary Project), 1988, pencil and ink, 13 x 20 in.

Betty Tompkins

Four years ago I began a series of works on the equality between animals and humans and the interchangeability of their situations and features. It has evolved into a depiction of the disintegration and rebuilding of culture. There is a history in mythology and religion of using animal symbolism and anthropomorphism to explain facets of the human psyche and mysterious forces of nature. Through ritualistic projection onto animals, people are given some emotional distance from the unexplained, which acquires a comfort-ing structure. Naturally enough, these pieces brought me to Greek and Roman mythology and subsequently to Greek and Roman sculpture and architecture. My current work includes scenes of classical statues and animals (dogs, deer, swans, etc.) in lush, overgrown forest or garden clearings. Sometimes there are architectural fragments. In some of the pieces the statues have an animated role and interact with the animals. In others they are more static, and the animals are present as attending cultural guardians or observers.

East/West, 1988, oil crayon, 30 x 22½ in.

Gladys Triana

My drawings are born from cultural influences found in the aesthetic expression of all aspects of human feelings. They are realistic in form, linear in character, but nonobjective and dramatic. The motion of the theme emerges, always following the descriptive exaltation of movement. With repetition of line, I attempt to define and synthesize successive stages of movement.

The force of cadence separates and fragments the image in a context that it did not have in reality but that is realized through distortion.

Centered in a variety of physical sensations, the major inspiration comes from a spiritual evocation of sound. Music has had a deep influence on the rhythm of the line and the shade of the dry brush. It creates the spontaneity of the hand gesture, revealing internal and external visions.

Keeping in mind Bergson's enigmatic axiom, "To perceive is . . . nothing more than an opportunity to remember," my imagery is the result of perceptions retained in memory.

Homage a Miró, *1988, watercolor, crayon, ink, and pencil, 22 x 30 in.*

Ursula von Rydingsvärd

Drawing offers me an opportunity to make art that is different, yet in ways not so unlike the making of my sculpture. The imagery, mood, and intensity are much the same in both my sculpture and my drawing. The process of drawing is different in that it is not shackled with as many physical responsibilities, such as the constant awareness of gravity. Is it possible for this object, given its weight and size, to exist within such a configuration without falling or coming apart in time? A kind of fluidity, then, can be established in a drawing, as it does not have to deal with the concreteness and resistance of physical material. A possibility exists of making lighter, more fluid, and perhaps more impulsive lines in the drawing. The drawings, too, are sometimes a representation of the moment, as in the registration of patches of light made by the sun framed by the window and projected on the floor and wall.

I have rarely done a drawing of a sculpture I was thinking of building; instead, the drawings often help clarify what will come later in the sculpture. In the drawings I can indulge in a kind of spontaneity, in experiments that do not have to feel so complete. I can deal with a moment in the present and take a more tentative stand.

Light Study 11:45, 1981, charcoal, 29 x 23 in.

Merrill Wagner

My interest in art began with drawing, with making images in pencil or pastel. During my art-school years, the ability to draw seemed far ahead of an ability to paint. Though I loved to draw and was often fascinated with the results of my efforts, it seemed more important to work hardest at the more difficult and complicated task of learning to paint.

During the mid-seventies, after several episodes of bronchitis, I became sensitive to turpentine and paint fumes and began working with sticks of graphite or oil pastel on paper, stone, or tape. These pieces were intended to be not studies for later paintings but explorations into materials and the nature of making marks and notations. From this work between 1975 and 1982, I came to understand how drawing can be a major expressive art form independent of painting.

The following thoughts also occurred to me:

A work on paper is not necessarily a drawing.
A drawing is not necessarily a work on paper.
A watercolor is a painting, not a drawing.
A drawing is made with a stick.
A painting is made with a brush.
A painting is wet.
A drawing is dry.
A pen-and-ink line drawing is a drawing.
A brush-and-ink wash drawing is a painting.

You can draw on slate or canvas or Masonite with oil pastel and it can look like a painting, but it is not. It is a drawing.

Turtleback Mountain, *1987, oil pastel mounted on bluestone, 19 x 29 in.*

Kay WalkingStick

I came to art making through the joy of drawing, as many artists have. Drawing is thinking "aloud," and just as a verbal idea doesn't coalesce until it is written or spoken, a visual thought doesn't gel until it's on paper. Once it is, I can manipulate it.

Drawing has the look of the hand; you can feel the energy of the artist in the marks themselves. It is as if the artist is there with you at a drawing show, speaking directly to you with all the hesitation, thought, inflection, and gesticulation of a personal conversation.

Drawing leads me through seeming dead ends in my work. It propels ideas. It puts the ephemeral on paper, making it concrete and therefore paintable. For me, it is the connection between raw, formless thought and palpable paint. Also, it is the connection between one series of paintings and another.

My present works are diptychs that describe land from different views. Both parts are simplified and formally arranged, but one is abstract. I want the two portions to resonate with one another like stanzas in a poem. One is not the abstraction but the extension of the other. They represent two kinds of memory (one momentary and particular, the other permanent and nonspecific) and two kinds of perception. The drawings are about the unity of these two kinds of memory—these two kinds of understanding. My goal is to make meaningful, intuitive connections between these different views.

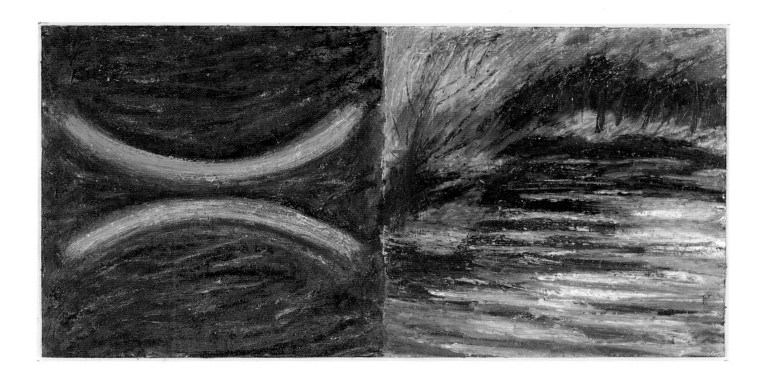

Compliments to Olmstead, Sketch II (diptych), 1988, oil stick and mixed media, 16 x 32 in.

Andrea Way

Initially, I thought about extracting patterns from nature. Serendipity was working when I first began using number patterns. I selected one drawing from a small sketchbook to expand to a larger size—the point was to increase the scale without enlarging the elements. That particular sketch was a river of numbers filling the page. I didn't realize at the time that this drawing with numbers would lead to what has become a lifetime pursuit and exploration of the evolution of patterns.

I am intrigued by the fact that everything in life can be described through pattern—whether biological, social, economic, etc., everything involves pattern. I am fascinated by the evolution/creation of complex patterns by the compounding of a few simple rules. The process I use is evolutionary. The drawings can be read as metaphor for the universal evolution of which we are all a part.

Treasure Map was completed after three years of exploration with the coded drawing series [involving a numeric accounting code written in the drawing—ED.]. Over time the work has grown more complex and layered, as well as larger and more organic. I think of myself as a naturalist—I create drawings that can be described as a naturalist's narrative abstraction.

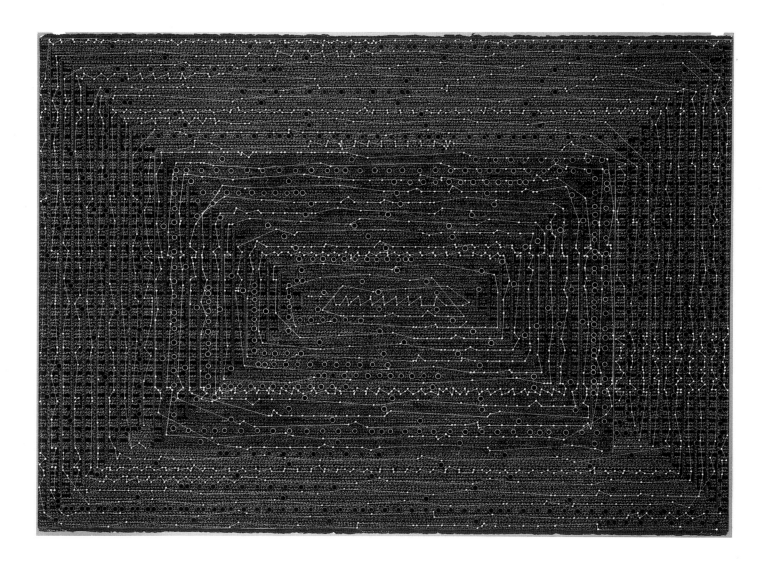

Treasure Map, 1984, ink, 22 x 30 in.

Joan Weber

The possibility of simplicity and spontaneity in drawing has always appealed to me. Drawing seems to be a direct line to the inner world of the artist, a graphic exploration of thoughts in process. This is what interests me when I draw and when I look at drawing.

Since 1982 I have been using dry pigment to draw with my fingers. These drawings are made intuitively, with no preconception. Only after they are made do I see their imagery. Although it comes from my subconscious, the imagery has been tempered by years of making abstract sculpture and wall pieces based on Islamic art, as well as mathematical compositions involving Fibonacci numbers. Also, many years of working from the figure have influenced these "automatic" drawings.

Drawing has become my major work. Although they are often studies for more complex paintings and sculpture, that moment of conception has been for me the most satisfying aspect of the work. Once these pigment drawings are made, there seems to be nothing more to do.

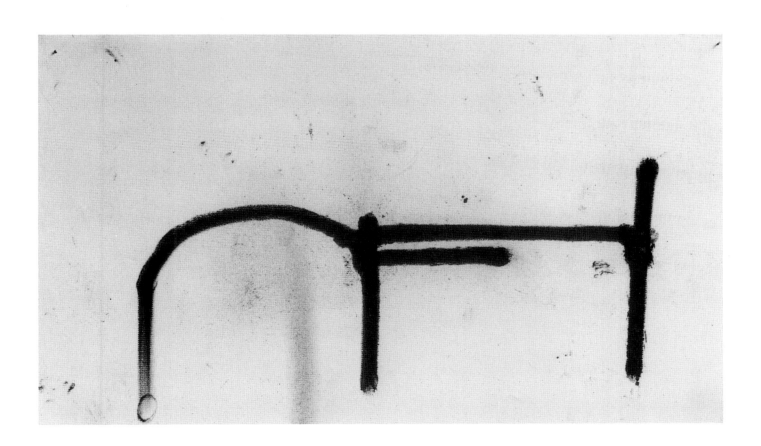

Figurative Bridge, *1982, dry pigment, 11½ x 19½ in.*

Mia Westerlund-Roosen

I have always loved to make drawings. They calm down the monster in me that would somehow like to paint. They are hard to start and get into, especially those on a large scale, but once the process is begun they become exciting and relaxing at the same time. They are a great relief from the heavy labor of working in concrete. Often I make a drawing to get a feeling for the scale of a piece I'm about to begin, and sometimes I do one after a work is completed, to savor the presence of the finished object. The drawings that I made from 1983 to 1987 are basically renderings of large work. I was looking at a Whistler, a full-scale portrait in pastel on canvas in the Boston museum, when it occurred to me that "portraits" of eccentric abstract sculpture would have the paradoxical elements of physical power, delicacy, and humor. I decided to make a series using traditional handling of the ground, moving from dark to light or light to dark. Layers of pastel are worked against the oil stick for more texture. These are slow, obsessively worked drawings. Even in smaller scale, I am trying to build toward a physical impact of image and surface. Almost all of these drawings are vertical because of this standing-portrait quality.

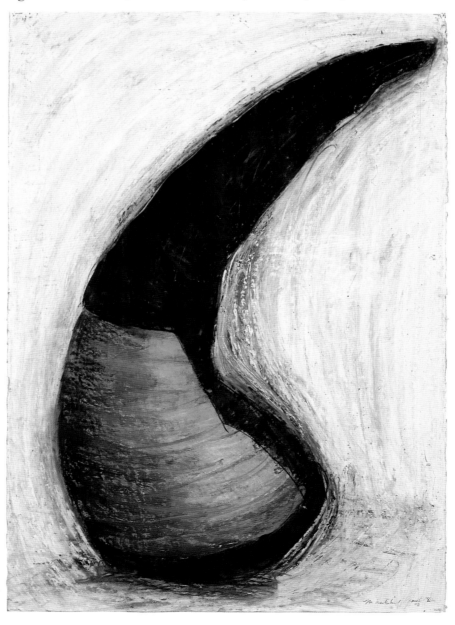

Drawing for Orlando, 1983, pastel and oil stick, 39½ x 28 in.

Jerilea Zempel

Drawing has a peculiar relationship to language, and I like to think about all the situations when words are inadequate and have to be replaced by images—medical illustrations, technical diagrams, scientific models, geological cross sections, maps, public signage, cartoons, etc. Generally, with these we imagine something that can't be seen easily, if at all, or they may reorder what we think we know, make our lives easier, or even keep us from danger. In moments of utopian fantasy I imagine that somewhere there is a drawing that might someday save my life. To me the clarity and urgency of these didactic images are expressive, often more so than conventional "art" drawings that duplicate idealized forms from the real world or refine purely formal relationships.

Drawing is territory where a sculptor can defy physical forces—build Rome in a day, take foolish risks; where failure is no big deal. For me, a stack of drawings is like money in the bank—a stockpile of possibilities against the slowness and uncertainty of sculptural materials and processes.

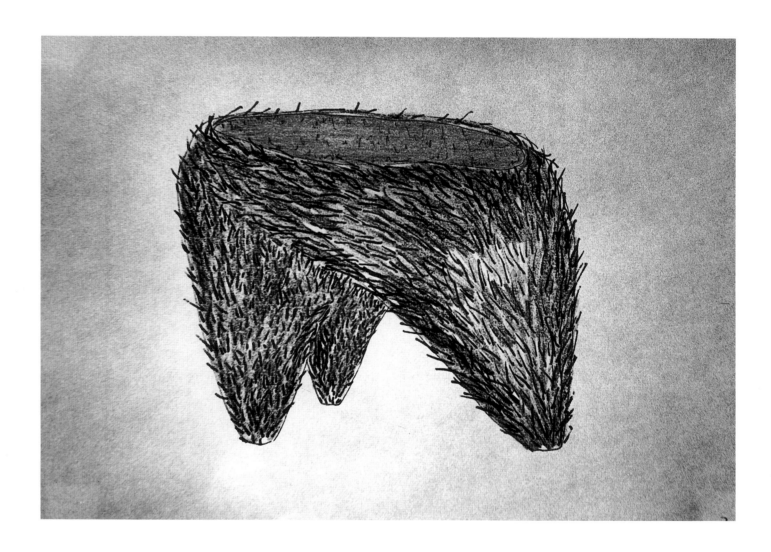

Drawing for a Sculpture from the Series "Original Sins," 1988, ink and crayon, 8½ x 11 in.

Salli Zimmerman

In my drawings I am not examining ideas for other media. My drawings are my ideas, my work. In them I incorporate everything I need to make an image: color, light, gesture, texture, space, and primarily feeling. Within the twenty years I have considered drawing my vehicle for expression, there have been changes in material, scale, and idea. Two decades ago drawings were not considered serious works of art. This attitude has finally begun to fade.

I began drawings limited to a use of charcoal that addressed value as the primary element. Pastels were added in order to include color in my vocabulary. Recently I have incorporated collage, pencil, and oil stick. Erasure has been an important part of my process, and in new work I have introduced scraping and tearing, which has led to new areas of investigation.

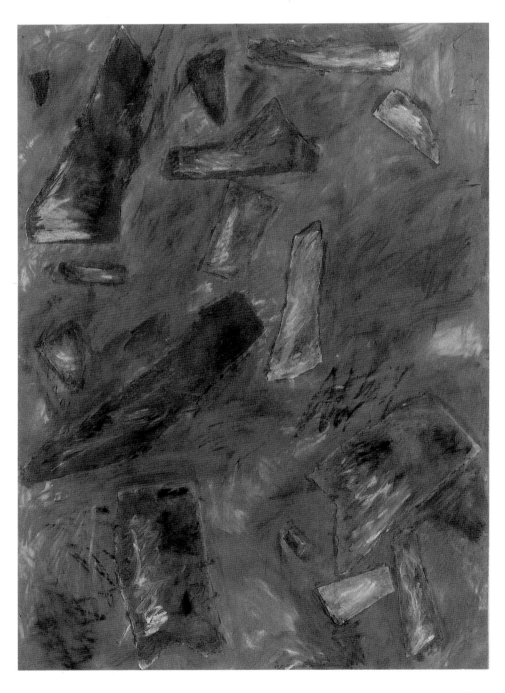

Above the Tideline of Grey #6, *1986, collage, pastel, charcoal, colored pencil, oil stick, and oil pastel, 39½ x 27½ in.*

Nola Zirin

Time, in a sense, controls our lives, and in my recent work I have included various elements related to time. For example, drawings and collaged paintings have been created from a hundred-year-old ledger book kept by a dry-goods salesman. He carefully recorded in brown ink, numerically, the days and events of his life. My work incorporates old prints, objects, cards, etc., through which one can see temporal transitions. Hand movement is evident in painterly surfaces, exposing a process over time.

Imagery or ready-mades are organized in various relationships on blue-toned paper, chosen to increase the drawing's luminosity. Lines divide the composition, while tonal areas establish a dialogue between objects and imagery.

Newer drawings are more literal, based upon an old book containing horological prints dealing with clock movements and tools. At a former time handmade objects were carefully crafted, highly valued and appreciated. A beauty exists in the form and shape of the tools and in the printed renderings. In my drawings I have tried to include these aesthetics.

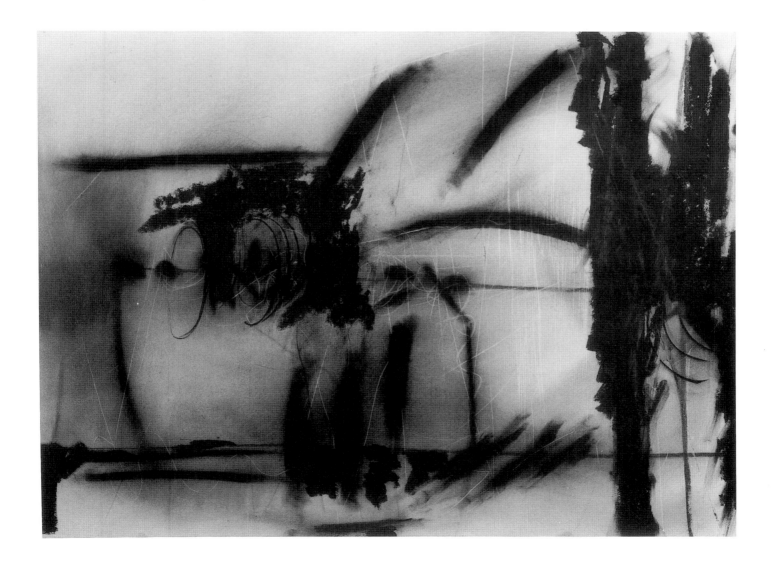

Horology Variation #2, *1988, pastel, pencil, and oil crayon, 22 x 30 in.*

Barbara Zucker

Drawing is thinking. It's your brain on the page. Drawing is easier than the "real" work we do: the sculpture or the painting. For that reason it's usually better and freer and more direct. It hasn't the fetters of consciousness. I must have a hundred little books filled with crabby little drawings: projects for my work, ideas for my life.

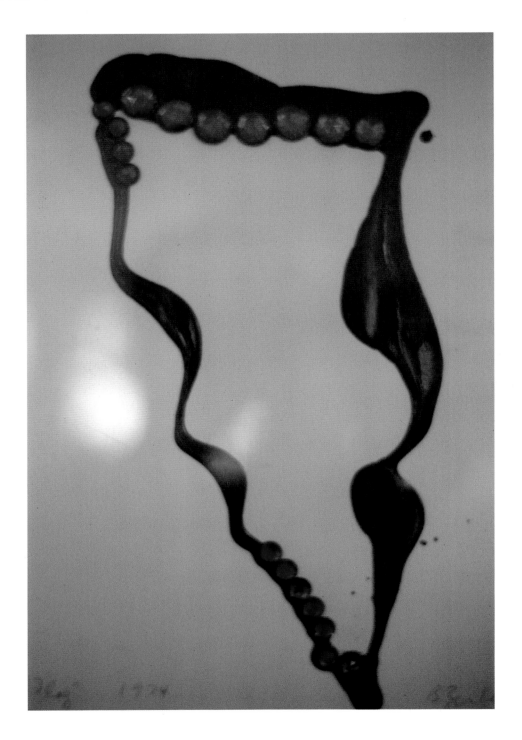

Flag, 1974, rubber latex and red paste jewels, 13½ x 11 in.

Abbreviated Biographies

Biographical information was selectively gathered from artists' résumés, from inquiries directed to individual artists, and from research sources.

Alice Adams

B. 1930, New York. Columbia University, New York. *One-Person Exhibitions*: Dag Hammarskjold Plaza, New York; Artemesia Gallery, Chicago; Hal Bromm Gallery, New York; 55 Mercer, New York. *Group Exhibitions*: Contemporary Arts Center, Cincinnati; P.S. 1, Long Island City, N.Y.; The Museum of Modern Art, New York; Whitney Biennial, New York, 1970–71, 1973; Artpark, Lewiston, N.Y.; Wave Hill, Bronx, N.Y.; Nassau County Museum of Fine Art, Roslyn Harbor, N.Y. *Awards*: Fulbright Fellowship, 1953; National Endowment for the Arts, 1978, 1984; Guggenheim Fellowship, 1981; American Academy and Institute of Arts and Letters, 1984. *Collections*: Everson Museum of Art of Syracuse and Onondaga County, Syracuse, N.Y.; Haags Gemeentemuseum, The Netherlands.

Candida Alvarez

B. 1955, Brooklyn, N.Y. Fordham University, New York. *One-Person Exhibitions*: Exit Art, New York; Real Art Ways, Hartford, Conn.; Cayman Gallery, New York; P.S. 1, Long Island City, N.Y. *Group Exhibitions*: June Kelly Gallery, New York; The Studio Museum in Harlem, New York; INTAR Latin American Gallery, New York; Nexus Contemporary Art Center, Atlanta; Mills College Art Gallery, Oakland, Calif.; Florida Atlantic University, Boca Raton; Nassau County Museum of Fine Art, Roslyn Harbor, N.Y. *Awards*: New York Foundation for the Arts, 1986; Creative Artists Network International Exchange Program, 1987. *Collections*: The Studio Museum in Harlem, New York; University Gallery, University of Delaware, Newark.

Emma Amos

B. 1938, Atlanta. New York University. *One-Person Exhibitions*: Jersey City Museum, N.J. Isobel Neal Gallery, Chicago; Parker/Bratton Gallery, New York; Galleri Oscar, Stockholm. *Group Exhibitions*: The Museum of Modern Art, New York; Associated American Artists, New York; Montclair Art Museum, N.J.; Landskrona Art Hall, Sweden; Jamaica Arts Center, N.Y.; Museum of Contemporary Hispanic Art, New York; The Clocktower, New York. *Awards*: National Endowment for the Arts, 1983. *Collections*: Columbia Museum, S.C.; The Museum of Modern Art, New York; United States Embassy, London.

Dotty Attie

B. 1938, Pennsauken, N.J. Philadelphia College of Art. *One-Person Exhibitions*: AIR Gallery, New York; Pennsylvania Academy of the Fine Arts, Philadelphia; Wadsworth Atheneum, Hartford, Conn.; Contemporary Arts Museum, Houston. *Group Exhibitions*: The Queens Museum, Flushing, N.Y.; P.S. 1, Long Island City, N.Y.; Neuberger Museum, State University of New York at Purchase; Museo Tamayo, Mexico City; Alternative Museum, New York; Institute of Contemporary Art-University of Pennsylvania, Philadelphia; Hirshhorn Museum and Sculpture Garden, Washington, D.C. *Awards*: National Endowment for the Arts, 1975, 1983; Creative Artists in Public Service, 1976. *Collections*: Smith College Museum of Art, Northampton, Mass.

Jill Baroff

B. 1954, Summit, N.J. Antioch College, Yellow Springs, Ohio. *One-Person Exhibitions*: 55 Mercer, New York. *Group Exhibitions*: Rosa Esman Gallery, New York; New York Studio School of Drawing, Painting & Sculpture; Hamilton College, Clinton, N.Y.; Edith C. Blum Art Institute, Bard College, Annandale-on-Hudson, N.Y.; Condeso/Lawler Gallery, New York; Sharpe Gallery, New York; Hillwood Art Gallery, Long Island University, Brookville, N.Y.; Just Above Midtown/Downtown, New York; Hallwalls, Buffalo, N.Y.; Dayton Art Institute, Ohio; Antioch College, Yellow Springs, Ohio. *Awards*: Artists Space, 1981, 1985; Pollock-Krasner Foundation, 1987. *Collections*: Appalachian State University, Boone, N.C.

Judith Bernstein

B. 1942, Newark, N.J. Yale University School of Art and Architecture, New Haven, Conn. *One-Person Exhibitions*: The University Museum, University of Arkansas, Fayetteville; AIR Gallery, New York; State University of New York, Stony Brook; University of Colorado Museum, Boulder. *Group Exhibitions*: Hillwood Art Gallery, Long Island University, Brookville, N.Y.; Haags Gemeentemuseum, The Netherlands; P.S. 1, Long Island City, N.Y.; Palazzo Grassi, Venice; The Brooklyn Museum, N.Y.; Museo de Arte Contemporáneo de Caracas, Venezuela; The Bronx Museum of the Arts, N.Y. *Awards*: National Endowment for the Arts, 1974, 1985; New York Foundation for the Arts, 1988. *Collections*: The Museum of Modern Art, New York; The Brooklyn Museum, N.Y.

Camille Billops

B. 1933, Los Angeles. City University of New York. *One-Person Exhibitions*: Calkins Gallery, Hofstra University, Hempstead, N.Y.; American Cultural Center, Taiwan; The Bronx Museum of the Arts, N.Y.; Amerika-Haus, Hamburg, West Germany; Gallerie Akhenaton, Cairo. *Group Exhibitions*: McIntosh Gallery, Atlanta; Frances Wolfson Art Gallery, Miami-Dade Community College; Jamaica Arts Center, N.Y.; Montclair Art Museum, N.J.; Hillwood Art Gallery, Long Island University, Brookville, N.Y.; The Studio Museum in Harlem, New York. *Awards*: Creative Artists in Public Service, 1984; New York State Council on the Arts, 1987. *Collections*: The Studio Museum in Harlem, New York; Museum of Drawers, Bern, Switzerland.

Judy Blum

B. 1943, New York. Cooper Union School of Art and Architecture, New York. *One-Person Exhibitions*: The

Bronx Museum of the Arts, N.Y.; Galerie Jean-Claude Riedel, Paris; Mabel Smith Douglass Library, Rutgers University, New Brunswick, N.J.; ABC No Rio, New York; Soho 20 Gallery, New York. *Group Exhibitions*: Museum of Contemporary Hispanic Art, New York; P.S. 39, Longwood Arts Gallery, Bronx, N.Y.; Port Authority Bus Terminal, New York; AIR Gallery, New York; Kenkeleba House Gallery, New York; The New Museum of Contemporary Art, New York; Alternative Museum, New York. *Awards*: Creative Artists in Public Service, 1982. *Collections*: Centre Georges Pompidou, Paris.

Louise Bourgeois

B. 1911, Paris. Sorbonne and Ecole des Beaux-Arts, Paris. *One-Person Exhibitions*: Robert Miller Gallery, New York; The Museum of Modern Art, New York; Maeght-Lelong, Paris; The Taft Museum, Cincinnati. *Group Exhibitions*: Whitney Biennial, New York, 1983, 1987; The Museum of Contemporary Art, Los Angeles; Storm King Art Center, Mountainville, N.Y.; La Boetie/Helen Serger, New York; The Museum of Modern Art, New York; Neuberger Museum, State University of New York at Purchase; P.S. 1, Long Island City, N.Y. *Awards*: Skowhegan Medal, 1985; Gold Medal of Honor for Excellence in Art, National Arts Club, New York, 1987. *Collections*: The Museum of Modern Art, New York; The Metropolitan Museum of Art, New York.

Dove Bradshaw

B. 1949, New York. School of the Museum of Fine Arts, Boston. *One-Person Exhibitions*: Razor Gallery, New York; Graham Modern, New York; Wave Hill, Bronx, N.Y.; Utica College Art Museum, N.Y. *Group Exhibitions*: P.S. 1, Long Island City, N.Y.; Leo Castelli Gallery, New York; Lorence-Monk, New York; Blum Helman Gallery, New York; American Academy and Institute of Arts and Letters, New York; Muestra International de Arte Grafico, Bilbao, Spain, 1984; American Center, Paris. *Awards*: National Endowment for the Arts, 1975; Pollock-Krasner Foundation, 1985. *Collections*: The Metropolitan Museum of Art, New York; The Museum of Modern Art, New York.

Phyllis Bramson

B. 1941, Madison, Wis. School of the Art Institute of Chicago. *One-Person Exhibitions*: Monique Knowlton Gallery, New York; Dart Gallery, Chicago; Renaissance Society, Chicago; Brody's Gallery, Washington, D.C. *Group Exhibitions*: Renwick Gallery of the National Museum of American Art, Washington, D.C.; Museum of Contemporary Art, Chicago; The New Museum of Contemporary Art, New York; Contemporary Arts Center, Cincinnati; The Art Institute of Chicago; Musée de Toulon, France; Kansas City Museum, Mo. *Awards*: National Endowment for the Arts, 1976, 1983; Louis Comfort Tiffany Foundation, 1980; Fulbright Fellowship, 1988. *Collections*:

Hirshhorn Museum and Sculpture Garden, Washington, D.C.; The Art Institute of Chicago.

Helene Brandt

B. 1936, Philadelphia. Columbia University, New York. *One-Person Exhibitions*: Pennsylvania Academy of the Fine Arts, Philadelphia; The Bronx Museum of the Arts, N.Y.; The Queens Museum, Flushing, N.Y.; Sculpture Center, New York. *Group Exhibitions*: Fort Wayne Museum of Art, Indiana; Hillwood Art Gallery, Long Island University, Brookville, N.Y.; Municipal Plaza, Philadelphia; P.S. 39, Longwood Arts Gallery, Bronx, N.Y.; Hal Bromm Gallery, New York; Allentown Art Museum, Pa.; Alternative Museum, New York. *Awards*: Betty Brazil Memorial Award, 1982; Guggenheim Fellowship, 1985. *Collections*: The Hudson River Museum of Westchester, Yonkers, N.Y.; Israel Museum, Jerusalem.

Nancy Brett

B. 1946, Jackson, Mich. Cranbrook Academy of Art, Bloomfield Hills, Mich. *One-Person Exhibitions*: Harm Bouckaert Gallery, New York; Ericson Gallery, New York; Gallery Seven, Detroit. *Group Exhibitions*: Hillwood Art Gallery, Long Island University, Brookville, N.Y.; Grace Borgenicht Gallery, New York; Associated American Artists, New York; The Clocktower, New York; Wayne State University Community Arts Gallery, Detroit; Herbert F. Johnson Museum of Art, Cornell University, Ithaca, N.Y.; Cranbrook Academy of Art Museum, Bloomfield Hills, Mich.; Susan Caldwell Gallery, New York. *Awards*: Yaddo Residency, 1983, 1984, 1985, 1986. *Collections*: Herbert F. Johnson Museum of Art, Cornell University, Ithaca, N.Y.; Best Products Corporation, Richmond, Va.

Joanne Brockley

B. 1958, Syracuse, N.Y. Empire State Studio Program, Westbeth, N.Y. *One-Person Exhibitions*: Avenue B Gallery, New York; P.S. 1, Long Island City, N.Y.; Windows on White Street, New York; Ten on Eight, New York. *Group Exhibitions*: Discovery Gallery, Glen Cove, N.Y.; Fashion Institute of Technology, New York; World Trade Center, New York; Kenkeleba House Gallery, New York; P.S. 1, Long Island City, N.Y.; Max Hutchinson Gallery, New York; 55 Mercer, New York. *Awards*: New York State Foundation for the Arts, 1988.

Joan Brown

B. 1938, San Francisco. San Francisco Art Institute. *One-Person Exhibitions*: Allan Frumkin Gallery, New York; Newport Harbor Art Museum, Newport Beach, Calif.; University Art Museum, Berkeley, Calif.; San Francisco Museum of Modern Art. *Group Exhibitions*: Columbus Museum of Art, Ohio; Whitney Museum of American Art, New York; The Queens Museum, Flushing, N.Y.; The New Museum of Contemporary Art, New York; Cor-

coran Biennial, Washington, D.C., 1983; The Grey Art Gallery and Study Center, New York University Art Collection; Hirshhorn Museum and Sculpture Garden, Washington, D.C. *Collections*: Whitney Museum of American Art, New York; Los Angeles County Museum of Art.

Vivian E. Browne

B. Laurel, Fla. Hunter College, New York. *One-Person Exhibitions*: Jamaica Arts Center, N.Y.; The Bronx Museum of the Arts, N.Y.; University of California, Santa Cruz; Soho 20 Gallery, New York. *Group Exhibitions*: INTAR Latin American Gallery, New York; The Museum of Modern Art, New York; Museum of Contemporary Hispanic Art, New York; El Choppo Museum of Art, Mexico City; Associated American Artists, New York; The New Museum of Contemporary Art, New York; Kenkeleba House Gallery, New York; The Studio Museum in Harlem, New York. *Awards*: MacDowell Fellowship, 1980. *Collections*: Jane Voorhees Zimmerli Art Museum, Rutgers University, New Brunswick, N.J.; Schomburg Center for Research, New York.

Beverly Buchanan

B. 1940, Fuguay, N.C. Columbia University, New York. *One-Person Exhibitions*: Heath Gallery, Atlanta; Visual Arts Gallery, University of Alabama, Birmingham; Kornblee Gallery, New York; Truman Gallery, New York. *Group Exhibitions*: Georgia Museum of Art, The University of Georgia, Athens; Atlanta Biennial (Nexus), 1987; Contemporary Arts Center, New Orleans; The Southeastern Center for Contemporary Art, Winston-Salem, N.C.; Weatherspoon Art Gallery, University of North Carolina, Greensboro; The Studio Museum in Harlem, New York; Jane Voorhees Zimmerli Art Museum, Rutgers University, New Brunswick, N.J. *Awards*: Guggenheim Fellowship, 1980; National Endowment for the Arts, 1980.

Cynthia Carlson

B. 1942, Chicago. Pratt Institute, Brooklyn, N.Y. *One-Person Exhibitions*: Fine Arts Gallery at Wright State University, Dayton, Ohio; Albright-Knox Art Gallery, Buffalo, N.Y.; Pam Adler Gallery, New York; Lowe Art Museum, University of Miami, Coral Gables. *Group Exhibitions*: Washington Project for the Arts, Washington, D.C.; Hayden Gallery and M.I.T. Permanent Collection, Cambridge; The Hudson River Museum of Westchester, Yonkers, N.Y.; The Queens Museum, Flushing, N.Y.; Creative Time, New York; The Brooklyn Museum, N.Y.; Cincinnati Art Museum. *Awards*: National Endowment for the Arts, 1975, 1978, 1981; Creative Artists in Public Service, 1978. *Collections*: The Metropolitan Museum of Art, New York; Solomon R. Guggenheim Museum, New York.

Paloma Cernuda

B. 1948, New York. Hunter College, New York. *One-*

Person Exhibitions: Museum of Contemporary Hispanic Art, New York; AFR Fine Art, Washington, D.C. *Group Exhibitions*: The Drawing Center, New York; The Berkshire Museum, Pittsfield, Mass.; Lehman College Art Gallery, Bronx, N.Y.; Los Angeles Municipal Art Gallery; Hillwood Art Gallery, Long Island University, Brooklyn Center, N.Y.; Leo Castelli Gallery, New York; Leubsdorf Gallery, Hunter College, New York. *Awards*: New York Foundation for the Arts, 1987; Yaddo Residency, 1987, 1988.

Emily Cheng

B. 1953, New York. Rhode Island School of Design, Providence. *One-Person Exhibitions*: Lang & O'Hara Gallery, New York; White Columns, New York; 55 Mercer, New York; Pittsburgh Plan for Art. *Group Exhibitions*: Annina Nosei Gallery, New York; Hallwalls, Buffalo, N.Y.; Grace Borgenicht Gallery, New York; Hewlett Gallery, Carnegie-Mellon University, Pittsburgh; Barbara Toll Gallery, New York; Asian Arts Institute, New York; Kenkeleba House Gallery, New York. *Awards*: National Endowment for the Arts, 1982. *Collections*: Chemical Bank, New York; Prudential Insurance Company of America, New York.

Eva Cockcroft

B. 1939, Vienna. Rutgers University, New Brunswick, N.J. *One-Person Exhibitions*: PZCA Gallery, New York; Gallery 345/Art for Social Change, New York; Jane Voorhees Zimmerli Art Museum, Rutgers University, New Brunswick, N.J.; University of Wisconsin-Milwaukee Union Art Gallery. *Group Exhibitions*: The Museum of Modern Art, New York; Exit Art, New York; Segunda Bienal, Museo Nacional de Bellas Artes, Havana, 1986; Museum of Contemporary Hispanic Art, New York; Fashion Moda, Bronx, N.Y.; Broadway/Lafayette Subway Station (mural), New York; 142nd St. between Amsterdam Avenue and Hamilton Place (mural), New York. *Awards*: National Endowment for the Arts, 1975; Warren O. Tanner Memorial Award, 1987. *Collections*: Flint Institute of Arts, Mich.; Health and Hospital Corporation, New York.

Clyde Connell

B. 1901, Belcher, La. Vanderbilt University, Nashville, Tenn. *One-Person Exhibitions*: Arthur Roger Gallery, New Orleans; Siegeltuch Gallery, New York; The Southeastern Center for Contemporary Art, Winston-Salem, N.C.; World's Fair, New Orleans. *Group Exhibitions*: Hirshhorn Museum and Sculpture Garden, Washington, D.C.; Everson Museum of Art of Syracuse and Onondaga County, N.Y.; Lawndale Annex, University of Houston; Contemporary Arts Center, New Orleans; Brattleboro Museum and Art Center, Vermont. *Awards*: Adolph and Esther Gottlieb Foundation, 1982; Awards in the Visual Arts 5, 1986. *Collections*: The Metropolitan Museum of Art, New York; The Museum of Fine Arts, Houston.

Petah Coyne

B. 1953, Oklahoma City. Art Academy of Cincinnati. *One-Person Exhibitions*: The Brooklyn Museum, N.Y.; Sculpture Center, New York; P.S. 1, Long Island City, N.Y.; Augustus Saint-Gaudens Memorial Gallery, Cornish, N.H. *Group Exhibitions*: Norton Gallery and School of Art, West Palm Beach, Fla.; David Winton Bell Gallery, Brown University, Providence, R.I.; Contemporary Arts Center, Cincinnati; Alternative Museum, New York; White Columns, New York; Robeson Center, Newark, N.J.; Danforth Museum of Art, Framingham, Mass. *Awards*: Pollock-Krasner Foundation, 1987; New York Foundation for the Arts, 1988. *Collections*: The Brooklyn Museum, N.Y.; The New School for Social Research, New York.

Elba Damast

B. 1944, Pedernales, Venezuela. Arturo Michelena Escuela Plastica Erte; Ely Palacios Escuela, Maturin, Venezuela. *One-Person Exhibitions*: Strand Gallery, Stockholm; Galería Freites, Caracas; Galería de Arte Nacional, Caracas; Cayman Gallery, New York. *Group Exhibitions*: Museum of Contemporary Hispanic Art, New York; Littlejohn-Smith Gallery, New York; Segunda Bienal, Museo de Arte Contemporáneo de Caracas, 1988; The Bronx Museum of the Arts, N.Y.; Quinta Bienal Latinoamericano, San Juan, Puerto Rico, 1988; The Queens Museum, Flushing, N.Y.; The Metropolitan Museum of Art, New York. *Collections*: Galería de Arte Nacional, Caracas; Museo de Arte Contemporáneo de Caracas; Cincinnati Art Museum.

Elisa D'Arrigo

B. Bronx, N.Y. State University of New York, New Paltz. *One-Person Exhibitions*: Luise Ross Gallery, New York. *Group Exhibitions*: White Columns, New York; Sculpture Center, New York; Hillwood Art Gallery, Long Island University, Brookville, N.Y.; Art in General, New York; Bronx River Art Gallery, N.Y.; Alternative Museum, New York; Rosa Esman Gallery, New York; The Newark Museum, N.J. *Awards*: Ariana Foundation for the Arts, 1984; MacDowell Fellowship, 1986, 1987. *Collections*: Charles Burchfield Center, Buffalo, N.Y.; Best Products Corporation, Richmond, Va.

Carol Becker Davis

B. 1945, Huntington, N.Y. Long Island University, Brookville, N.Y. *One-Person Exhibitions*: Discovery Gallery, Glen Cove, N.Y. *Group Exhibitions*: Islip Art Museum, East Islip, N.Y.; AIR Gallery, New York; Heckscher Museum, Huntington, N.Y.; Washington County Museum of Fine Arts, Hagerstown, Md.; The Clocktower, New York; Brooklyn Terminal Building, N.Y.; Central Hall Gallery, New York. *Collections*: Islip Art Museum, East Islip, N.Y.

Agnes Denes

B. Budapest, Hungary. Columbia University, New York. *One-Person Exhibitions*: University of Hawaii Art Gallery, Honolulu; Kunsthalle Nürnberg, West Germany; Hayden Gallery and M.I.T. Permanent Collection, Cambridge; Institute of Contemporary Arts, London. *Group Exhibitions*: Whitney Museum of American Art, New York; Documenta VI, Kassel, West Germany, 1977; Venice Biennale, 1978; Centre Georges Pompidou, Paris; The Brooklyn Museum, N.Y.; Kunsthalle Köln, West Germany; The New Museum of Contemporary Art, New York. *Awards*: Creative Artists in Public Service, 1972, 1974, 1980; National Endowment for the Arts, 1974, 1975, 1981. *Collections*: The Museum of Modern Art, New York; Philadelphia Museum of Art.

Donna Dennis

B. 1942, Springfield, Ohio. Art Students League of New York. *One-Person Exhibitions*: Dayton City Beautiful, Ohio; The Brooklyn Museum, N.Y.; Neuberger Museum, State University of New York at Purchase; University Gallery, University of Massachusetts at Amherst; Holly Solomon Gallery, New York. *Group Exhibitions*: Sarah Campbell Blaffer Gallery, University of Houston; Contemporary Arts Center, Cincinnati; Walker Art Center, Minneapolis; Gallerie Salamon Agustoni Algranti, Bologna, Italy; Hirshhorn Museum and Sculpture Garden, Washington, D.C.; Venice Biennale, 1982, 1984; Whitney Biennial, New York, 1979. *Awards*: National Endowment for the Arts, 1977, 1980, 1986; Guggenheim Fellowship, 1979. *Collections*: The Brooklyn Museum, N.Y.; Chase Manhattan Bank, New York.

Jane Dickson

B. 1952, Chicago. School of the Museum of Fine Arts, Boston. *One-Person Exhibitions*: Brooke Alexander Gallery, New York; Delahunty Gallery, New York. *Group Exhibitions*: Laforet Museum, Harajuku, Tokyo; Whitney Biennial, New York, 1985; Anchorage Creative Time, New York; The Museum of Modern Art, New York; Kansas City Art Institute, Mo.; The Brooklyn Museum, N.Y. *Awards*: National Endowment for the Arts, 1985; Ariana Foundation for the Arts, 1985. *Collections*: The Art Institute of Chicago; Victoria and Albert Museum, London.

Lesley Dill

B. 1950, Bronxville, N.Y. The Maryland Institute, College of Art, Baltimore. *One-Person Exhibitions*: G. H. Dalsheimer Gallery, Baltimore; Carlo Lamagna Gallery, New York; Galerie Taub, Philadelphia; 55 Mercer, New York. *Group Exhibitions*: Brattleboro Museum and Art Center, Vermont; Midtown Galleries, New York; Helander Gallery, Palm Beach, Fla.; Woods-Gerri Gallery, Rhode Island School of Design, Providence; Montclair Art Museum, N.J.; The Drawing Center, New York; The Decker

and Meyerhoff Galleries, The Maryland Institute, College of Art, Baltimore. *Awards*: Artist in Residence, Dominican Republic, 1984. *Collections*: Best Products Corporation, Richmond, Va.; Prudential Insurance Company of America, New York.

Judite Dos Santos

B. 1945, Porto, Portugal. Rutgers University, New Brunswick, N.J. *One-Person Exhibitions*: Spectacolor Electronic Board, Times Square, Public Art Fund, New York; INTAR Latin American Gallery, New York; City Without Walls Gallery, Newark, N.J.; Museum of Contemporary Hispanic Art, New York. *Group Exhibitions*: Exit Art, New York; Contemporary Arts Center, New Orleans; Fashion Moda, Bronx, N.Y.; Whitney Museum of American Art, New York; Pyramid Arts Center, Rochester, N.Y.; Art Awareness, Lexington, N.Y.; Lehman College Art Gallery, Bronx, N.Y. *Awards*: Pollock-Krasner Foundation, 1987; New York Foundation for the Arts, 1987. *Collections*: Franklin Furnace, New York.

Mary Beth Edelson

B. East Chicago, Indiana. New York University. *One-Person Exhibitions*: Danforth Museum of Art, Framingham, Mass.; P.S. 1, Long Island City, N.Y.; Carnegie Mellon Art Gallery, Pittsburgh; Albright-Knox Art Gallery, Buffalo, N.Y. *Group Exhibitions*: The Museum of Modern Art, New York; Walker Art Center, Minneapolis; Corcoran Gallery of Art, Washington, D.C.; Everson Museum of Art of Syracuse and Onondaga County, N.Y.; The Queens Museum, Flushing, N.Y.; Washington Project for the Arts, Washington, D.C.; The National Museum of Women in the Arts, Washington, D.C. *Awards*: National Endowment for the Arts, 1981; Creative Artists in Public Service, 1982. *Collections*: Solomon R. Guggenheim Museum, New York; Museum of Contemporary Art, Chicago.

Margery Edwards

B. 1933, Newcastle, Australia. Morley College of Art, London. *One-Person Exhibitions*: Leo Kamen Gallery, Toronto; Cathedral of St. John the Divine, New York; Gallery Gabrielle Pizzi, Melbourne; Holdsworth Gallery, Sydney; Gallery Hirondelle, New York. *Group Exhibitions*: Münchner Stadtmuseum, West Germany; Summit Art Center, N.J.; Sydney University; Frank Marino Gallery, New York; Parsons-Dreyfus Gallery, New York. *Collections*: Art Bank, Sydney; Power Gallery of Contemporary Art, Sydney; Jane Voorhees Zimmerli Art Museum, Rutgers University, New Brunswick, N.J.

Elizabeth Egbert

B. 1945, Charleston, W.Va. New York University. *One-Person Exhibitions*: Newhouse Gallery, Snug Harbor, Staten Island, N.Y.; Sculpture Center, New York; Wom-

en's Interart Center, New York; Discovery Room, Nassau County Museum of Fine Art, Roslyn Harbor, N.Y. *Group Exhibitions*: South Beach Psychiatric Center, Staten Island, N.Y.; Sid Deutsch Gallery, New York; Wards Island, New York; Lever House, New York; Temple University, Philadelphia; The Aldrich Museum of Contemporary Art, Ridgefield, Conn.; Manhattan Community College, New York. *Awards*: Staten Island Council on the Arts, 1984, 1985. *Collections*: Citibank, New York; Xerox Corporation, New York.

Camille Eskell

B. 1954, Kew Gardens, N.Y. Queens College, Flushing, N.Y.; City University of New York. *One-Person Exhibitions*: First Street Gallery, New York; Doshi Center for Contemporary Art, Harrisburg, Pa.; University of Massachusetts, Lowell; Moravian College, Bethlehem, Pa. *Group Exhibitions*: Islip Art Museum, East Islip, N.Y.; Hillwood Art Gallery, Long Island University, Brookville, N.Y.; The University Gallery, Memphis State University, Tenn.; Heckscher Museum, Huntington, N.Y.; The Clocktower, New York; The Morris Museum, Morristown, N.J. *Awards*: New York Foundation for the Arts, 1986. *Collections*: Islip Art Museum, East Islip, N.Y.

Lauren Ewing

B. 1946, Fort Knox, Ky. University of California, Santa Barbara. *One-Person Exhibitions*: Diane Brown Gallery, New York; Interim Art, London; Artemesia Gallery, Chicago; P.S. 1, Long Island City, N.Y. *Group Exhibitions*: Socrates Sculpture Park, Long Island City, N.Y.; John Weber Gallery, New York; University of Pittsburgh; Crocker Art Museum, Sacramento, Calif.; The New Museum of Contemporary Art, New York; Jane Voorhees Zimmerli Art Museum, Rutgers University, New Brunswick, N.J.; Hirshhorn Museum and Sculpture Garden, Washington, D.C. *Awards*: National Endowment for the Arts, 1980, 1982. *Collections*: Neuberger Museum, State University of New York at Purchase; Williams College Museum of Art, Williamstown, Mass.

Heide Fasnacht

B. 1951, Cleveland. New York University. *One-Person Exhibitions*: Germans Van Eck Gallery, New York; Saxon-Lee Gallery, Los Angeles; Vanderwoude-Tananbaum Gallery, New York; Cleveland Center for Contemporary Art. *Group Exhibitions*: New Orleans Museum of Art; Rosa Esman Gallery, New York; The Aldrich Museum of Contemporary Art, Ridgefield, Conn.; Muhlenberg College, Allentown, Pa.; Los Angeles Institute of Contemporary Art; Documenta VI, Kassel, West Germany, 1977; Pratt Manhattan Center, New York. *Awards*: Louis Comfort Tiffany Foundation, 1986; Awards in the Visual Arts, 1986. *Collections*: Cincinnati Art Museum; Columbus Museum of Art, Ohio.

Harriet Feigenbaum

B. 1939, New York. Columbia University, New York. *One-Person Exhibitions*: Pennsylvania Academy of the Fine Arts, Philadelphia; Marian Locks Gallery, Philadelphia; City University of New York, Graduate Center; Warren Benedek Gallery, New York. *Group Exhibitions*: American Bar Association, San Francisco; Los Angeles Institute of Contemporary Art; Whitney Museum of American Art, New York; The Brooklyn Museum, N.Y.; Hayden Gallery and M.I.T. Permanent Collection, Cambridge; Creative Time, New York; Artpark, Lewiston, N.Y. *Awards*: Creative Artists in Public Service, 1977; National Endowment for the Arts, 1984. *Collections*: Corcoran Gallery of Art, Washington, D.C.; Collection, City of New York, work in progress.

Jackie Ferrara

B. Detroit. Columbia University, New York. *One-Person Exhibitions*: Moore College of Art, Philadelphia; San Antonio Art Institute, Tex.; Galleriet Lund, Sweden; Lowe Art Museum, University of Miami, Coral Gables. *Group Exhibitions*: The Queens Museum, Flushing, N.Y.; The Aspen Art Museum, Colo.; The Bronx Museum of the Arts, N.Y.; Museum of Contemporary Art, Chicago; Cleveland Center for Contemporary Art; The High Museum of Art, Atlanta; Walker Art Center, Minneapolis. *Awards*: National Endowment for the Arts, 1973, 1977, 1987; Guggenheim Fellowship, 1975. *Collections*: The Baltimore Museum of Art; National Museum of American Art, Washington, D.C.

Janet Fish

B. 1938, Boston. Yale University School of Art and Architecture, New Haven, Conn. *One-Person Exhibitions*: Robert Miller Gallery, New York; Smith College Museum of Art, Northampton, Mass.; University of Richmond, Va.; Columbia Museum, S.C. *Group Exhibitions*: New Jersey State Museum, Trenton; The Queens Museum, Flushing, N.Y.; Allentown Art Museum, Pa.; Contemporary Arts Museum, Houston; University of Pennsylvania, Philadelphia. *Awards*: MacDowell Fellowship, 1968, 1969, 1972; Australian Council for the Arts, 1975. *Collections*: Whitney Museum of American Art, New York; The Metropolitan Museum of Art, New York.

Mary Frank

B. 1933, London. American Art School, New York. *One-Person Exhibitions*: Zabriskie Gallery, New York; The Brooklyn Museum, N.Y.; De Cordova and Dana Museum and Park, Lincoln, Mass.; Everson Museum of Art of Syracuse and Onondaga County, N.Y. *Group Exhibitions*: Solomon R. Guggenheim Museum, New York; Whitney Biennial, New York, 1973, 1979; The Art Institute of Chicago; Philadelphia Museum of Art; Contemporary Arts Center, Cincinnati; The Queens Museum, Flushing, N.Y.;

The Metropolitan Museum of Art, New York. *Awards*: Guggenheim Fellowship, 1973, 1983; Brandeis University Creative Arts Award, 1977. *Collections*: The Museum of Modern Art, New York; Whitney Museum of American Art, New York.

Sandy Gellis

B. 1944, Bronx, N.Y. School of Visual Arts, New York. *One-Person Exhibitions*: Experimental Glass Workshop, New York; 55 Mercer, New York; Charlottenborg, Copenhagen; Luise Ross Gallery, New York. *Group Exhibitions*: City Gallery, New York; Storefront for Art and Architecture, New York; Islip Art Museum, East Islip, N.Y.; Brattleboro Museum and Art Center, Vermont; Squibb Gallery, Princeton, N.J.; Pratt Manhattan Center, New York; Creative Time, New York. *Awards*: Creative Artists in Public Service, 1978; National Endowment for the Arts, 1979, 1981, 1987; MacDowell Fellowship, 1979. *Collections*: The Brooklyn Museum, N.Y.

Gina Gilmour

B. 1948, Charlotte, N.C. Sarah Lawrence College, Bronxville, N.Y. *One-Person Exhibitions*: Vanderwoude/Tananbaum, New York; Brody's Gallery, Washington, D.C.; Jerald Melberg Gallery, Charlotte, N.C.; Gibbes Art Gallery, Charleston, S.C. *Group Exhibitions*: Gilliam-Peden Gallery, Raleigh, N.C.; Kenkeleba House Gallery, New York; Hillwood Art Gallery, Long Island University, Brookville, N.Y.; Ronald Feldman Gallery, New York; Equitable Gallery, New York; Alternative Museum, New York. *Awards*: MacDowell Fellowship, 1976, 1979; Awards in the Visual Arts, 1988. *Collections*: The Newark Museum, N.J.; Mint Museum of Art, Charlotte, N.C.

Grace Graupe-Pillard

B. New York. City University of New York. *One-Person Exhibitions*: Hal Bromm Gallery, New York; Real Art Ways, Hartford, Conn.; Millsaps College, Jackson, Miss.; Razor Gallery, New York. *Group Exhibitions*: The Drawing Center, New York; The Hudson River Museum of Westchester, Yonkers, N.Y.; Hallwalls, Buffalo, N.Y.; Randolph-Macon Women's College, Lynchburg, Va.; The New Museum of Contemporary Art, New York; Indianapolis Museum of Art, Ind.; The Museum of Modern Art, New York. *Awards*: National Endowment for the Arts, 1985; Weintraub Foundation, 1988. *Collections*: AT&T Corporation, New York; Coca-Cola Corporation, Atlanta.

Nancy Graves

B. 1940, Pittsfield, Mass. Yale University School of Art and Architecture, New Haven, Conn. *One-Person Exhibitions*: The Brooklyn Museum, N.Y.; M. Knoedler & Co., New York; Fort Worth Art Museum, Tex.; Hirshhorn Museum and Sculpture Garden, Washington, D.C. *Group Exhibitions*: The Museum of Modern Art, New York; The

Brooklyn Museum, N.Y.; Williams College Museum of Art, Williamstown, Mass.; Whitney Biennial, New York, 1973, 1983; Venice Biennale, 1980; Documenta V and VI, Kassel, West Germany, 1972, 1977. *Awards*: Fulbright Grant, 1965; National Endowment for the Arts, 1972; Skowhegan Medal, 1980. *Collections*: The Metropolitan Museum of Art, New York; The Museum of Modern Art, New York; Solomon R. Guggenheim Museum, New York.

Renée Green

B. 1959, Cleveland. Wesleyan University, Middletown, Conn. *One-Person Exhibitions*: Jersey City Museum, N.J.; John Jay College, New York; Spare Room, New York; Rogers & Cogswell, Hoboken, N.J. *Group Exhibitions*: Bronx River Art Gallery, N.Y.; Four Walls, Hoboken, N.J.; The Drawing Center, New York; Just Above Midtown, New York; Goddard-Riverside Community Center, New York; Diverse Works Gallery, Houston; The Works Gallery, Newark, N.J. *Awards*: Geraldine Dodge Foundation, 1988; New Jersey State Council on the Arts, 1988. *Collections*: The Studio Museum in Harlem, New York.

Chris Griffin

B. 1950, Boston. Columbia University, New York. *One-Person Exhibitions*: Pictogram Gallery, New York; 65 White Street, New York. *Group Exhibitions*: Sculpture Center, New York; Henry Street Settlement, New York; Beaver College, Philadelphia; Thorpe Intermedia Gallery, Sparkill, N.Y.; City Hall Park, New York; Florida State University, Tallahassee; Islip Art Museum, East Islip, N.Y. *Awards*: New York Foundation for the Arts, 1985. *Collections*: Everson Museum of Art of Syracuse and Onondaga County, N.Y.; Philip Morris Corporation, New York; Mobil Oil Corporation, New York.

Nancy Grossman

B. 1940, New York. Pratt Institute, Brooklyn, N.Y. *One-Person Exhibitions*: Terry Dintenfass Gallery, New York; Heath Gallery, Atlanta; Barbara Gladstone Gallery, New York; Cordier & Ekstrom, New York. *Group Exhibitions*: The Brooklyn Museum, N.Y.; Corcoran Gallery of Art, Washington, D.C.; Whitney Museum of American Art, New York; Fogg Art Museum, Cambridge, Mass.; P.S. 1, Long Island City, N.Y.; Ronald Feldman Gallery, New York; Contemporary Arts Center, Cincinnati. *Awards*: American Academy and Institute of Arts and Letters, 1974; National Endowment for the Arts, 1984. *Collections*: The Baltimore Museum of Art; Hirshhorn Museum and Sculpture Garden, Washington, D.C.; National Museum of American Art, Washington, D.C.

Marina Gutierrez

B. 1954, New York. Cooper Union School of Art and Architecture, New York. *One-Person Exhibitions*: West-minster Gallery, Bloomfield College, N.J. *Group Exhibitions*: The Museum of Modern Art, New York; PPOW Gallery, New York; Bronx River Art Gallery, New York; El Bohío Gallery, New York; Plaza Las Américas, San Juan, Puerto Rico; Museum of Contemporary Hispanic Art, New York; Bienal, Museo Nacional de Bellas Artes, Havana, Cuba, 1986; Palmer Museum of Art, The Pennsylvania State University, University Park; Jamaica Arts Center, N.Y. *Collections*: Anheuser-Busch Company, St. Louis; Museo Nacional de Bellas Artes, Havana, Cuba.

Susan Hall

B. 1943, Point Reyes, Calif. University of California, Berkeley. *One-Person Exhibitions*: Trabia-MacAfee Gallery, New York; Ovsey Gallery, Los Angeles; San Francisco Museum of Modern Art; Dart Gallery, Chicago. *Group Exhibitions*: Graham Modern, New York; University Art Museum, University of California, Santa Barbara; Museum of Fine Arts, Boston; San Francisco Museum of Modern Art; Museum of Art, Rhode Island School of Design, Providence; The Brooklyn Museum, N.Y.; Whitney Museum of American Art, New York. *Awards*: Creative Artists in Public Service, 1977; National Endowment for the Arts, 1979, 1987. *Collections*: Whitney Museum of American Art, New York; The Carnegie Museum of Art, Pittsburgh.

Harmony Hammond

B. 1944, Chicago. University of Minnesota, Minneapolis. *One-Person Exhibitions*: Museum of Fine Arts, Santa Fe, N.M.; Trabia-MacAfee Gallery, New York; Bernice Steinbaum Gallery, New York; Wadsworth Atheneum, Hartford, Conn. *Group Exhibitions*: Contemporary Arts Center, Cincinnati; Phoenix Art Museum, Ariz.; Palladium, New York; The Studio Museum in Harlem, New York; The Brooklyn Museum, N.Y.; The New Museum of Contemporary Art, New York; American Center, Paris. *Awards*: National Endowment for the Arts, 1979, 1983; Creative Artists in Public Service, 1982. *Collections*: The Metropolitan Museum of Art, New York; The Art Institute of Chicago.

Jane Hammond

B. 1950, Bridgeport, Conn. University of Wisconsin, Madison. *One-Person Exhibitions*: Nina Freudenheim Gallery, Buffalo, N.Y. *Group Exhibitions*: Hunter College, New York; Grace Borgenicht Gallery, New York; Stux Gallery, New York; G.H. Dalsheimer Gallery, Baltimore; Calvin-Morris Gallery, New York. *Awards*: Ludwig Vogelstein Foundation, 1985; Yaddo Residency, 1985; Art Matters, 1987. *Collections*: Albright-Knox Art Gallery, Buffalo, N.Y.; The Baltimore Museum of Art; Prudential Insurance Company of America, New York.

Maren Hassinger

B. 1947, Los Angeles. University of California, Los Angeles. *One-Person Exhibitions*: Contemporary Arts Forum and Alice Keck Park, Santa Barbara, Calif.; Northridge Art Gallery, California State University, Northridge; Los Angeles City College; Los Angeles County Museum of Art. *Group Exhibitions*: P.S. 39, Longwood Arts Gallery, Bronx, N.Y.; AIR Gallery, New York; The Studio Museum in Harlem, New York; P.S. 1, Long Island City, N.Y.; Zabriskie Gallery, New York; Artpark, Lewiston, N.Y.; Seattle Transit Project, Wash. *Awards*: National Endowment for the Arts, 1980, 1984; New York Foundation for the Arts, 1988. *Collections*: The Studio Museum in Harlem, New York; California Afro-American Museum, Los Angeles.

Phoebe Helman

B. 1929, New York. Washington University, St. Louis. *One-Person Exhibitions*: Russell Sage College, Albany, N.Y.; State University of New York, Cortland; Jane Voorhees Zimmerli Art Museum, Rutgers University, New Brunswick, N.J.; University Art Galleries at Wright State University, Dayton, Ohio. *Group Exhibitions*: Miami-Dade Community College; Islip Art Museum, East Islip, N.Y.; Bernice Steinbaum Gallery, New York; Marion Locks Gallery, Philadelphia; Akron Art Museum, Ohio; Neuberger Museum, State University of New York at Purchase; Roland Gibson Gallery, State University College at Potsdam, N.Y. *Awards*: Guggenheim Fellowship, 1979; National Endowment for the Arts, 1981; New York State Foundation for the Arts, 1986. *Collections*: Fox, Glynn, and Melamed, New York; Ciba-Geigy Corporation, Ardsley, N.Y.

Janet Henry

B. 1947, New York. School of Visual Arts, New York. *One-Person Exhibitions*: The Studio Museum in Harlem, New York; Just Above Midtown, New York; Basement Workshop, New York; The Exhibitionists Gallery, New York. *Group Exhibitions*: INTAR Latin American Gallery, New York; Bronx River Art Gallery, N.Y.; P.S. 39, Longwood Arts Gallery, Bronx, N.Y.; White Columns, New York; The Clocktower, New York; Ohio State University Gallery, Columbus; University of South Florida Art Museum, College of Fine Arts, Tampa. *Awards*: Rockefeller Foundation, 1974, 1975; Public Art Fund, New York, 1987.

Carol Hepper

B. 1953, McLaughlin, S.D. South Dakota State University, Brookings. *One-Person Exhibitions*: Hill Gallery, Birmingham, Mich.; Rosa Esman Gallery, New York; Dahl Fine Arts Center, Rapid City, S.D.; P.S. 1, Long Island City, N.Y. *Group Exhibitions*: Freedman Gallery, Albright College, Reading, Pa.; Sculpture Center, New York; Solomon R. Guggenheim Museum, New York; David Winton Bell Gallery, Brown University, Providence, R.I.; Contemporary Arts Center, Cincinnati; North Dakota Museum of Art, Grand Forks; Jane Voorhees Zimmerli Art Museum, Rutgers University, New Brunswick, N.J. *Awards*: Pollock-Krasner Foundation, 1986; Edward F. Albee Foundation, 1986. *Collections*: Dannheisser Foundation, New York; Solomon R. Guggenheim Museum, New York.

Eva Hesse

B. 1936, Hamburg, West Germany; d. 1970. Cooper Union School of Art and Architecture, New York. *One-Person Exhibitions*: Solomon R. Guggenheim Museum, New York; Whitechapel Art Gallery, London; Allen Memorial Art Museum, Oberlin College, Ohio; Rose Art Museum, Brandeis University, Waltham, Mass. *Group Exhibitions*: Fischbach Gallery, New York; Whitney Museum of American Art, New York; Institute of Contemporary Art-University of Pennsylvania, Philadelphia; Kunsthalle Bern, Switzerland; Fondation Maeght, Saint-Paul-de-Vence, France; Documenta V and VI, Kassel, West Germany, 1972, 1977; The Art Museum, Princeton University, N.J. *Collections*: Whitney Museum of American Art, New York; Solomon R. Guggenheim Museum, New York.

Robin Hill

B. 1955, Houston. Kansas City Art Institute, Mo. *One-Person Exhibitions*: Lang & O'Hara Gallery, New York; Small Walls, New York; A Place Apart, Brooklyn, N.Y. *Group Exhibitions*: Kunsthaus, Aarau, Switzerland; American Academy and Institute of Arts and Letters, New York; Zabriskie Gallery, New York; Artists Space, New York; Hillwood Art Gallery, Long Island University, Brookville, N.Y.; Craig Cornelius Gallery, New York; Grand Army Plaza, Brooklyn, N.Y. *Awards*: Pollock-Krasner Foundation, 1986; National Endowment for the Arts, 1986; New York Foundation for the Arts, 1987. *Collections*: Hillwood Art Gallery, Long Island University, Brookville, N.Y.

Nancy Holt

B. 1938, Worcester, Mass. Tufts University, Medford, Mass. *One-Person Exhibitions*: John Weber Gallery, New York; Whitney Museum of American Art, New York; Flow Ace Gallery, Los Angeles; Bykert Gallery, New York; IRT Subway, Fulton Street, New York; St. James Park, Toronto; Federal Building, Saginaw, Mich. *Group Exhibitions*: Los Angeles County Museum of Art; Hirshhorn Museum and Sculpture Garden, Washington, D.C.; Hayden Gallery, Massachusetts Institute of Technology, Cambridge; The New Museum of Contemporary Art, New York. *Awards*: National Endowment for the Arts, 1975, 1978, 1983, 1985; Guggenheim Fellowship, 1978. *Collections*: National Museum of American Art, Washington, D.C.; The New Museum of Contemporary Art, New York.

Nene Humphrey

B. 1947, Portage, Wis. York University, Toronto. *One-Person Exhibitions*: Sculpture Center, New York; Waterworks Gallery, Salisbury, N.C.; Alternative Museum, New York; University of Wisconsin, Oshkosh. *Group Exhibitions*: Siegeltuch Gallery, New York; AIR Gallery, New York; P.S. 39, Longwood Arts Gallery, Bronx, N.Y.; Gallery Schweitzer, Montreal; Creative Time, New York; Artpark, Lewiston, N.Y.; The Atlanta College of Art. *Awards*: National Endowment for the Arts, 1983; Rockefeller Foundation, 1987. *Collections*: The High Museum of Art, Atlanta; Best Products Corporation, Richmond, Va.

Patricia Johanson

B. 1940, New York. School of Architecture, City College of New York. *One-Person Exhibitions*: Montclair State College, N.J.; The Berkshire Museum, Pittsfield, Mass.; Dallas Museum of Art; Twining Gallery, New York. *Group Exhibitions*: Marisa del Re Gallery, New York; Hayden Gallery, Massachusetts Institute of Technology, Cambridge; The Metropolitan Museum of Art, New York; Museum of Contemporary Art, Chicago; Laumeier Sculpture Park and Gallery, St. Louis; The Brooklyn Museum, N.Y.; Cooper-Hewitt Museum, Smithsonian Institution, New York. *Awards*: Guggenheim Fellowship, 1970, 1980; National Endowment for the Arts, 1975. *Collections*: The Metropolitan Museum of Art, New York; The Museum of Modern Art, New York.

Anne Griffin Johnson

B. 1943, Saginaw, Mich. Portland State University, Oreg. *One-Person Exhibitions*: Fountain Gallery, Portland, Oreg.; Lynn McAllister Gallery, Seattle. *Group Exhibitions*: Portland Center for the Arts, Oreg.; Oregon Art Institute, Portland; Willamette University, Salem, Oreg.; Marylhurst Education Center, Lake Oswego, Oreg.; Portland Art Museum, Oreg. *Collections*: Portland Art Museum, Oreg.; City of Portland, Oreg.

Carla Rae Johnson

B. 1947, East Chicago, Ind. University of Iowa, Iowa City. *One-Person Exhibitions*: Soho 20 Gallery, New York; Meridian Museum of Art, Miss. *Group Exhibitions*: Lever House, New York; Discovery Metro, Long Island City, N.Y.; Minor Injury, Brooklyn, N.Y.; Hera Gallery, Wakefield, R.I.; Nippon Club Gallery, New York; Hillwood Art Gallery, Long Island University, Brookville, N.Y.; Lehigh University Art Galleries, Bethlehem, Pa.

Shelagh Keeley

B. 1954, Oakville, Ontario. York University, Toronto. *One-Person Exhibitions*: Sagacho Exhibit Space, Tokyo; Tomoko Liguori Gallery, New York; Grunwald Gallery, Toronto; Art Gallery of Southern Alberta, Lethridge, Canada. *Group Exhibitions*: The Drawing Center, New York; Artists Space, New York; Siegeltuch Gallery, New York; Exit Art, New York; Miyagi Museum, Sendai, Japan; Harbourfront Art Gallery, Toronto; Centre Saidye Bronfman, Montreal. *Awards*: Ontario Arts Council, 1977, 1984; Canada Council Arts, 1981, 1983. *Collections*: National Gallery of Canada, Ontario; Canada Council Art Bank, Ottawa.

Vera Klement

B. 1929, Danzig, Poland. Cooper Union School of Art and Architecture, New York. *One-Person Exhibitions*: Spertus Museum of Judaica, Chicago; Goethe Institute, Chicago; CDS Gallery, New York; Artemesia Gallery, Chicago. *Group Exhibitions*: The Museum of Modern Art, New York; Walker Art Center, Minneapolis, Minn.; Terra Museum of American Art, Chicago; Indianapolis Museum of Art; The Jewish Museum, New York; Museo de Bellas Artes, Caracas; Universidade de São Paulo. *Awards*: Tiffany Foundation, 1954; Guggenheim Fellowship, 1981; National Endowment for the Arts, 1987. *Collections*: Philadelphia Museum of Art; Smithsonian Institution, Washington, D.C.

Alison Knowles

B. 1933, New York. Pratt Institute, Brooklyn, N.Y. *One-Person Exhibitions*: Emily Harvey Gallery, New York; Nordjyllands Kunstmuseum, Aalborg, Denmark; Walker Art Center, Minneapolis; Centre Georges Pompidou, Paris. *Group Exhibitions*: The Museum of Modern Art, New York; Hood Museum of Art, Dartmouth College, Hanover, N.H.; Neuberger Museum, State University of New York at Purchase; The Drawing Center, New York; P.S. 1, Long Island City, N.Y.; Museu de Arte Contemporanea, São Paulo; Los Angeles Institute of Contemporary Art. *Awards*: Guggenheim Fellowship, 1968; National Endowment for the Arts, 1981, 1985. *Collections*: Bibliothèque Nationale, Paris; Nordjyllands Kunstmuseum, Aalborg, Denmark.

Grace Knowlton

B. 1932, Buffalo, N.Y. Smith College, Northampton, Mass. *One-Person Exhibitions*: Hillwood Art Gallery, Long Island University, Brookville, N.Y.; Twining Gallery, New York; Witkin Gallery, New York; Razor Gallery, New York. *Group Exhibitions*: International Center of Photography, New York; Corcoran Gallery of Art, Washington, D.C.; The Aldrich Museum of Contemporary Art, Ridgefield, Conn.; Wards Island, New York; Parsons-Dreyfus Gallery, New York; San Francisco Museum of Modern Art; The Metropolitan Museum of Art, New York. *Collections*: The Metropolitan Museum of Art, New York; Corcoran Gallery of Art, Washington, D.C.

Ellen Kozak

B. 1955, Roslyn, N.Y. Massachusetts Institute of Tech-

nology, Cambridge. *One-Person Exhibitions*: Port Washington Public Library, N.Y.; Jay Gallery, New York; Osaka Contemporary Art Center, Japan; Gallery Amelia, Tokyo. *Group Exhibitions*: Sragow Gallery, New York; Associated American Artists, New York; Addison Gallery of American Art, Andover, Mass.; Castelli Uptown, New York; De Cordova and Dana Museum and Park, Lincoln, Mass.; Jay Gallery, New York. *Awards*: Yaddo Residency, 1986; Blue Mountain Colony Fellowship, 1988. *Collections*: Tochigi Prefectural Museum of Fine Arts, Japan.

Lee Krasner

B. 1908, Brooklyn, N.Y.; d. 1984. National Academy of Design, New York. *One-Person Exhibitions*: Whitechapel Art Gallery, London; Whitney Museum of American Art, New York; The Museum of Modern Art, New York; Corcoran Gallery of Art, Washington, D.C. *Group Exhibitions*: Whitney Annual, New York, 1956, 1957; Guild Hall, East Hampton, N.Y.; Whitney Biennial, New York, 1973; Los Angeles County Museum of Art; Herbert F. Johnson Museum of Art, Cornell University, Ithaca, N.Y.; Solomon R. Guggenheim Museum, New York; Hirshhorn Museum and Sculpture Garden, Washington, D.C. *Awards*: Chevalier de l'Ordre des Arts et des Lettres, French Minister of Culture, 1982; Honorary Doctorate, State University of New York, Stony Brook, 1984. *Collections*: The Metropolitan Museum of Art, New York; National Museum of American Art, Washington, D.C.

Lois Lane

B. 1948, Philadelphia. Yale University School of Art and Architecture, New Haven, Conn. *One-Person Exhibitions*: Barbara Mathes Gallery, New York; Willard Gallery, New York; Akron Art Museum, Ohio; Artists Space, New York. *Group Exhibitions*: P.S. 1, Long Island City, N.Y.; Vassar College Art Gallery, Poughkeepsie, N.Y.; Whitney Museum of American Art, New York; Grey Art Gallery, New York University; Kunstmuseum Luzern, Switzerland; Philadelphia Museum of Art; Whitney Biennial, New York, 1979. *Awards*: Creative Artists in Public Service, 1977; National Endowment for the Arts, 1978. *Collections*: National Gallery of Art, Washington, D.C.; The Museum of Modern Art, New York.

Ellen Lanyon

B. 1936, Chicago. University of Iowa, Iowa City. *One-Person Exhibitions*: Zabriskie Gallery, New York; Richard Gray Gallery, Chicago; Krannert Art Museum, Champaign, Ill.; Marion Koogler McNay Art Museum, San Antonio, Tex. *Group Exhibitions*: Venice Biennale, 1981; Walker Art Center, Minneapolis; Museum of Contemporary Art, Chicago; The Museum of Modern Art, New York; The Brooklyn Museum, N.Y.; Jane Voorhees Zimmerli Art Museum, Rutgers University, New Brunswick, N.J.; Corcoran Gallery of Art, Washington, D.C.

Awards: Fulbright Fellowship, 1950; National Endowment for the Arts, 1974, 1988. *Collections*: The Art Institute of Chicago; Des Moines Art Center, Iowa.

Susan Laufer

B. 1950, Tuckahoe, N.Y. New York University. *One-Person Exhibitions*: Germans Van Eck Gallery, New York; Barbara Krakow Gallery, Boston; Van Straaten Gallery, Chicago; 55 Mercer, New York. *Group Exhibitions*: Spencer Museum of Art, University of Kansas, Lawrence; Greenville County Museum of Art, S.C.; Center for Contemporary Art, Chicago; Siegeltuch Gallery, New York; Barbara Toll Gallery, New York; Edith C. Blum Art Institute, Bard College, Annandale-on-Hudson, N.Y.; Alternative Museum, New York. *Awards*: National Endowment for the Arts, 1984; Ariana Foundation for the Arts, 1985. *Collections*: Albright-Knox Art Gallery, Buffalo, N.Y.; American Express Company, New York.

Stephanie Brody Lederman

B. 1939, New York. Long Island University, Brookville, N.Y. *One-Person Exhibitions*: Elaine Benson Gallery, Bridgehampton, N.Y.; Rastovski Gallery, New York; Kathryn Markel Gallery, New York; Anderson Gallery, Virginia Commonwealth University, Richmond, Va. *Group Exhibitions*: Carlo Lamagna Gallery, New York; American Academy and Institute of Arts and Letters, New York; The Clocktower, New York; Brent Gallery, Houston; Henry Street Settlement, New York; The Metropolitan Museum of Art, New York; Palladium, New York. *Awards*: Creative Artists in Public Service, 1977; Artists Space Grant, 1986. *Collections*: Chase Manhattan Bank, New York; Newark Museum, N.J.

Claire Lieberman

B. 1954, Milwaukee, Wis. Tufts University, Medford, Mass. *One-Person Exhibitions*: 56 Bleeker Gallery, New York; Jayne Baum Gallery, New York; Van Straaten Gallery, Chicago. *Group Exhibitions*: AIR Gallery, New York; P.S. 122, New York; Jayne Baum Gallery, New York; Art in General, New York; The Drawing Center, New York; Bess Cutler Gallery, New York; Sculpture Center, New York; Stux Gallery, Boston. *Awards*: MacDowell Fellowship, 1981, 1985. *Collections*: Milwaukee Jewish Federation, Wis.

Li-Lan

B. 1943, New York. *One-Person Exhibitions*: O. K. Harris Gallery, New York; Nantenshi Gallery, Tokyo; Asher/Faure Gallery, Los Angeles; Robert Miller Gallery, New York. *Group Exhibitions*: Elaine Benson Gallery, Bridgehampton, N.Y.; P.S. 1, Long Island City, N.Y.; Asian Arts Institute, New York; Sheldon Memorial Art Gallery, University of Nebraska, Lincoln; Guild Hall, East Hamp-

ton, N.Y.; Weatherspoon Art Gallery, University of North Carolina at Greensboro; Heckscher Museum, Huntington, N.Y.; Albright-Knox Art Gallery, Buffalo, N.Y. *Collections*: Guild Hall, East Hampton, N.Y.; Vassar College Art Gallery, Poughkeepsie, N.Y.

Jane Logemann

B. 1942, Milwaukee, Wis. University of Wisconsin, Milwaukee. *One-Person Exhibitions*: Courtney Sales Gallery, Dallas; Everson Museum of Art of Syracuse and Onondaga County, N.Y. *Group Exhibitions*: City Gallery, New York; Sandra Gering Fine Arts, Oyster Bay, N.Y.; Peder Bonnier Gallery, New York; William Paterson College, Wayne, N.J.; Dayton Art Institute, Ohio; The Sarah Doyle Center, Brown University, Providence, R.I.; Marian Goodman Gallery, New York. *Collections*: The Museum of Modern Art, New York; Wadsworth Atheneum, Hartford, Conn.

Winifred Lutz

B. 1942, Brooklyn, N.Y. Cranbrook Academy of Art, Bloomfield Hills, Mich. *One-Person Exhibitions*: Marilyn Pearl Gallery, New York; Dolan-Maxwell Gallery, Philadelphia; Kalamazoo Art Institute, Mich.; Museum of Contemporary Crafts, New York. *Group Exhibitions*: Leopold-Hoesch-Museum, Düren, West Germany; Carnegie-Mellon University, Pittsburgh; Miami University Art Museum, Oxford, Ohio; Nassau County Museum of Fine Art, Roslyn Harbor, N.Y.; The Cleveland Museum of Art; Albright-Knox Art Gallery, Buffalo, N.Y.; National Collection of Fine Arts, Washington, D.C. *Awards*: National Endowment for the Arts, 1984. *Collections*: Albright-Knox Art Gallery, Buffalo, N.Y.; The Art Institute of Chicago.

Margo Machida

B. 1950, Hilo, Hawaii. Hunter College, New York. *One-Person Exhibitions*: The Bronx Museum of the Arts, N.Y.; Catherine Gallery, New York; 55 Mercer, New York; Alternative Museum, New York. *Group Exhibitions*: Henry Street Settlement, New York; INTAR Latin American Gallery, New York; San Diego Museum of Art, Calif.; Asian Arts Institute, New York; Hunter College, New York; Exit Art, New York; P.S. 39, Longwood Arts Gallery, Bronx, N.Y. *Awards*: National Endowment for the Arts, 1983; Washington Project for the Arts, 1987, 1988. *Collections*: Chemical Bank, New York; Best Products Corporation, Richmond, Va.

Marisol (Escobar)

B. 1930, Paris. Ecole des Beaux-Arts, Paris. *One-Person Exhibitions*: Sidney Janis Gallery, New York; Moore College of Art, Philadelphia; Worcester Art Museum, Mass.; Columbus Gallery of Fine Arts, Ohio. *Group Exhibitions*: Tate Gallery, London; Haags Gemeentemuseum, The Netherlands; Whitney Museum of American Art, New York; Venice Biennale, 1968; The Art Institute of Chicago; Institute of Contemporary Arts, London; Los Angeles County Museum of Art. *Awards*: American Academy and Institute of Arts and Letters. *Collections*: The Museum of Modern Art, New York; The Metropolitan Museum of Art, New York.

Kathleen McCarthy

B. 1952, Pittsburgh. Indiana University, Bloomington. *One-Person Exhibitions*: President's Boardroom, Long Island University, Brookville, N.Y.; White Columns, New York; Public Image Gallery, New York; Hobart and William Smith Colleges, Geneva, N.Y. *Group Exhibitions*: AIR Gallery, New York; Sala Uno, Rome; Bronx River Art Gallery, N.Y.; Mokotoff Gallery, New York; PPOW Gallery, New York; Hillwood Art Gallery, Long Island University, Brookville, N.Y.; Contemporary Arts Forum and Alice Keck Park, Santa Barbara, Calif. *Awards*: Cummington Community for the Arts Fellowship, 1985; National Endowment for the Arts, 1988. *Collections*: NYNEX Corporation, New York.

Ana Mendieta

B. 1948, Cuba; d. 1985. University of Iowa, Iowa City. *One-Person Exhibitions*: The New Museum of Contemporary Art, New York; Terne Gallery, New York; Museo Nacional de Bellas Artes, Havana; Jane Voorhees Zimmerli Art Museum, Rutgers University, New Brunswick, N.J. *Group Exhibitions*: Museum of Contemporary Hispanic Art, New York; Zeus-Trabia Gallery, New York; The Southeastern Center for Contemporary Art, Winston-Salem, N.C.; Fisher Gallery, University of Southern California, Los Angeles; Edith C. Blum Art Institute, Bard College, Annandale-on-Hudson, N.Y.; Palazzo Piccoli, Spoleto, Italy; The Chrysler Museum, Norfolk, Va. *Awards*: National Endowment for the Arts, 1978, 1980, 1982; Guggenheim Fellowship, 1980; American Academy in Rome Fellowship, 1983. *Collections*: East Michigan University, Ypsilanti.

Melissa Meyer

B. 1947, New York. New York University. *One-Person Exhibitions*: R. C. Erpf Gallery, New York; Leslie Cecil Gallery, New York; Janet Steinberg Gallery, San Francisco; Douglass College, New Brunswick, N.J. *Group Exhibitions*: The Aldrich Museum of Contemporary Art, Ridgefield, Conn.; Kouros Gallery, New York; Creative Time, New York; American Academy of Arts and Letters, New York; Exit Art, New York; Janus Gallery, Los Angeles; Hillwood Art Gallery, Long Island University, Brookville, N.Y. *Awards*: Yaddo Residency, 1974, 1975, 1979; American Academy in Rome Fellowship, 1980; National Endowment for the Arts, 1984. *Collections*: Solomon R. Guggenheim Museum, New York; The Metropolitan Museum of Art, New York.

Yong Soon Min

B. 1953, Bukok, South Korea. University of California, Berkeley. *One-Person Exhibitions*: Trisolini Gallery, Ohio University, Athens; San Jose Institute of Contemporary Art, Calif.; Jamaica Arts Center, N.Y.; Museum of Contemporary Art, Cleveland. *Group Exhibitions*: INTAR Latin American Gallery, New York; The Museum of Modern Art, New York; BACA Gallery, Brooklyn, N.Y.; Jamaica Arts Center, N.Y.; El Bohío Gallery, New York; Asian Arts Institute, New York; Henry Street Settlement, New York. *Awards*: Baker Award, Ohio University, 1982; Yaddo Residency, 1985. *Collections*: County of Cleveland, England.

Mary Miss

B. 1944, New York. Rinehart School of Sculpture, Baltimore. *One-Person Exhibitions*: Architectural Association, London; Protetch-McNeil Gallery, New York; Institute of Contemporary Art, London; Laumeier Sculpture Park and Gallery, St. Louis. *Group Exhibitions*: La Jolla Museum of Contemporary Art, Calif.; Los Angeles County Museum of Art; Whitney Museum of American Art, New York; Hayden Gallery and M.I.T. Permanent Collection, Cambridge; Institute of Contemporary Art-University of Pennsylvania, Philadelphia; Whitney Biennial, New York, 1973; Venice Biennale, 1980. *Awards:* National Endowment for the Arts, 1974, 1975; Guggenheim Fellowship, 1986. *Collections*: The Museum of Modern Art, New York; Solomon R. Guggenheim Museum, New York.

Joan Mitchell

B. 1926, Chicago. School of the Art Institute of Chicago. *One-Person Exhibitions*: Robert Miller Gallery, New York; Xavier Fourcade, New York; Galerie Jean Fournier, Paris; Whitney Museum of American Art, New York. *Group Exhibitions*: Corcoran Biennial, Washington, D.C., 1950, 1975, 1981; Whitney Annual, New York, 1955, 1965, 1967; Whitney Biennial, New York, 1983; The Museum of Modern Art, New York; Hirshhorn Museum and Sculpture Garden, Washington, D.C.; Newport Harbor Art Museum, Newport Beach, Calif.; Documenta II, Kassel, West Germany, 1959; Venice Biennale, 1958. *Awards*: Honorary Doctorate, Miami University, Oxford, Ohio, 1971; Brandeis University Creative Arts Award, 1974. *Collections*: Solomon R. Guggenheim Museum, New York; The Museum of Modern Art, New York.

Ree Morton

B. 1936, Ossining, N.Y.; d. 1977. Rhode Island School of Design, Providence. *One-Person Exhibitions*: Solomon R. Guggenheim Museum, New York; Max Protetch Gallery, New York; The New Museum of Contemporary Art, New York; Whitney Museum of American Art, New York. *Group Exhibitions*: Whitney Biennial, New York, 1973; University Art Museum, University of California, Santa Barbara; The Brooklyn Museum, N.Y.; Institute of Contemporary Art-University of Pennsylvania, Philadelphia; Contemporary Arts Center, Cincinnati; Hirshhorn Museum and Sculpture Garden, Washington, D.C.; Allen Memorial Art Museum, Oberlin College, Ohio.

Judith Murray

B. 1941, New York. Pratt Institute, Brooklyn, N.Y. *One-Person Exhibitions*: Jan Turner Gallery, Los Angeles; Pam Adler Gallery, New York; Hillwood Art Gallery, Long Island University, Brookville, N.Y.; Dallas Museum of Art. *Group Exhibitions*: WARM Gallery, Minneapolis; Weatherspoon Art Gallery, University of North Carolina, Greensboro; Lincoln Center Gallery, New York; Milwaukee Art Museum, Wis.; Whitney Biennial, New York, 1979; Otis Art Institute, Los Angeles; P.S. 1, Long Island City, N.Y. *Awards*: National Endowment for the Arts, 1983. *Collections*: The Museum of Modern Art, New York; The Metropolitan Museum of Art, New York.

Alice Neel

B. 1900, Merion Square, Pa.; d. 1984. Philadelphia School of Design for Women. *One-Person Exhibitions*: Robert Miller Gallery, New York; Nassau County Museum of Fine Art, Roslyn Harbor, N.Y.; Pennsylvania Academy of the Fine Arts, Philadelphia; Whitney Museum of American Art, New York. *Group Exhibitions*: The Metropolitan Museum of Art, New York; Whitney Museum of American Art, New York; Philadelphia Museum of Art; Terra Museum of American Art, Chicago; San Francisco Museum of Modern Art; The High Museum of Art, Atlanta; Sidney Janis Gallery, New York. *Collections*: The Metropolitan Museum of Art, New York; The Museum of Modern Art, New York.

Terry Niedzialek

B. 1956, Brooklyn, N.Y. New York Institute of Technology, Old Westbury, N.Y. *One-Person Exhibitions*: The Painted Bride, Philadelphia; Fashion Moda, Bronx, N.Y.; Il Diaframma, Milan; Galerie Alain Oudin, Paris. *Group Exhibitions*: Fashion Institute of Technology, New York; Jus de Pomme Gallery, New York; Hillwood Art Gallery, Long Island University, Brookville, N.Y.; Hempstead Harbor Artists Association, Glen Cove, N.Y.; Islip Museum, East Islip, N.Y.; The Brooklyn Museum, N.Y.; Avenue B Gallery, New York. *Awards*: Pennsylvania Council on the Arts, 1987. *Collections*: Il Diaframma, Milan; New York Institute of Technology, Old Westbury, N.Y.

Helen Oji

B. 1950, Sacramento, Calif. California State University, Sacramento. *One-Person Exhibitions*: Monique Knowlton Gallery, New York; INTAR Latin American Gallery, New York. *Group Exhibitions*: Long Island University, Brook-

lyn Campus, N.Y.; Dance Theater Workshop, New York; Sidney Janis Gallery, New York; The New Museum of Contemporary Art, New York; The Drawing Center, New York; Nordjyllands Kunstmuseum, Aalborg, Denmark; Greenville County Museum of Art, S.C. *Awards*: Creative Artists in Public Service, 1982; Ariana Foundation for the Arts, 1984. *Collections*: Jacksonville Art Museum, Fla.; Prudential Insurance Company of America, New York.

Beverly Pepper

B. 1924, New York. Pratt Institute, Brooklyn, N.Y., and Art Students League, New York. *One-Person Exhibitions*: Albright-Knox Art Gallery, Buffalo, N.Y.; André Emmerich Gallery, New York; San Francisco Museum of Modern Art; The Brooklyn Museum, N.Y. *Group Exhibitions*: International Sculpture Conference, Washington, D.C., 1980; Documenta VI, Kassel, West Germany, 1977; The Museum of Contemporary Art, Los Angeles; Seattle Art Museum; National Collection of Fine Arts, Washington, D.C.; Venice Biennale, 1972; Storm King Art Center, Mountainville, N.Y. *Awards*: National Endowment for the Arts, 1975, 1979; *Collections*: Albright-Knox Art Gallery, Buffalo, N.Y.; The Metropolitan Museum of Art, New York.

Judy Pfaff

B. 1946, London. Yale University School of Art and Architecture, New Haven, Conn. *One-Person Exhibitions*: Carnegie Mellon Art Gallery, Pittsburgh; Holly Solomon Gallery, New York; Venice Biennale, 1982; Albright-Knox Art Gallery, Buffalo, N.Y. *Group Exhibitions*: Holly Solomon Gallery, New York; The Queens Museum, Flushing, N.Y.; Whitney Biennial, New York, 1981, 1987; The Museum of Modern Art, New York; Hirshhorn Museum and Sculpture Garden, Washington, D.C.; Stadt Köln, West Germany; Wacoal Art Center, Tokyo. *Awards*: National Endowment for the Arts, 1979, 1986; Guggenheim Fellowship, 1983. *Collections*: Whitney Musuem of American Art, New York; The Museum of Modern Art, New York.

Ellen Phelan

B. 1943, Detroit. Wayne State University, Detroit. *One-Person Exhibitions*: Barbara Toll Gallery, New York; Susanne Hilberry Gallery, Birmingham, Mich.; Dart Gallery, Chicago; Wadsworth Atheneum, Hartford, Conn. *Group Exhibitions*: Whitney Museum of American Art, New York; The Parrish Art Museum, Southampton, N.Y.; Curt Marcus Gallery, New York; The Drawing Center, New York; Artists Space, New York; Museum of Contemporary Art, Chicago; Cranbrook Academy of Art Museum, Bloomfield Hills, Mich. *Awards*: National Endowment for the Arts, 1978. *Collections*: The Museum of Modern Art, New York; Hayden Gallery, Massachusetts Institute of Technology, Cambridge.

Howardena Pindell

B. 1943, Philadelphia. Yale University School of Art and Architecture, New Haven, Conn. *One-Person Exhibitions*: Birmingham Museum of Art, Ala.; Studio Museum in Harlem, New York; Grand Rapids Art Museum, Mich.; Liz Harris Gallery, Boston. *Group Exhibitions*: INTAR Latin American Gallery, New York; Yale University Art Gallery, New Haven, Conn.; Studio Museum in Harlem, New York; Sidney Janis Gallery, New York; The Clocktower, New York; The New Museum of Contemporary Art, New York; The Oakland Museum, Calif. *Awards*: National Endowment for the Arts, 1972, 1983; Guggenheim Fellowship, 1987. *Collections*: The Metropolitan Museum of Art, New York; The Museum of Modern Art, New York.

Jody Pinto

B. 1944, New York. Philadelphia College of Art. *One-Person Exhibitions*: Hal Bromm Gallery, New York; Marian Locks Gallery, Philadelphia; Pennsylvania Academy of the Fine Arts, Philadelphia; Institute of Contemporary Art-University of Pennsylvania, Philadelphia. *Group Exhibitions*: Hallwalls, Buffalo, N.Y; Contemporary Arts Center, Cincinnati; Dayton Art Institute, Ohio; The Wellesley College Museum, Mass.; Whitney Museum of American Art, New York; Edith C. Blum Art Institute, Bard College, Annandale-on-Hudson, N.Y.; Hayden Gallery, Massachusetts Institute of Technology, Cambridge. *Awards*: National Endowment for the Arts, 1979; New Jersey State Council on the Arts, 1982. *Collections*: Solomon R. Guggenheim Museum, New York; Philadelphia Museum of Art.

Rona Pondick

B. 1952, Brooklyn, N.Y. Yale University School of Art and Architecture, New Haven, Conn. *One-Person Exhibitions*: Sculpture Center, New York; fiction/nonfiction, New York. *Group Exhibitions*: University Art Museum, University of California, Santa Barbara; Galerie Alfred Kren, Cologne, West Germany; Zabriskie Gallery, New York; Carl Solway Gallery, Cincinnati; Jack Tilton Gallery, New York; Jersey City Museum, N.J.; Rosa Esman Gallery, New York. *Awards*: Ludwig Vogelstein Foundation, 1985.

Kristin Reed

B. 1952, Morristown, N.J. Pratt Institute, Brooklyn, N.Y. *One-Person Exhibitions*: CEPA Gallery, Buffalo, N.Y.; Printed Matter, New York. *Group Exhibitions*: Broadway/Lafayette Subway Station (mural), New York; City Without Walls Gallery, Newark, N.J.; PPOW Gallery, New York; Exit Art, New York; University of Puerto Rico, San Juan; The New Museum of Contemporary Art, New York; Emilie A. Wallace Gallery, State University of New York, Old Westbury. *Awards*: Art Matters, 1986; Manhattan Community Arts Fund, 1986.

Deborah Remington

B. 1935, Haddonfield, N.J. San Francisco Art Institute. *One-Person Exhibitions*: Jack Shainman Gallery, New York; Newport Harbor Art Museum, Newport Beach, Calif.; Hamilton Gallery, New York; San Francisco Museum of Modern Art. *Group Exhibitions*: The Aldrich Museum of Contemporary Art, Ridgefield, Conn.; American Academy and Institute of Arts and Letters, New York; Galleria National d'Arte Moderno, Lisbon, Portugal; National Collection of Fine Arts, Washington, D.C.; Whitney Annual and Biennial, New York, 1965, 1967, 1972; Stamford Museum, Conn.; The Oakland Museum, Calif. *Awards*: National Endowment for the Arts, 1979; Guggenheim Fellowship, 1984. *Collections*: The Art Institute of Chicago; Centre Georges Pompidou, Paris.

Edda Renouf

B. 1943, Mexico City. Columbia University, New York. *One-Person Exhibitions*: Blum Helman Gallery, New York; Yvon Lambert, Paris; Margo Leavin Gallery, Los Angeles; Wadsworth Atheneum, Hartford, Conn. *Group Exhibitions*: Fridericianum Museum, Kassel, West Germany; The Metropolitan Museum of Art, New York; The Tel Aviv Museum, Israel; Oscarsson Hood Gallery, New York; Leo Castelli Gallery, New York; Whitney Biennial, New York, 1979; Centre Georges Pompidou, Paris; The Art Institute of Chicago. *Awards*: National Endowment for the Arts, 1978. *Collections*: Yale University Art Gallery, New Haven, Conn.; The Metropolitan Museum of Art, New York.

Faith Ringgold

B. 1930, New York. City College of New York. *One-Person Exhibitions*: Bernice Steinbaum Gallery, New York; Real Art Ways, Hartford, Conn.; The Deland Museum of Art, De Land, Fla.; The Baltimore Museum of Art. *Group Exhibitions*: Boston University Art Gallery; University Art Museum, University of California, Berkeley; Palmer Museum of Art, The Pennsylvania State University, University Park; The Museum of Modern Art, New York; Port Authority Bus Terminal, New York; Museum of Contemporary Hispanic Art, New York; Jamaica Art Center, N.Y. *Awards*: Honorary Doctorate, College of Wooster, Ohio, 1986; Guggenheim Fellowship, 1987. *Collections*: The Museum of Modern Art, New York; Studio Museum in Harlem, New York.

Sophie Rivera

B. New York. Art Students League, New York. *One-Person Exhibitions*: El Museo del Barrio, New York. *Group Exhibitions*: INTAR Latin American Gallery, New York; Goddard-Riverside Community Center, New York; Henry Street Settlement, New York; The Bronx Museum, N.Y.; El Museo del Barrio, New York; Museo Nacional de Bellas Artes, Havana. *Collections*: El Museo del Barrio, New York; En Foco, New York.

Dorothea Rockburne

B. Verdun, Quebec. Black Mountain College, N.C. *One-Person Exhibitions*: André Emmerich Gallery, New York; Xavier Fourcade, New York; Margo Leavin Gallery, Los Angeles; The Museum of Modern Art, New York. *Group Exhibitions*: Los Angeles County Museum of Art; National Collection of Fine Arts, Washington, D.C.; Whitney Biennial, New York, 1977, 1979; Documenta VI, Kassel, West Germany, 1977; Corcoran Gallery of Art, Washington, D.C.; The Art Museum, Princeton University, N.J.; The Museum of Modern Art, New York. *Awards*: Guggenheim Fellowship, 1972; National Endowment for the Arts, 1974. *Collections*: Fogg Art Museum, Harvard University, Cambridge, Mass.; Philadelphia Museum of Art.

Miriam Schapiro

B. 1923, Toronto. University of Iowa, Iowa City. *One-Person Exhibitions*: Bernice Steinbaum Gallery, New York; College of Wooster Art Museum, Ohio; Allen Memorial Art Museum, Oberlin College, Ohio; André Emmerich Gallery, New York. *Group Exhibitions*: Cincinnati Art Museum; The Museum of Modern Art, New York; Sidney Janis Gallery, New York; Marion Koogler McNay Art Museum, San Antonio, Tex.; Contemporary Arts Museum, Houston; Jane Voorhees Zimmerli Art Museum, Rutgers University, New Brunswick, N.J.; Institute of Contemporary Art-University of Pennsylvania, Philadelphia. *Awards*: National Endowment for the Arts, 1976; Guggenheim Fellowship, 1987. *Collections*: Hirshhorn Museum and Sculpture Garden, Washington D.C.; National Gallery of Art, Washington, D.C.

Maria Scotti

B. 1942, Providence, R.I. Rhode Island School of Design, Providence. *One-Person Exhibitions*: Michael Walls Gallery, New York; Ruth Siegel, New York; Pamela Auchincloss Gallery, Santa Barbara, Calif.; Galleria Mazzuchielle, Florence. *Group Exhibitions*: Wright Gallery, Dallas; Fendrick Gallery, Washington, D.C.; Graham Modern, New York; Indianapolis Museum of Art, Ind.; Greenville County Museum of Art, S.C.; Franklin Furnace, New York; Susan Caldwell Gallery, New York.

Carole Seborovski

B. 1960, San Diego, Calif. Hunter College, New York. *One-Person Exhibitions*: Lorence-Monk, New York; Hunter College Art Gallery, New York; Damon Brandt Gallery, New York. *Group Exhibitions*: Carnegie-Mellon University Art Gallery, Pittsburgh; Lorence-Monk, New York; American Academy and Institute of Arts and Letters, New York; The Brooklyn Museum, N.Y.; Weatherspoon Art Gallery, University of North Carolina, Greensboro; Manhattan Art Center, New York; Willard Gallery, New York; Barbara Krakow Gallery, Boston. *Awards*: Pollock-

Krasner Foundation, 1986. *Collections*: The Brooklyn Museum, N.Y.; The Metropolitan Museum of Art, New York; The Museum of Modern Art, New York.

Katie Seiden

B. New York. New York University. *One-Person Exhibitions*: Sensory Evolution Gallery, New York; Washington County Museum of Fine Arts, Hagerstown, Md.; The 5 & Dime, New York; Edward Williams Gallery, Hackensack, N.J. *Group Exhibitions*: International Shoebox Sculpture, Honolulu, Hawaii, 1988; San Francisco International Airport; The Clocktower, New York; Heckscher Museum, Huntington, N.Y.; Islip Art Museum, East Islip, N.Y.; Schenectady Museum, N.Y.; International Biennial, Gabrova, Bulgaria, 1989. *Awards*: Artists Space, 1988. *Collections*: Grand Manan Museum, New Brunswick, Canada; House of Humour & Satire, Gabrova, Bulgaria.

Joan Semmel

B. 1932, New York. Pratt Institute, Brooklyn, N.Y. *One-Person Exhibitions*: Gruenebaum Gallery, New York; St. Louis Gallery 210, University of Missouri, St. Louis; 112 Greene Street, New York; Lerner-Heller Gallery, New York. *Group Exhibitions*: Mint Museum of Art, Charlotte, N.C.; Roland Gibson Gallery, State University of New York, Potsdam; Minneapolis College of Art and Design Gallery, Minn.; The Chrysler Museum, Norfolk, Va.; The Brooklyn Museum, N.Y.; Haags Gemeentemuseum, The Netherlands; Snite Museum of Art, University of Notre Dame, South Bend, Ind. *Awards*: Creative Artists in Public Service, 1975; National Endowment for the Arts, 1980, 1985. *Collections*: Museum of Contemporary Art, Houston; New Jersey State Museum, Trenton.

Judith Shea

B. 1948, Philadelphia. Parsons School of Design/The New School for Social Research, New York. *One-Person Exhibitions*: La Jolla Museum of Contemporary Art, Calif.; Curt Marcus Gallery, New York; Willard Gallery, New York; Pennsylvania Academy of the Fine Arts, Philadelphia; The Nelson-Atkins Museum of Art, Kansas City, Mo. *Group Exhibitions*: Walker Art Center, Minneapolis; Albright-Knox Art Gallery, Buffalo, N.Y.; Contemporary Arts Center, Cincinnati; P.S. 1, Long Island City, N.Y.; Hayden Gallery; Massachusetts Institute of Technology, Cambridge; Hirshhorn Museum and Sculpture Garden, Washington, D.C.; Whitney Biennial, New York, 1981. *Awards*: National Endowment for the Arts, 1984, 1986. *Collections*: Walker Art Center, Minneapolis; The Brooklyn Museum, N.Y.

Maura Sheehan

B. 1954, New York. San Francisco Art Institute. *One-Person Exhibitions*: Art Galaxy, New York; Bruno Facchetti

Gallery, New York; Everson Museum of Art of Syracuse and Onondaga County, N.Y.; Grey Art Gallery, New York University. *Group Exhibitions*: Weatherspoon Art Gallery, University of North Carolina, Greensboro; Staedtische Kunsthalle, Düsseldorf, West Germany; The Queens Museum, Flushing, N.Y.; P.S. 1, Long Island City, N.Y.; Civilian Warfare, New York; New Math Gallery, New York; Baskerville & Watson Gallery, New York. *Awards*: Creative Artists in Public Service, 1983; National Endowment for the Arts, 1987. *Collections*: Hamden Plaza, Conn.; Weatherspoon Art Gallery, University of North Carolina, Greensboro.

Hollis Sigler

B. 1948, Gary, Ind. School of the Art Institute of Chicago. *One-Person Exhibitions*: Chicago Cultural Center; Dart Gallery, Chicago; Akron Art Museum, Ohio; Barbara Gladstone Gallery, New York. *Group Exhibitions*: Terra Museum of American Art, Chicago; Museum of Contemporary Art, Chicago; Contemporary Arts Center, Cincinnati; Corcoran Biennial, Washington, D.C., 1985; The Art Institute of Chicago; The Museum of Modern Art, New York; Sidney Janis Gallery, New York. *Awards*: Awards in the Visual Arts, 1986; National Endowment for the Arts, 1987. *Collections*: Museum of Contemporary Art, Chicago; Seattle Art Museum.

Sandy Skoglund

B. 1946, Quincy, Mass. University of Iowa, Iowa City. *One-Person Exhibitions*: Lorence-Monk, New York; Leo Castelli Gallery, New York; Minneapolis Institute of Arts, Minn.; Wadsworth Atheneum, Hartford, Conn. *Group Exhibitions*: National Museum of American Art, Washington, D.C.; Harvard University, Cambridge, Mass.; The Baltimore Museum of Art; Los Angeles County Museum of Art; Walker Art Center, Minneapolis; John and Mable Ringling Museum of Art, Sarasota, Fla.; Laguna Beach Museum of Art, Calif. *Awards*: National Endowment for the Arts, 1980; New York Foundation for the Arts, 1988. *Collections*: The Metropolitan Museum of Art, New York; The Baltimore Museum of Art.

Sylvia Sleigh

B. Handudno, North Wales. Brighton-Hone Art School, London University. *One-Person Exhibitions*: Soho 20 Gallery, New York; G. W. Einstein, New York; The Canton Art Institute, Ohio; AIR Gallery, New York. *Group Exhibitions*: Newhouse Gallery, Snug Harbor, Staten Island, N.Y.; Cooper-Hewitt Museum, Smithsonian Institution, New York; Zoller Gallery, The Pennsylvania State University, University Park; The Butler Institute of American Art, Youngstown, Ohio; Museum of Contemporary Art, Chicago; De Cordova and Dana Museum and Park, Lincoln, Mass.; The Queens Museum, Flushing, N.Y. *Awards*: National Endowment for the Arts, 1982. *Collec-

tions: Everson Museum of Art of Syracuse and Onondaga County, N.Y.; Virginia Museum of Fine Arts, Richmond.

Jaune Quick-to-See Smith

B. 1940, St. Ignatius, Mont. University of New Mexico, Albuquerque. *One-Person Exhibitions*: Bernice Steinbaum Gallery, New York; Marilyn Butler Gallery, Santa Fe, N. Mex.; Yellowstone County Museum, Billings, Mont.; University of Missouri, St. Louis. *Group Exhibitions*: The Chrysler Museum, Norfolk, Va.; Fort Wayne Museum of Art, Ind.; Museum of Contemporary Hispanic Art, New York; University of Northern Iowa, Cedar Falls; Bernice Steinbaum Gallery, New York; The Brooklyn Museum, N.Y.; Artists Space, New York. *Awards*: WESTAF Fellowship, Santa Fe, N. Mex., 1988. *Collections*: National Museum of American Art, Washington, D.C.; Minneapolis Institute of Arts, Minn.

Joan Snyder

B. 1940, Highland Park, N.J. Rutgers University, New Brunswick, N.J. *One-Person Exhibitions*: Hirschl and Adler Gallery, New York; Fine Arts Center, State University of New York, Stony Brook; Wadsworth Atheneum, Hartford, Conn.; Los Angeles Institute of Contemporary Art. *Group Exhibitions*: Sidney Janis Gallery, New York; Museum of Fine Arts, Boston; Whitney Biennial, New York, 1973, 1981; The Brooklyn Museum, N.Y.; Corcoran Biennial, Washington, D.C., 1987; Institute of Contemporary Art, Boston; The Detroit Institute of Arts. *Awards*: National Endowment for the Arts, 1975; Guggenheim Fellowship, 1981. *Collections*: The Museum of Modern Art, New York; The Metropolitan Museum of Art, New York.

Kit-Yin Snyder

B. Canton, China. Claremont College, Calif. *One-Person Exhibitions*: The Hudson River Museum of Westchester, Yonkers, N.Y.; Sculpture Center, New York; Graduate Center, City University of New York; Just Above Midtown, New York. *Group Exhibitions*: Anchorage, New York; Sala Uno, Rome; The Bruce Museum, Greenwich, Conn.; Houston Festival; California State University, Fullerton; Artpark, Lewiston, N.Y.; Doris Freedman Gallery, The Urban Center, New York. *Awards*: National Endowment for the Arts, 1986; New York Foundation for the Arts, 1986. *Collections*: Margaret Mitchell Square, Atlanta; Lannan Foundation, Palm Beach, Fla.

Helen Soreff

B. New York; Long Island University, Brookville, N.Y. *One-Person Exhibitions*: M-13 Gallery, New York; Condeso-Lawler Gallery, New York; Bertha Urdang Gallery, New York; Guild Hall, East Hampton, N.Y. *Group Exhibitions*: Graham Modern, New York; The Clocktower, New York; Hillwood Art Gallery, Long Island University,

Brookville, N.Y.; Kathryn Markel Gallery, New York; Marianne Deson Gallery, Chicago; Guild Hall, East Hampton, N.Y.; Hal Bromm Gallery, New York. *Awards*: Adolph and Esther Gottlieb Foundation, 1986; New York Foundation for the Arts, 1987. *Collections*: Hillwood Art Gallery, Long Island University, Brookville, N.Y.; Best Products Corporation, Richmond, Va.

Nancy Spero

B. 1926, Cleveland, Ohio. School of the Art Institute of Chicago. *One-Person Exhibitions*: Josh Baer Gallery, New York; Barbara Gladstone Gallery, New York; Everson Museum of Art of Syracuse and Onondaga County, N.Y.; Institute of Contemporary Arts, London. *Group Exhibitions*: The Museum of Modern Art, New York; Exit Art, New York; Documenta VIII, Kassel, West Germany, 1987; Centre International d'Art Contemporain de Montréal, Canada; Sydney Biennial, Australia, 1986; Centro Cultural/Arte Contemporaneo, Mexico City. *Awards*: Creative Artists in Public Service, 1976; National Endowment for the Arts, 1977. *Collections*: The Museum of Modern Art, New York; Philadelphia Museum of Art.

May Stevens

B. 1924, Boston. Massachusetts College of Art, Boston. *One-Person Exhibitions*: The New Museum of Contemporary Art, New York; Orchard Gallery, Derry, North Ireland; Kenyon College Art Gallery, Gambier, Ohio; Wight Art Gallery, University of California, Los Angeles. *Group Exhibitions*: The Museum of Modern Art, New York; University Art Museum, University of California, Berkeley; Studio Museum in Harlem, New York; Institute of Contemporary Arts, London; Haags Gemeentemuseum, The Netherlands; Casa de la Obra Pia, Havana; Museo Universitario del Chopo, Mexico City. *Awards*: National Endowment for the Arts, 1983; Guggenheim Fellowship, 1986. *Collections*: Whitney Museum of American Art, New York; Herbert F. Johnson Museum of Art, Cornell University, Ithaca, N.Y.

Lawre Stone

B. 1960, Hartford, Conn. Bard College, Aannandale-on-Hudson, N.Y. *Group Exhibitions*: John Davis Gallery, New York; White Columns, New York; Rotunda Gallery, Brooklyn, N.Y.; Inroads Gallery, New York; North Main Street Space, Providence, R.I.; Woods Gerry Gallery, Providence, R.I.

Marjorie Strider

B. Guthrie, Okla. Kansas City Art Institute, Mo. *One-Person Exhibitions*: Marion Koogler McNay Art Museum, San Antonio, Tex.; Joslyn Art Museum, Omaha, Nebr.; The Clocktower, New York; Pace Gallery, New York. *Group Exhibitions*: Newhouse Gallery, Snug Harbor, Staten Island, N.Y.; Bernice Steinbaum Gallery, New York; Stam-

ford Museum, Conn.; Drawing Biennale, Lisbon, Portugal, 1981; Museum of Contemporary Art, Chicago; The Aldrich Museum of Contemporary Art, Ridgefield, Conn.; P.S. 1, Long Island City, N.Y. *Awards*: Longview Foundation, 1973; National Endowment for the Arts, 1974, 1980. *Collections*: Solomon R. Guggenheim Museum, New York; Albright-Knox Art Gallery, Buffalo, N.Y.

Michelle Stuart

B. Los Angeles. Chouinard Art Institute, Los Angeles. *One-Person Exhibitions*: Rose Art Museum, Brandeis University, Waltham, Mass.; Hillwood Art Gallery, Long Island University, Brookville, N.Y.; Anders Tornberg Gallery, Lund, Sweden; Institute of Contemporary Arts, London. *Group Exhibitions*: Philadelphia Museum of Art; Everson Museum of Art of Syracuse and Onondaga County, N.Y.; The Brooklyn Museum, N.Y.; Moderna Museet, Stockholm; Arts Council of Great Britain, London; Hirshhorn Museum and Sculpture Garden, Washington, D.C.; Documenta VI, Kassel, West Germany, 1977. *Awards*: Guggenheim Fellowship, 1975; National Endowment for the Arts, 1975, 1977, 1980. *Collections*: The Museum of Modern Art, New York; Walker Art Center, Minneapolis.

Vicki Teague-Cooper

B. 1951, Fort Smith, Ark. University of Texas, Austin. *One-Person Exhibitions*: Siegeltuch Gallery, New York; Galveston Arts Center, Tex.; 500 Exposition Gallery, Dallas; Carver Cultural Center, San Antonio, Tex. *Group Exhibitions*: Center for Contemporary Art, Chicago; The Bronx Museum of the Arts, N.Y.; Laguna Gloria Art Museum, Austin, Tex.; San Antonio Art Institute, Tex.; Ben Shahn Gallery, William Paterson College, Wayne, N.J.; Lyman Allyn Museum, New London, Conn.; Art Network, Tucson, Ariz. *Collections*: The Museum of Fine Arts, Houston; Chase Manhattan Bank, New York.

Gillian Theobald

B. 1944, La Jolla, Calif. San Diego State University, Calif. *One-Person Exhibitions*: Cirrus Gallery, Los Angeles; Patty Aande Gallery, San Diego, Calif.; James Crumley Gallery, Mira Costa College, Carlsbad, Calif.; Installation Gallery, San Diego, Calif. *Group Exhibitions*: Laguna Beach Museum of Art, Calif.; Greenville County Museum of Art, S.C.; La Jolla Museum of Contemporary Art, Calif.; University Art Museum, University of California, Santa Barbara; Galerie Akmak, West Berlin; University Art Galleries at Wright State University, Dayton, Ohio; G. W. Einstein, New York.

Betty Tompkins

B. 1945, Washington, D.C. Syracuse University, N.Y. *One-Person Exhibitions*: P.S. 1, Long Island City, N.Y.;

Jane Voorhees Zimmerli Art Museum, Rutgers University, New Brunswick, N.J.; Stamford Museum, Conn. *Group Exhibitions*: Hallwalls, Buffalo, N.Y.; La Mama-La Galleria Second Classe, New York; Fashion Moda, Bronx, N.Y.; Zeus-Trabia Gallery, New York; The Clocktower, New York; The Aldrich Museum of Contemporary Art, Ridgefield, Conn.; Harm Bouckaert Gallery, New York. *Awards*: MacDowell Fellowship, 1982, 1983; Creative Artists in Public Service, 1983. *Collections*: The Aldrich Museum of Contemporary Art, Ridgefield, Conn.; Stamford Museum, Conn.

Gladys Triana

B. 1937, Camaguey, Cuba. Long Island University, Brookville, N.Y. *One-Person Exhibitions*: Cuban Museum of Art and Culture, Miami; INTAR Latin American Gallery, New York; Tramontana Gallery, Madrid; Universidad National Autonoma de Mexico, Mexico City. *Group Exhibitions*: El Museo del Barrio, New York; Museum of Contemporary Hispanic Art, New York; Cayman Gallery, New York; The Bronx Museum of the Arts, N.Y.; Bienal de Segovia, Spain, 1972; International Monetary Fund Gallery, Washington, D.C.; Museo Nacional de Bellas Artes, Havana. *Collections*: Palacio de Bellas Artes, Havana.

Ursula von Rydingsvärd

B. 1942, Deensen, Germany. Columbia University, New York. *One-Person Exhibitions*: Laumeier Sculpture Park and Gallery, St. Louis; Studio Bassanese, Trieste, Italy; Exit Art, New York; Rosa Esman Gallery, New York. *Group Exhibitions*: The Queens Museum, Flushing, N.Y.; Contemporary Arts Center, Cincinnati; Carl Solway Gallery, Cincinnati; Santa Barbara Contemporary Arts Forum, Calif.; Battery Park City, New York; Wave Hill, Bronx, N.Y.; Penn's Landing, Philadelphia. *Awards*: National Endowment for the Arts, 1979, 1986; Guggenheim Fellowship, 1983. *Collections*: The Metropolitan Museum of Art, New York; The Aldrich Museum of Contemporary Art, Ridgefield, Conn.

Merrill Wagner

B. 1935, Seattle. Sarah Lawrence College, Bronxville, N.Y. *One-Person Exhibitions*: Traver Sutton Gallery, Seattle; John Gibson Gallery, New York; Tacoma Art Museum, Wash.; The Clocktower, New York. *Group Exhibitions*: Ben Shahn Gallery, William Paterson College, Wayne, N.J.; City Gallery, New York; P.S. 1, Long Island City, N.Y.; The Bronx Museum of the Arts, N.Y.; Hillwood Art Gallery, Long Island University, Brookville, N.Y.; Sidney Janis Gallery, New York; Weatherspoon Art Gallery, University of North Carolina, Greensboro. *Collections*: Chase Manhattan Bank, New York; Weatherspoon Art Gallery, University of North Carolina, Greensboro.

Kay WalkingStick

B. 1935, Syracuse, N.Y. Pratt Insitute, Brooklyn, N.Y. *One-Person Exhibitions*: Wenger Gallery, Los Angeles; M-13 Gallery, New York; Bertha Urdang Gallery, New York; New Jersey State Museum, Trenton. *Group Exhibitions*: INTAR Latin American Gallery, New York; Artists Space, New York; American Academy and Institute of Arts and Letters, New York; Sierra Nevada Museum, Reno; Exit Art, New York; The Heard Museum, Phoenix, Ariz.; Modernism Gallery, San Francisco; The Bronx Museum of the Arts, N.Y. *Awards*: New Jersey State Council on the Arts, 1981, 1985; National Endowment for the Arts, 1983. *Collections*: Albright-Knox Art Gallery, Buffalo, N.Y.; Herbert F. Johnson Museum of Art, Cornell University, Ithaca, N.Y.

Andrea Way

B. 1949, San Francisco. Indiana University, Bloomington. *One-Person Exhibitions*: Brody's Gallery, Washington, D.C.; Fendrick Gallery, Washington, D.C.; Barbara Kornblatt Gallery, Washington, D.C.; Barbara Fiedler Gallery, Washington, D.C. *Group Exhibitions*: Baumgartner Galleries, Washington, D.C.; Brody's Gallery, Washington, D.C.; Arlington Art Center, Va.; Corcoran Gallery of Art, Washington, D.C.; The Drawing Center, New York; The Clocktower, New York; Jane Haslem Gallery, Washington, D.C. *Collections*: National Museum of American Art, Washington, D.C.; The Cleveland Museum of Art.

Joan Weber

B. 1944, Miami. Columbia University, New York. *One-Person Exhibitions*: Freedman Gallery, Albright College, Reading, Pa. *Group Exhibitions*: Henry Street Settlement, New York; Sculpture Center, New York; City Without Walls Gallery, Newark, N.J.; Islip Art Museum, East Islip, N.Y.; 55 Mercer, New York; The Drawing Center, New York; The Queens Museum, Flushing, N.Y. *Awards*: Millay Colony Residency, 1981; Virginia Center for the Creative Arts Residency, Sweet Briar.

Mia Westerlund-Roosen

B. 1942, New York. Art Students League, New York. *One-Person Exhibitions*: Leo Castelli Gallery, New York; The New Museum of Contemporary Art, New York; The Clocktower, New York; Storm King Arts Center, Mountainville, N.Y. *Group Exhibitions*: Germans Van Eck Gallery, New York; Edith C. Blum Art Institute, Bard College, Annandale-on-Hudson, N.Y.; Sidney Janis Gallery, New York; Zabriskie Gallery, New York; Neuberger Museum, State University of New York at Purchase; Stedman Art Gallery, Rutgers University, Camden, N.J.; Hillwood Art Gallery, Long Island University, Brookville, N.Y. *Awards*: Canada Council Arts, 1972; National Endowment for the Arts, 1988. *Collections*: The Metropolitan Museum of Art, New York; Yale University Art Gallery, New Haven, Conn.

Jerilea Zempel

B. 1947, Pittsburgh. Columbia University, New York. *One-Person Exhibitions*: Kenmare Square, New York; Sculpture Center, New York; Real Art Ways, Hartford, Conn.; Kingsborough Community College Art Gallery, Brooklyn, N.Y. *Group Exhibitions*: Art in General, New York; Newhouse Gallery, Snug Harbor, Staten Island, N.Y.; Nassau County Museum of Fine Art, Roslyn Harbor, N.Y.; Prospect Park Boathouse, Brooklyn, N.Y.; Sculpture Space, Utica, N.Y.; Artpark, Lewiston, N.Y.; Art Awareness, Lexington, N.Y. *Awards*: National Endowment for the Arts, 1981; New York Foundation for the Arts, 1985. *Collections*: Columbia University, New York; Printmaking Workshop, New York.

Salli Zimmerman

B. 1943, Syracuse, N.Y. Pratt Institute, Brooklyn, N.Y. *One-Person Exhibitions*: Firehouse Gallery, Garden City, N.Y.; Central Hall Gallery, Port Washington, N.Y.; Plandome Gallery, New York. *Group Exhibitions*: Islip Art Museum, East Islip, N.Y.; 55 Mercer, New York; Contemporary Arts Forum and Alice Keck Park, Santa Barbara, Calif.; City University of New York, Graduate Center; Adelphi University, Garden City, N.Y.; Visual Arts Museum, School of Visual Arts, New York; B. J. Spoke Gallery, Port Washington, N.Y.; Hillwood Art Gallery, Long Island University, Brookville, N.Y.

Nola Zirin

B. New York. New York University. *One-Person Exhibitions*: Giordano Gallery, Dowling College, Oakdale, N.Y.; Nassau Museum of Fine Art, Roslyn, N.Y.; Atlantic Gallery, New York; Discovery Gallery, Glen Cove, N.Y. *Group Exhibitions*: Leonarda DiMauro Gallery, New York; Wilson Arts Center, Rochester, N.Y.; Sandra Gering Fine Arts, Oyster Bay, N.Y.; La Galleria, Bologna, Italy; Islip Art Museum, East Islip, N.Y.; Museum of the Hudson Highlands, Cornwall-on-Hudson, N.Y.; Fine Arts Museum of Long Island, Hempstead, N.Y. *Collections*: IBM Corporation, New York; NYNEX Corporation, New York.

Barbara Zucker

Hunter College, New York. *One-Person Exhibitions*: Pam Adler Gallery, New York; Fine Arts Center, University of Massachusetts, Amherst; Joslyn Art Museum, Omaha, Nebr.; Pennsylvania Academy of the Fine Arts, Philadelphia. *Group Exhibitions*: The Queens Museum, Flushing, N.Y.; Brainerd Art Gallery, State University of New York, Potsdam; Contemporary Arts Center, Cincinnati; The Art Museum, Princeton University, N.J.; Nassau County Museum of Fine Art, Roslyn Harbor, N.Y.; Sidney Janis Gallery, New York. *Awards*: National Endowment for the Arts, 1975; Yaddo Residency, 1977, 1986. *Collections*: The Brooklyn Museum, N.Y.; Whitney Museum of American Art, New York.

Sources

Louise Bourgeois
From Jeffrey Hogrefe, "Call of the Wild," *Washington Post*, September 18, 1984.

Joan Brown
Opening paragraphs from Zan Dubin, "An Artist's Vision of Peace," *Los Angeles Times*, September 16, 1986; last paragraph from Andrée Maréchal-Workman, "An Interview with Joan Brown," *Expo-see Magazine*, March/April 1985.

Jane Dickson
From Claudia Gould, "Jane Dickson: An Interview," *Print Collector's Newsletter* 17 (January/February 1987), p. 204.

Janet Fish
Unpublished, courtesy Robert Miller Gallery, New York.

Mary Frank
From Paul Cummings, "Mary Frank Talks with Paul Cummings," *Drawing* 3 (May/June 1981), p. 11

Eva Hesse
From Lucy Lippard, *Eva Hesse* (New York: New York University Press, 1976), p. 131.

Lee Krasner
From Cindy Nemser, "A Conversation with Lee Krasner," *Arts Magazine* 47 (April 1973), p. 45.

Lois Lane
From Craig Gholson, "Willard Gallery, New York Exhibit," *Arts Magazine* 54 (February 1978), p. 24.

Marisol
From Grace Glueck, "It's Not Pop, It's Not Op—It's Marisol," *New York Times*, March 7, 1965, pp. 34, 46.

Ana Mendieta
From Linda Montano, "Ana Mendieta: A Selection of Statements and Notes," *Sulfur* 22 (Spring 1988), p. 72.

Mary Miss
From Deborah Nevins, "An Interview with Mary Miss," *Princeton Journal* 2 (1985), p. 99.

Joan Mitchell
From Judith E. Bernstock, *Joan Mitchell* (New York: Hudson Hills Press, 1988), p. 31.

Ree Morton
From her notebook of December 1973, quoted in Allan Schwartzman and Kathleen Thomas, *Ree Morton* (New York: The New Museum of Contemporary Art, 1980), p. 36.

Alice Neel
From Elaine Warren, "Alice Neel, 83, Loves Painting City 'Freaks,'" *Los Angeles Herald Examiner*, April 5, 1983, p. C2.

Ellen Phelan
From Gerrit Henry, "Ellen Phelan: The Interpretation of Dolls," *Print Collector's Newsletter* 19 (May/June 1988), p. 51.

Faith Ringgold
Last three paragraphs from Charlotte Robinson, *The Artist and the Quilt* (New York: Alfred A. Knopf, 1983), pp. 104–5.

Dorothea Rockburne
From Dorothea Rockburne, "Notes on Creativity," lecture, Columbia University, New York, 1988.

Bibliography

Books

Alberts, Calvin. *Figure Drawing Comes to Life*. New York: Prentice-Hall, 1987.

Betti, Claudia, and Teel Sale. *Drawing: A Contemporary Approach*. New York: CBS Publishing, 1986.

Cummings, Paul. *Twentieth-Century American Drawing*. New York: Whitney Museum of American Art, 1984.

Field, Richard S., and Ruth E. Fine. *A Graphic Muse: Prints by Contemporary American Women*. New York: Hudson Hills Press, 1987.

Kaupelis, Robert. *Experimental Drawing*. New York: Watson-Guptill, 1980.

Lauter, Estella. *Women as Mythmakers—Poetry and Visual Art by Twentieth-Century Women*. Bloomington: Indiana University Press, 1984.

Lippard, Lucy L. *Get the Message: A Decade of Art for Social Change*. New York: E. P. Dutton, 1983.

Munro, Eleanor. *Originals: American Women Artists*. New York: Simon & Schuster, 1979.

Parker, Rosika, and Griselda Pollock, eds. *Framing Feminism: Art and the Women's Movement*. London: Pandora, 1987.

Raven, Arlene. *Crossing Over: Feminism and Art of Social Concern*. Ann Arbor, Mich.: UMI Research Press, 1987.

Robbins, Corrine. *The Pluralist Era—American Art, 1968–81*. New York: Harper & Row, 1984.

Rubinstein, Charlotte. *American Women Artists*. New York: Avon Books, 1982.

Thorson, Victoria, ed. *The Twentieth Century: Great Drawings of All Time*, 2 vols. Redding, Conn.: Talisman Books, 1979.

Torre, Susana, ed. *Women in American Architecture: A Historic and Contemporary Perspective*. New York: Whitney Library of Design, Watson-Guptill, 1977.

Tufts, Eleanor. *American Women Artists, Past and Present*. New York: Garland Publishing, 1984.

Van Wagner, Judy Collischan. *Women Shaping Art: Profiles of Power*. New York: Praeger, 1984.

Catalogues

Albright-Knox Art Gallery, Buffalo, N.Y. *With Paper, about Paper*, by Charlotta Kotik, 1980.

The Brooklyn Museum, N.Y. *Works on Paper/Women Artists*, 1975.

Contemporary Arts Center, Cincinnati, Ohio. *Standing Ground: Sculpture by American Women*, by Sarah Rogers-Lafferty, 1987.

Dayton Art Institute, Ohio. *Paper*, 1978.

Gallery of the American Indian Community House, New York. *Women of Sweetgrass, Cedar, and Sage*, 1985. *See* essays by Lucy Lippard, Jaune Quick-to-See Smith, and Erin Younger.

Gentofte Rådhus, Copenhagen. *Yngre amerikansk kunst; tegninger og grafik* (Young American Artists: Drawings and Graphics), with introduction by Steingrim Laursen, 1973.

Hillwood Art Gallery, Long Island University, Brookville, N.Y. *Monumental Drawings by Sculptors*, by Judy Collischan Van Wagner, 1982.

——. *Drawing in Situ*, 1986. *See* essay by Tiffany Bell.

Institute of Contemporary Art-University of Pennsylvania, Philadelphia. *Drawings: The Pluralist Decade*, by Janet Kardon, 1980.

——. *Desenhos: Década Pluralista*, 1981. (With the Fundação Calouste Gulbenkian, Galerias de Exposições Temporárias, Lisbon, and the International Communication Agency; essays in Portuguese by John Neff, Rosalind Krauss, Richard Lorber, Edit de Ak, John Perreault, and Howard Fox.)

INTAR Latin American Gallery, New York. *Autobiography: In Her Own Image*, 1988.

The Museum of Modern Art, New York. *Drawing Now*, by Bernice Rose, 1976.

Sculpture Center, New York. *Between Drawing and Sculpture*, by Douglas Dreishspoon, 1985.

Studio Museum in Harlem, New York. *Tradition and Conflict: Images of a Turbulent Decade*, 1985. *See* essays by Mary Schmidt Campbell and Lucy Lippard.

University Art Museum, University of California, Santa Barbara. *Contemporary Drawing/New York*, 1978.

Whitney Museum of American Art, New York. *Drawing Acquisitions: 1978–1981*, by Paul Cummings, 1981.

——. *Abstract Drawings, 1911–1981*, 1982.

——. *The Sculptor as Draughtsman*, by Paul Cummings, 1984.

Photograph Credits

Michael Abeloff: Joan Weber, *Figurative Bridge*. Karen Bell: Faith Ringgold, *Echoes of Harlem*; Jaune Quick-to-See Smith, *Cowboy*. Geoffrey Clements: Elizabeth Egbert, *Triton's Tower*; Lois Lane, *Untitled #65*; Sylvia Sleigh, *Head of Philip Golub Reclining*. Dennis Cowley: Jackie Ferrara, *Red House*. Ivan Dalla Tana: Jane Dickson, *Study for Sizzlin' Chicken*. Bevan Davies: May Stevens, *Adelaide*. D. James Dee: Alice Adams, *Platform Gate Study*; Emma Amos, *Starchart with the Twins*; Judy Blum, *Heart Map*; Vivian E. Browne, *Tuolumne*; Donna Dennis, *Imaginary "Tunnel Tower" Outdoors in Dayton, Ohio (Mad River) at Night*; Judite Dos Santos, *The Fallen Man—El Salvador*; Camille Eskell, *Shutting Them Out*; Lauren Ewing, *Pure Vision of the Ideal Lady*; Maren Hassinger, *Botanicum*; Shelagh Keeley, *Objects of Daily Use*; Ellen Lanyon, *Panama*; Howardena Pindell, *Parabia Text #5*; Kristin Reed, *Who Are the Terrorists?*; Deborah Remington, *Euros X*; Katie Seiden, *Ascent of the Pigs*; Sandy Skoglund, *Drawing for "Radioactive Cats."* eeva-inkeri: Joan Brown, *The Black Cat*; Lee Krasner, *Untitled*. Roy M. Elkind: Mary Miss, *Study for "Field Rotation."* Allan Finkelman: Marisol, *Black Bird Love*. Bernard Handzel: Salli Zimmerman, *Above the Tideline of Grey #6*. Leslie Harris: Michelle Stuart, *Malakut: Makān Series*. Lisa Kahane: Heide Fasnacht, *Two-Fisted Head II*; Susan Laufer, *Lifeline Drawing Series*. Suzanne Kaufman: Helen Soreff, *Inbound Out*. Julius Kozlowski: Judy Pfaff, *Untitled*. Lary Lamé: Carol Hepper, *Untitled*. Robert E. Mates: Louise Bourgeois, *Girl Falling*. Kathleen McCarthy: Helene Brandt, *Flying*; Kathleen McCarthy, *Head with Cups, IV*. Editha Mesina: Yong Soon Min, *While*. Bernard H. Palais: Janet Henry, *Self-Portrait*; Alison Knowles, *Performance Notation from "Jem Duck"*; Ree Morton, *Line Series #3*. Pelka/Noble Photography: Melissa Meyer, *Untitled*. Pollitzer, Strong & Meyer: Nola Zirin, *Horology Variation #2*. Rona Pondick: Rona Pondick, *Untitled*. Nathan Rabin: Merrill Wagner, *Turtleback Mountain*. Adam Reich: Dotty Attie, *His Smile*. Jon Reis: Kay WalkingStick, *Compliments to Olmstead, Sketch II*. Earl Ripling: Maria Scotti, *Not Titled*. F. Scruton: Nancy Holt, *Roundabout*. Squidds & Nunns: Gillian Theobald, *Self-Portraits in Meditation*. Julius Vitali: Terry Niedzialek, *Family Shelter Designs*. Donald Waller: Maura Sheehan, *3 Gorgons*. Ellen Page Wilson: Chris Griffin, *Untitled*; Claire Lieberman, *Breathing*. Dorothy Zeidman: Nancy Brett, *Study for "Roots."* Zindman/Fremont: Janet Fish, *Cat and Fruit*; Eva Hesse, *Untitled*; Ellen Phelan, *Beth as Diva*.